P9-DEX-926

HAWK

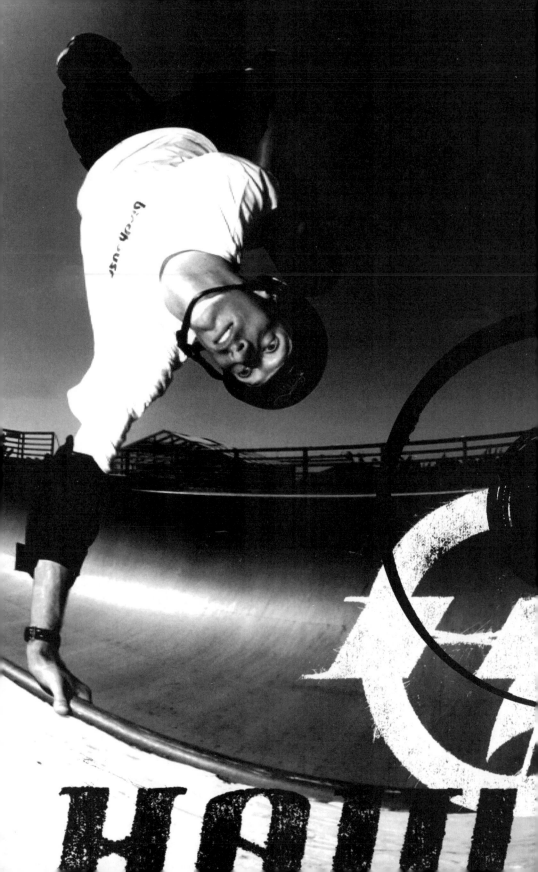

HAWK
OCCUPATION: SKATEBOARDER

TONY HAWK
WITH SEAN MORTIMER

ReganBooks
An Imprint of HarperCollins*Publishers*

HAWK

1ST EDITION

HAWK. COPYRIGHT © 2000 BY TONY HAWK. ALL RIGHTS RESERVED. PRINTED IN THE UNITED STATES OF AMERICA. NO PART OF THIS BOOK MAY BE USED OR REPRODUCED IN ANY MANNER WHATSOEVER WITHOUT WRITTEN PERMISSION EXCEPT IN THE CASE OF BRIEF QUOTATIONS EMBODIED IN CRITICAL ARTICLES AND REVIEWS. FOR INFORMATION ADDRESS HARPERCOLLINS PUBLISHERS INC., 10 EAST 53RD STREET, NEW YORK, NY 10022.

HARPERCOLLINS BOOKS MAY BE PURCHASED FOR EDUCATIONAL, BUSINESS, OR SALES PROMOTIONAL USE. FOR INFORMATION PLEASE WRITE: SPECIAL MARKETS DEPARTMENT, HARPERCOLLINS PUBLISHERS INC., 10 EAST 53RD STREET, NEW YORK, NY 10022.

DESIGNED BY BAU-DA DESIGN LAB, INC.
PRINTED ON ACID-FREE PAPER

LIBRARY OF CONGRESS CATALOGING-IN-PUBLICATION DATA
HAWK, TONY.
HAWK: OCCUPATION: SKATEBOARDER / TONY HAWK WITH SEAN MORTIMER.—1ST ED.
P. CM.
ISBN 0-06-019860-5
1. HAWK, TONY. 2. SKATEBOARDERS—UNITED STATES—BIOGRAPHY. I. MORTIMER, SEAN. II. TITLE.
GV859.8.H39 2000
796.22'092—DC21
[B] 00-040279
00 01 02 03 04 ÷/RRD 10 9 8 7

For Frank and Nancy Hawk—
thank you for the undying support

CONTENTS

INTRODUCTION: THE 900 | 1

1 DEMON BOY | 7

2 SCAB COLLECTION | 23

3 THE BONES BRIGADE | 47

4 UNDERAGE PRO | 59

5 PREFERENTIAL TREATMENT? | 73

6 WORLD CHAMPION | 97

7 FREEDOM | 113

8 ROCK STAR BURNOUT | 127

9 THE COMING DEATH | 149

10 AN UGLY DEATH | 159

11 WORLD CHAMPION, BUT WHO CARES? | 165

12 THE LONG WAY HOME | 173

13 THE EXTREME GAMES | 187

14 WE DON'T WEAR SPANDEX | 195

15 THE END | 211

16 1998 | 223

17 1999, THE YEAR OF THE 9 | 227

18 ONE 900 HISTORY | 233

19 AFTER 9 | 243

20 STILL GOING | 253

APPENDIX A:
PROFESSIONAL SKATEBOARDING AT A GLANCE | 259

APPENDIX B: TRICKS ARE FOR KIDS | 261

APPENDIX C: THE CONTESTS | 272

APPENDIX D: A TOUR IN THE LIFE | 274

PHOTOGRAPHY CAPTIONS AND CREDITS | 286

ACKNOWLEDGMENTS | 291

INTRODUCTION
THE 900

I FELT THE COLD WIND THAT BLEW in from the San Francisco Bay whip across the top of the vert ramp and onto the deck as I walked around waiting my turn. It was June 27, and I was competing in the best-trick contest at the 1999 Summer X Games with four of the best vert skaters in the world: Bucky Lasek, Colin McKay, Bob Burnquist, and Andy Macdonald. We'd been skating for fifteen minutes—it was midway through the half-hour designated for tricks—when I landed the varial 720. It's a difficult trick to do

because I have to go up the ramp backward and spin two rotations with my body, while I hold my board and turn it 180 degrees so that I come down the ramp facing forward and my board is backward. I didn't know if I could win with it, but it was all I had planned.

The crowd was huge (the X Games claim fifty thousand people), and I'd never seen this many people in such a frenzy over skateboarding. But they definitely had something to cheer about. The level of skating was so high, it was ridiculous. Colin did five differ-

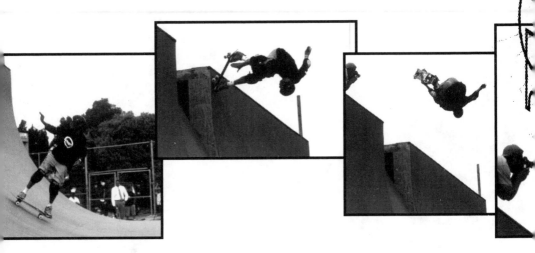

ent tricks and each could have won on its own. Bob Burnquist landed a fakie 5-0 to kickflip and Bucky Lasek was throwing down tricks like heelflip frontside Cabs. I had fifteen minutes to kill, so why not let the clock run out with a few 900 attempts? Show off a bit for the excited crowd.

I wasn't that serious, I just thought I'd crank a few, but they felt different from the get-go; the spin was consistent on most of my attempts. I knew the only way the night would end was with me stomping one down or knocking myself out in the process. I had no excuses. For thirteen years I'd been spinning the trick, only to wreck myself or wimp out.

Everything blanked out except the 9. The announcer's voice occasionally drifted into my head, telling me time was up, that this was

my last try, but there was no way I was about to stop when the 9s felt that good. They'd need every security guard on site to pull me off the ramp. I'd keep attempting the trick after everyone left and the lights were turned off if I had to. It was like Cake's song "He's Going the Distance."

I don't recall walking up the ramp after each attempt. All I thought about was getting a good look in the middle of the spin so I could spot a landing. I'd just drop in, spin, fall, get up, and walk up the

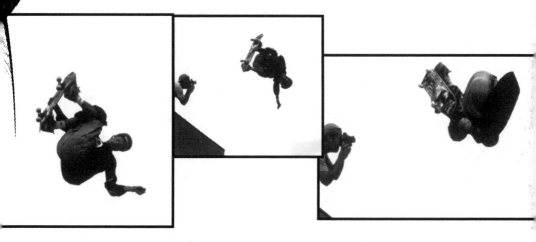

ramp over and over again. Everyone else had stopped skating. I remember thinking since the time limit was up I wasn't going to win the best trick with a 9, but it wasn't about the contest.

On my twelfth try the spin was fast and I had enough height, so I shifted my weight and threw it back, but it still felt like all the others. Then I realized, a little after the fact, that I was rolling across the flat bottom and up the other side of the ramp. After thirteen years of trying unsuccessfully to land the 9, all I could think was, *Finally!*

I freaked out as a mob of friends jumped on the ramp and tackled me. They hoisted me on their shoulders and carried me around. I was about to explode, I was so happy. I'm usually a stoic guy, and more than a few people (my wife included) have commented that

I'm hard to read, but that night I let it go. I couldn't keep anything in. I thanked the crowd and announced that this was "the best day of my life."

The best day of my life. I got into some shit over that comment at home, but I meant it in the context of my skating career. Nothing compares to having kids and a wife, but after so many years of frustration and failure this was the largest hurdle I've ever gone over. Some people and a few reporters gave me grief, but screw 'em—if my family understands, that's all I care about.

I could barely sleep that night. I was like a kid on Christmas Eve. I paced around the room, watched my youngest son, Spencer, sleeping (Riley was with his mom, Cindy), drank a few Heinekens, and popped a few Advils because my back was starting to tighten up. I had been so high from landing the 9 that it overrode any pain until late that evening. The next morning I had a professional massage.

I figured skaters would be excited about my landing the 9, but never in my life did I expect the public interest and media avalanche that followed. The morning following the contest, somebody handed me *USA Today* and showed me the article on the event. The headlines read "Hawk Lands Historic Skateboard Trick." As if people who read newspapers would even know who "Hawk" was.

It's hard to believe that so many people around the world saw me land the 9, and the one person who would have appreciated it the most wasn't there. Out of all my skateboarding accomplishments, I wish my dad, Frank Hawk, was still alive to have seen me do it. He set the stage by starting the National Skateboard Association in the '80s and helped elevate skateboarding before ESPN or the Gravity Games came onto the scene. He would have been blown away by all the attention. I'm positive he would have said a few "My son is the best" sort of things and embarrassed the hell out of me, but it would have been worth it. I also hope Stacy Peralta saw it on TV, because he played such a huge part in making me the skater that I am. He prepared me for the responsibilities of professional skating from the age of twelve.

4

HAWK

One thing I hope the 9 showed people is that skating is not a competitive sport and that night no one won and no one lost. Skating is not about winning, it's about skating the best you can and mutual appreciation. It's about pulling a trick after years of not being able to and having other skaters be happy for you. I didn't win and nobody lost on that night. My landing the 9 wasn't equivalent to Jordan making a last-minute shot and crushing the other team. It was one skater landing a trick and other skaters appreciating it. The next day, when I saw the pictures on the front of various sports pages of skaters carrying me around cheering, I couldn't help thinking what a contrast it was to regular sports. Essentially it was the *other team* that was cheering for me.

I've done a few 900s since the X Games, and they still scare the crap out of me, but a wave of relief swept over me that day after I landed it. I relaxed like I never have before. I've always had a mental wish list of tricks, such as the 900, varial 720, kickflip 540, ollie 540, and slowly over the years I checked them off one by one until the 9 was the only one left. Everything else now is purely for fun.

DEMON BOY

I SPOT HER HEAD OVER the wooden guardrail and track the cloud of grandmotherly, curly white hair drifting past. I only see the top of her head, so I know she's across the room. She's probably heading into the kitchen to make me some food—I have only a small window of opportunity before she's out of range. I have to act fast. No hesitation. I pull myself up, wobble a bit on my just-learning-to-walk legs, and pick up my red metal car. I lock the center of her aged shoulders in my crosshairs. She's turned her back on me—fatal mis-

take. I couldn't have wished for more. I aim, cock my arm back, and fire. My red car shoots across the room and finds the target. My arm is pretty feeble. I don't nail her straight in the back, but I wing her on the hip. She squawks, grabs her hip, and turns to confront her assassin. I scowl back from my crib, my one-and-a-half-year-old attitude burning, meeting her sweetness head-on.

I don't know why I threw my toys at the sweet elderly baby-sitter who looked after me as an infant. She never took me behind the woodpile and beat me with a shaving strap. In fact, I don't remember her ever doing anything mean to me. I remember her being nice. Maybe she was just the perfect-sized target.

The thing that probably pulled my trigger was that she had power over me. She told me what to eat, and where to sit, when to wash, and decided when to exile me back to Stalag 17, my baby crib. After a few months of dealing with my target practice, she quit. She wasn't upset because of my wimpy ambushes, she just didn't think it was healthy that I was so angry. Had she continued baby-sitting, I think my life would have been a lot different. I might have been a professional baseball pitcher instead of a pro skater.

My general disposition didn't change once the nanny left. In fact, that was just a warm-up. I may not have thrown toys at my parents (my dad probably would have thrown them back), but I definitely participated in some serious parental abuse. Even now, I can't figure out why I was such a nightmare. I was born extremely high strung. A picture of me as a week-old infant shows my hands clenched into fists and a faint scowl on my face. I look like I'm ready to punch the photographer. If my sons, Riley and Spencer, ever acted like I did, I'd make my wife hold them down while I checked their heads for the number of the beast.

HAWK

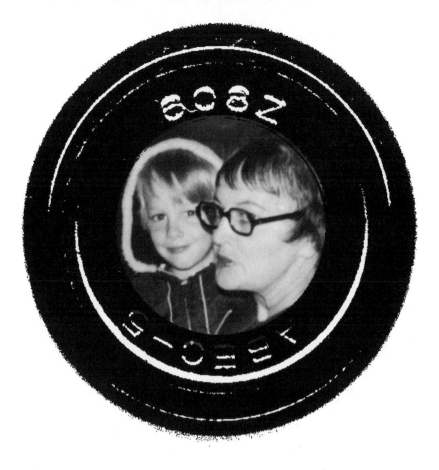

PUNISH THY PARENTS

Making my parents' lives miserable was more difficult than it sounds. I was an accident; my mom was forty-three years old and my dad was forty-five when I popped out. Mom and Dad thought they were entering a nice, relaxing phase of their life when I interrupted. They lived comfortably in Serra Mesa, California; my sister Lenore was twenty-one, my sister Patricia was eighteen, and my brother Steve was twelve. My parents handled everything in their lives with a mixture of humor (dry and dark) and severe understatement. My party crashing was no exception. When my mom announced to the family that she was pregnant, she received a variety of responses.

"Well, Mother, some of my friends have had to tell their mothers that they were pregnant, but you're the first mom I know who's had

to tell her twenty-one-year-old daughter she was expecting," Lenore said.

Pat looked at my dad, raised her eyebrows knowingly, and said, "Well . . . good old Dad."

Steve was a little more stressed. "But Mooooom, I really hadn't been planning on anything like this."

Mom looked at him, raising her Jack Nicholson–like eyebrows, and said that he wasn't the only one.

Birth and potential death were treated with identical humor in my family. One Friday night when my mom was five months into building me, my dad walked through the door holding his chest. He looked like he was trying to release a big belch, which he'd been known to do.

"Are you all right?" Mom asked.

"Well, either I have a bad case of indigestion, or I'm having a heart attack."

He was rushed to the hospital and into the emergency room. A heart specialist came in to examine him and told my dad he'd had a heart attack. He wasn't allowed to leave the hospital for two weeks. The doctors wouldn't even let him lift his arms, because the strain would be too much for his heart.

My mom, naturally, was concerned. One day she leaned over his bed and told him how much crap he'd be in if he died and left her knocked up. Afterward she started joking about it and telling friends my dad had had the heart attack the moment she told him she was pregnant. He felt much better when he returned home, but after two weeks in the hospital he'd lost his job as a salesman. This marked the beginning of his job jumping, which continued throughout the rest of his life. But as uncertain as situations became, my parents always made sure I had what I needed. I never realized how tight money had been back then until I was a teenager.

On May 12, 1968, I made my entrance into the world. When I came home from Sharp Hospital in San Diego, both my sisters were already off at college. My parents had worked hard raising their three kids, and all of them were pretty mild mannered until I made an appearance.

HAWK

I rebelled more as an infant than my brother and sisters did as teenagers. The main reason for their lack of rebellion stemmed from the fact that my parents supported whatever we kids did. Steve surfed, so my dad drove him to the beach every morning before school and sat in the car to watch until Steve was done. He also managed Pat's band and hauled music equipment to her gigs. All while selling everything from R2D2 coffee mugs, to used cars, to TVs and musical instruments.

My mom wasn't taking it easy either. She'd decided to go back to school when she was thirty-eight. She worked full time, raised her kids, and took classes at night. When she was in her fifties she earned her master's, and she was sixty-two years old when she finally earned her doctorate in education. We weren't your stereotypical family.

Since my parents were fairly old when I came around, they'd outgrown the strict mom-and-pop rearing and slipped into the grandparent mentality. Mom thought everything I did was cute, and I could do no wrong in my dad's eyes. This was surprising, because he came from an extremely disciplined lifestyle. He'd been a Navy pilot and had flown bombing missions in World War II and the Korean War. He had won the Distinguished Flying Cross, three Air Medals, and a Gold Star. (Once, when I was a teenager and he took me out to eat, I asked him if he'd ever been to Japan. "I haven't visited," he said between chews of a beef sandwich, "but I bombed it once.") I'm sure my parents employed different child-raising techniques with my brother and sisters, but they had less energy with me—it was easier for them to compromise than fight. They were my cheerleaders. If they had seen me clock the nanny, they would have complimented me on my throwing technique.

PRESCHOOL DROPOUT

From the start, I knew I had my parents wrapped around my finger. My problems began when I had to leave the house and enter into the cold world, and it didn't get any colder than Christopher Robin Preschool. My first impression was that any attempt at escape would be impossible. It was a fortress enclosed with chain-link fences and guards—I mean teachers—patrolling every student's move. I wasn't even three years old yet, and perhaps my memory is a tad subjective, but from my first glimpse I knew I was in trouble.

We had something resembling a fire drill every day that was supposed to train us to follow orders. The entire school would line up, ready for evacuation, walk outside, and silently wait for instructions. At lunchtime we had to sit at a picnic table, put our heads on our arms, and maintain silence before we could eat. We even had a game where we sat around a table as the teachers put one bullet in a gun's chamber and . . . no, wait, that was the movie *The Deer Hunter*. But we were forced to take naps. Naps! I never had naps at home and was a bit on the hyper side (some might say spastic), so

12

the half hour was akin to jamming bamboo under my fingernails. I remember lying in the dark staring at my fellow students dozing peacefully as I tried to play dead because I didn't want the teachers to notice me and try putting me to sleep. I was ready to explode by the time naptime ended. These three tortures overwhelmed me, and I clicked into survival mode. I devised a complex plan that would force them to release me. I would cry. It was genius!

Early on in life I had learned the value of the temper tantrum. A crying jag usually rendered my parents useless and got me whatever I wanted. My dad would drive me to school every morning in his Singer sports car and as we neared the school, the tears and the shrieking would begin. I'd latch on to the car's interior and cry. He'd win the wrestling match to get me out of the car, then I'd seize any available body part—his leg, a dangling arm, hair, anything—as he dragged me through Christopher Robin's entrance doors. My dad was a softie, so I know it killed him to drop me off while I was freaking out. But he still did it. When all my attempts failed and he was leaving, I ran to the chain-link fence and bawled and snot-bubbled as he faded into the distance.

Once I was in the enemy fortress, attach-to-fence-and-cry outlined my survival plan. The teachers had to pry my fingers from the interlocked wire while attempting to soothe me. Every day I followed the same routine. My sister Lenore once visited for lunch and I latched on to her leg with a death grip and wouldn't let go.

After a few months of putting up with my behavior, the teachers demanded my dad come in for a conference. I don't know what went down, but I was expelled the next day. My parents didn't get too upset—in fact, my dad rewarded me! He bought me a miniature, red motorized car that I could putt around the house in at five miles per hour. My mom watched from the kitchen and said to my dad, "Just what the world needs, another school dropout with a slick car."

Lenore visited us a few days later and asked me why I got kicked out. I smiled slyly and said, "Because I cried." I wasn't a champion crybaby, but I was good, and I had, without realizing it, learned the value of tenacity, which would help me later in my skating career.

CLASS SPAZZ

Luckily, my loathing of preschool didn't jade my entire scholastic career. I didn't hate school; I just hated *that* school. In kindergarten there were no mandatory naps, and I actually liked going to school and learning. I watched *Sesame Street* religiously, and by the time I turned five, Oscar, the Count, and Grover had taught me reading and arithmetic. *Sesame Street* worked so well that I started reading the next grade's books. Eventually, the teacher asked me to read to the class instead of just reading to myself. I could also count and subtract quickly, thanks to matriculating with the Count, and I started working ahead of the class in math.

At school I was aware of how far I could push things and so I was mellow. Home was another matter, and my reign of terror continued. Two factors contributed to this: my diet, and the fact that I was

14

naturally as competitive as a varsity jock jacked up on steroids. Both factors combined were as explosive as soap and gasoline, and I napalmed the house with my rampages. I was ridiculous. I can't believe my parents didn't duct tape me up, stuff a sock in my mouth, and throw me in the corner. *I* would have.

If we played Scrabble and I started losing, I'd fling the board off the table. Cards would fly through the air if I didn't think I would win. If we all had bowls of ice cream and mine was smaller, forget about it. I went ballistic. But my parents let me eat anything! By my sixth birthday I had ingested more caffeine than a Starbucks store. I was addicted to Coca-Cola and ice cream. For the next few years I followed a daily ritual. I'd come home from school, switch on cartoons, and set up my TV tray loaded with a bowl of vanilla ice cream with chocolate syrup, a bowl of Cap'n Crunch, and a Coke.

When my mom went shopping at the grocery store, I'd go along and make a scene until she finally gave up and let me push along my own cart, filling it with whatever I wanted.

When we went out to eat, I'd order the largest milkshake on the menu. "Are you sure you'll have room left in your stomach after you finish the milkshake?" my dad would ask.

"Yeah, yeah, yeah," I'd say, angry that they'd even ask. The milkshake would come and I'd inhale it and, naturally, be too full to eat anything of substance. This happened every time, but they never forbade me from ordering a milkshake. Worse, I'd always be starving (I have a manic metabolism and still get headaches the moment I'm hungry), so I'd order a huge meal that even my dad couldn't finish. Whenever I ordered, my mom would ask, "Tony, are you sure you can eat all of that? Would you like to split it with me?"

"No! I want my own food!" I'd bark. She finally stopped ordering for herself and would simply eat my leftovers.

My bad behavior didn't end with food. When I was four, my parents took me on a road trip to visit some of their friends. At the time, I was obsessed with a Cat Stevens tape and forced my parents to listen to it nonstop during the drive. When we arrived at our hosts' house, I insisted that we listen to the tape inside. This was the '70s, and tape players were pretty high-tech; there wasn't any way this

DEMON BOY

17

couple would let a bratty four-year-old mess around with their hi-fi. I seethed and spent the evening attempting to convince my parents to stay somewhere else.

My unsuspecting mom tried to introduce me to tennis when I was five. She explained the rules to me and gently lobbed a tennis ball over the net. I snapped and ran at the ball as fast as possible, hitting it as hard as I could *at her*. I didn't only want to win; I wanted to crush her. My mom, naturally, thought this was a mistake or a case of hyperactivity. She never believed her baby capable of being so evil. But I wised her up. For ten minutes of "tennis," I ran full-tilt at every ball and whacked them at her. She was my personal piñata. Finally, after a dozen direct hits, she called me over to the net.

"Now, Tony," she said in a soothing voice, "I think you're trying to hit me on purpose." I was jumping back and forth, amped up and ready to hit some more balls. "If you don't want to play nice, I'll stop playing and go home."

I scowled at her. What a whiny sportsman! I didn't even want to play after that, because if I couldn't kill the competition, what was the point? What can I say? I was a hyper, rail-thin geek on a sugar buzz.

Even after the tennis ball assault, my mom championed me. After observing an afternoon of my regular behavior, one of her friends commented, "You know, Nancy, I think Tony is spoiled rotten."

My mom, not missing a beat, answered, "He's not spoiled rotten, he's loved."

"Yeah, well," the friend said, "then he's loved rotten."

When I was six, my mom took me swimming at an Olympic-sized pool. The whole session I tried to swim the entire length underwater. I was furious, because I'd failed. Nothing my mom did consoled me. When I was older, my parents told me that they admired my determination and appreciated my need to question everything. They never scolded me, because they felt that as tough as I was on everybody else, I was twice as tough on myself.

The craziest thing about my relationship with my parents was how adept I was at pushing my dad's buttons. We'd disagree, and after a few minutes I would drag him down into the gutter of a five-year-

old's argument. It never failed. It was as if he wanted to try and beat me at my own game. He was my dad! He could have had control and could have, probably *should* have, played his parent trump card and sent me to my room. But he never did. We'd yell at each other until I wore him out and he gave up. I wasn't about to let anybody win against me. As a parent, I'm amazed at the patience my parents had with me. If I were in their place I would have Oliver Twisted my ass to the nearest orphanage.

SMART ENOUGH TO KNOW I DON'T LIKE BEING HIT IN THE HEAD

Before I entered the second grade, I swung to the dark side and decided I wanted to be a math teacher. Patience was never my virtue, and I wasn't about to wait twenty years to realize my dream. So I collected ten friends from my neighborhood and started my own school. I meticulously set up chairs and tables in my backyard, laid out pencils and papers, and invited "my students" over for some schooling. I'd walk the rows helping kids with basic arithmetic until we all burned out. I admit it; I was a geek.

By the time I entered the second grade, I was really out of control. I couldn't sit still. Sitting listening to the teacher talk about basic math made me feel like I had ants crawling all over me. I started to perform mini-aerobic workouts at my desk, fidgeting nonstop. I couldn't switch off my frenzied movement. I'm surprised that the teacher didn't run over and jam a wallet into my mouth. I baffled my teachers. I baffled my parents. I baffled myself. Nobody knew what was going on. I wasn't goofing off or being a poor student—I continued to maintain excellent grades. Luckily, this was the '70s, so the teacher didn't immediately diagnose me with ADD and stab a Ritalin-filled syringe into my butt the moment I acted up. My mom thought I was somewhat bright (what mom doesn't?) and that my movements were due to lack of stimulation. She had the school perform an IQ test on me. I don't even remember taking the test, but I scored 144, which placed me in the "gifted" (whatever that means)

category. The teacher explained to my parents that my main problem was that I had a twelve-year-old's brain in an eight-year-old body. My brain was telling me to do things my body couldn't do. The school board decided I should be bumped up a grade, but my parents vetoed that decision. They were afraid it would mess me up socially. Instead, they stuck me in advanced courses so I wouldn't be bored with the curriculum.

The following year I was bumped up to a fourth-grade reading and math level. Any thoughts I had about fidgeting in these classes were shut down the first day, when the teacher whacked a student in the head with a stack of papers. I froze and stared wide-eyed at the Babe Ruth of teaching. I thought this was the reality of big-boy classes: if you failed to read properly you received a beatdown. The first chance I got, I hightailed it back to my old class with my tail between my legs. I stammered out a feeble excuse to my teacher about how I liked her reading class better. A lot better. My favorite class in school, as a matter of fact. And I stopped fidgeting.

chapter

2

SCAB COLLECTION

I RECOGNIZED MY NATURAL TALENT for scab collecting early. The moment I stopped crawling, I started falling. I was too hyper to think ahead and I ran into walls, chairs, tables, and knee-caps constantly. I hadn't discovered skateboarding yet, so I wasn't a serious collector, but I made up for it with my enthusiasm. My feet tangled up, I tripped over curbs, tumbled down stairs, and fell out of chairs. Scabs tattooed my elbows, knees, and forehead.

I joined Little League basketball and baseball when I was seven years old and took full advantage of their crash potential. My dad,

with his usual enthusiasm, became coach of my Little League baseball team and I played the game with my usual enthusiasm. But I wasn't that into baseball and basketball because of the team aspect. I felt guilty, as if I had let everyone down, each time I struck out or missed a shot. When I was playing basketball, I was out of control. I'd run for the ball as though I were playing a football game. I fell almost every game and once fractured my finger diving for the ball.

My first time at bat when I started playing baseball, I cracked a decent hit and made it to first base. This game was all right, I thought to myself. I liked it. But the next time at bat I struck out. I couldn't believe the umpire when he yelled, "Strike three!" Instantly, depression saturated my skinny body. I placed the bat on the ground and made a straight line from home plate to a steep gorge on the other side of the field. My parents followed, calling after me. However, I was young and quick, and by the time they peered over the edge of the ravine I was nowhere to be found. I had crawled down the side and hidden in a small cave. My dad stood at the top and yodeled bribes down to me. When an offer for an ice-cream sundae echoed down, I poked my head out and climbed up. I may have struck out, but at least I got an ice-cream sundae out of the deal.

Because my brother surfed religiously, he dabbled in skateboarding. In the late '60s, skateboarding was "sidewalk surfing," and skaters mimicked surfing's style. The first skaters were surfers who cruised around on their homemade boards when the ocean was flat. They pretended they were doing cutbacks and bottom turns as they crouched down low and carved the street or the local school banks. By the time I turned nine, skating had matured and the surfing emulation had basically ended.

When I was six, Steve moved to Santa Barbara to study journalism. My parents relocated to Tierrasanta, because there were no playmates in our old neighborhood. On one of his visits, my brother pulled out of the garage his blue fiberglass Bahne. It was an old, skinny banana board that had a worn tail-edge so sharp it was capable of slicing paper. I didn't know anything about skating, but we goofed around on it. He took me to an alley and let me roll around. I couldn't figure out how to turn; I'd roll down the alley until I ran

24

HAWK

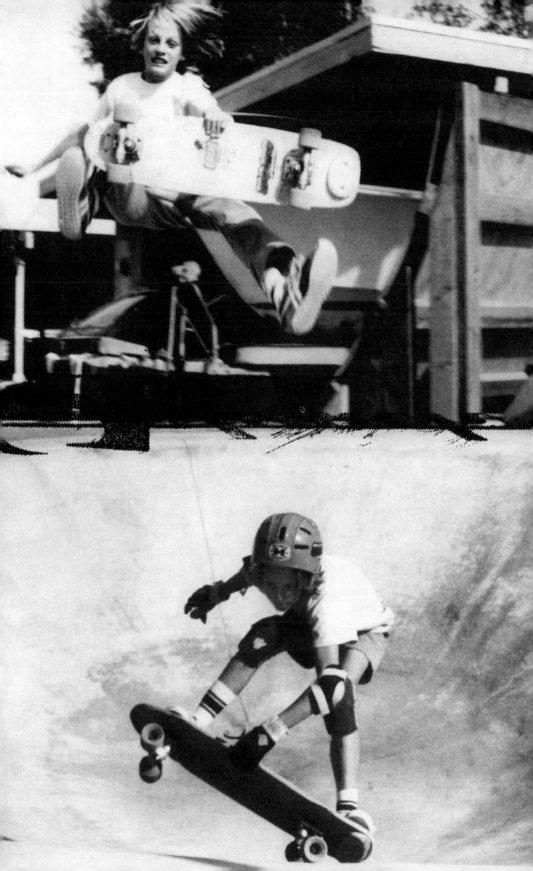

out of speed or almost hit a fence. I'd have to pick up the board, turn it around, and get back on. Naturally, I became frustrated immediately and whined to Steve that I couldn't turn. He spent the rest of the day showing me carves and kickturns. Since he didn't use his board anymore, he gave it to me. I didn't really care; to me it was just another play object, like a Nerf football. If I couldn't find anything else to do, I would screw around on it for half an hour and then toss it back in the garage. I don't remember a skateboard rapture at the time, but something had begun to itch.

I started skating a little more six months later with my fourth-grade buddies. We'd skate around the neighborhood a couple days a week, falling all over the place. The only facility I knew of was Oasis Skatepark, a fifteen-minute drive toward San Diego directly under an 805 freeway overpass. I'd peer out the window every time we drove over. The place always seemed to be packed. It was a few acres of gray concrete, polka-dotted with off-white pools. There were two big pools; a snake run, which is a long, twisted series of hips and banks that resembles a snake; a reservoir, a halfpipe with no flatbottom; and a flat beginner's area.

The frenzied activity of the hundreds of skateboarders hypnotized me. They looked like molecules in the middle of a nuclear reaction. Skateboarders whipped around in every direction, carving the bowls and popping tiny airs and inverts. I was surprised they never hit each other. I nagged my parents, moaning like a dying man about how badly I needed an Oasis membership. Oasis wasn't the start of an intense infatuation with skateboarding; it was just something that caught my attention and, naturally, I *had* to have it now—this instant.

My dad did the next best thing; he built a small wedge ramp in our driveway. I didn't skate it too much, though. My fourth-grade buddies would cruise over and we'd kickturn on it for a while, then we'd hop on our bikes and bomb around the neighborhood.

In the fifth grade, the mom of a friend of mine piled a bunch of us into her car on a Saturday and drove us to Oasis. I had finally arrived at the holy gates (in this case, a mobile home that doubled as a pro shop and the office where you'd register before skating). We

26

signed in and walked through the entrance. I experienced an epiphany. The place had every type of transition (the ramp's curved walls) you could wish for and six million skaters bombing around. At least it seemed like that many. Skating was at its peak, and everybody and his brother appeared to be at Oasis.

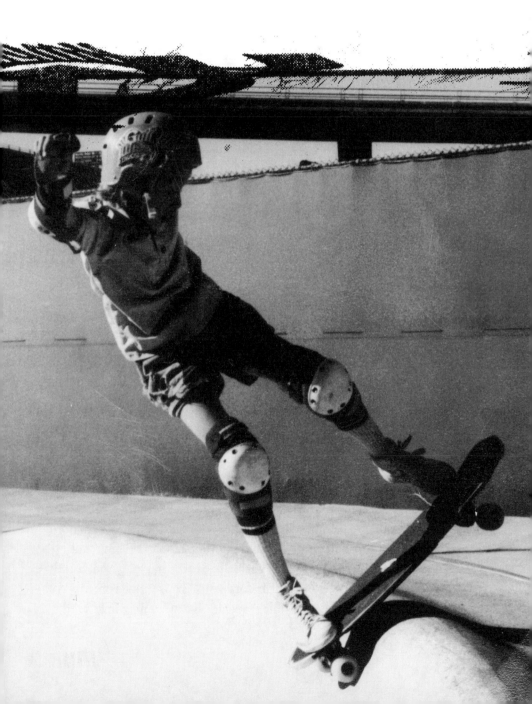

When skaters go to a skatepark, it's like entering utopia. Yeah, there are lots of stinky and sweaty guys skating around, but it's *our* place. It's like the Elk's Club for kids with scabs. I loved it back then and love it just as much today.

My first "real" board was a Dave Andrecht model by Sims that my dad got me. Although we had boards, my neighborhood posse didn't have safety equipment, so we rented knee and elbow pads and helmets. Now, if you've never rented pads at a skatepark it's impossible to understand how gnarly the experience can be. It's the ultimate "extreme" sport, and takes more balls than motocross, skateboarding, and BMX combined. Imagine walking into a locker room a week after a football game and having to wear the reeking, sweat-stained equipment. No, it was worse, because that day four other skaters had worn the equipment before you—your pads were always premoistened with other people's sweat. If by some miracle they

HAWK

weren't damp, then they had hardened, and even the soft elastic materials made crunching sounds when you moved. The stench was disgusting—salt mixed with an open sewer. You could almost see the bacteria cruising around for a more comfortable place. Looking back, putting on a rental helmet was one of the bravest things I've ever done. I never saw a cleaning agent in the rental office. But I was a kid, and I was skating the famed Oasis. I would have worn a used diaper on my head if it had been the rule.

Padded up like an American Gladiator, I walked into the skating area. Skaters carved around pulling tricks that seemed impossible to me. I had entered another dimension and liked it a lot better than the one I was accustomed to. I skated everything, barely taking a break the whole day. It was a vacuum that sucked all my energy, and for the first time in my life I actually felt . . . content. It was an alien feeling.

From that day on, my energy was focused on hooking up rides to Oasis after school. I delivered papers (which would turn out to be my only "real" job) and busted my piggy bank once a week to skate.

My brother had graduated from college and worked at *The Blade Citizen*, a local newspaper. Every Thursday he'd take me to the park, and occasionally he'd skate with me. But his work got hectic, and after a few months my rides evaporated. After moaning to my parents for a few days, my dad became my personal chauffeur a few times a week. I'm still not sure if my parents were being supportive, or if they just welcomed the time away from me. My old friends lost interest in skating, and I lost interest in everything *but* skating. I barely saw them anymore.

Spending all my time at the park changed my perspective on life. I was a skater, and inside Oasis's gates age didn't matter as much as in the outer world. Older skaters (and they were almost all a few years older), who could be a bit on the rowdy side, became my friends. I never had problems with any of them, and most locals actually liked me—probably because they felt sorry for me. I was the skinny kid with a squeaky voice who skated relentlessly and looked ridiculous.

I was so skinny that regular safety equipment didn't fit. The smallest kneepads dwarfed my knees, and would slip down if I hiccuped. I had to wear elbow pads on my knees, and my legs were so thin that even these barely fit. My massive helmet slid around my head. I looked like I was wearing a plastic bucket—not the most effective form of protection. My shoes were held together with duct tape, and blond straw hair poked out in every direction. I slammed so often my clothes were torn to shreds; my wardrobe looked like it had been employed as a shotgun target. I resembled a scarecrow more than a skater.

The park itself could get rowdy. Since Oasis was located underneath a freeway overpass, drivers would regularly launch bottles out their window at us. We'd be sessioning the bowl and a beer bottle would explode like a grenade beside us, glass shrapnel spraying everywhere. We'd run for cover like seasoned 'Nam vets. I can still

hear the shouts of "Incoming!" as we ran away. My friend Matt ended up with stitches in his leg from one such episode.

One day I saw an issue of *Skateboarder* magazine, and it changed my life. Imagine, a magazine dedicated to skateboarding! But it wasn't the skateboarding that sucked me in; *Skateboarder* had pictures of amateur kids from all around the world ripping. Oasis had more than its fair share of insane skaters; in fact, two of the '70s' best pro skaters in the world were locals, Steve Cathey and Dave Andrecht. Dave was one of the burliest skaters in the world at the time (at around this time he went over five feet on a backside air during a Big O contest—unbelievable for back then). Steve was a more clean-cut guy with a smooth style. They both lived in San Diego and had pictures in my first issue of *Skateboarder*. That was as famous as anybody could get for me.

My dad would pick me up at Oasis to bring me to basketball practice. One day, when we were running late, I rushed onto the court. I was ready to play. I hadn't realized I still had my kneepads on. As I sat on the bench to remove my pads, I looked at my dad. I knew I had to come out of the closet and tell him I didn't want to play any more team sports. The only thing I really liked besides skateboarding was playing the violin. In my brain, skateboarding and playing the violin didn't seem that different, because they were individual pursuits. I sucked in a deep breath and looked at the floor. "Dad, I'd rather skate than play basketball. I'm having more fun skating, and I feel like getting better."

I thought he'd get upset. He was one of the coaches, after all, and the association had just elected him Little League president. I pretended to be messing around with my pads as I waited for the pep talk, but my dad had realized a long time before what skating meant to me.

"Fine by me," he answered, and my career as a jock officially ended.

THE EXORCISM

I noticed a change in my attitude once I started skating more. I don't know what exactly caused the exorcism of my evil self, but I remember thinking one day, "I'm tired of being a jerk to my parents." It was a conscious decision, as if one of my schizophrenic voices had instructed me. I always figured I had to disagree with my parents because nobody was ever going to tell me what to do. I hated not having 100 percent control over my life.

Skating definitely helped improve my attitude, but the introduction of a pet in my life may have also helped, especially since this cat had an attitude problem too. I found one of my best friends digging around in a pile of trash when I was ten. He was a black-and-white tomcat with a temper, but for some reason he liked me. I played with

him for a few hours before taking him home and convincing my parents I had to keep him. It was a raw deal for them, because Zorro, as my dad named him, didn't like my parents. I can count on one hand how many people he liked in his lifetime. Mom and Dad bought the food and paid the vet bills for an ungrateful cat. It was bad enough that they had to deal with me as a kid; now they had an antisocial roommate with claws.

Zorro was . . . well, let's just say he could be abusive. He'd chase

HAWK

and attack dogs if they tried to mess with him, and I never saw him lose a fight. If anyone tried to pet him, he'd shoot a warning glare. If the person continued, Zorro would attack him. In the coming years, more than a few visiting skaters would fall victim to Zorro. Once Mike McGill, a popular '80s skater, came over. He tried to pet Zorro, who wrapped himself around Mike's arm with his front paws and kicked with his hind legs, slicing up Mike's hand and arm.

Skating became the black hole of my life. Every day I doodled skateboarding in school, skated in the house, and skated anywhere nearby. The first real tricks I learned were rock 'n' rolls, which aren't too hard—all you do is slap your board on the lip of the ramp or the pool and turn 180 degrees and skate back down—but they're a foundation for learning balance and control of your board on a

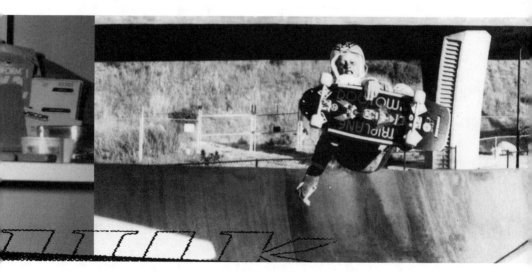

ramp. Then I learned airs, which were a lot harder, but you couldn't progress without airs. And I had Dave Andrecht, the skater who went the highest at the time, helping me. My rock to fakies, on the other hand (where you do a regular rock 'n' roll but don't turn 180 degrees, and instead end up coming down the ramp backwards), were so sketchy that people would look away when I did them. My front truck would regularly bash into the coping. The only reason I can give for not hanging up and falling backward ten feet onto my

head is that I weighed slightly more than a Chihuahua—this fact also being my largest obstacle in skateboarding at the time.

I was so light I couldn't produce enough momentum to do most tricks, so I learned a different technique to pop higher: I ollied into my airs. At the time, my style was a huge joke; nobody ollied into tricks, everybody early-grabbed. With today's new style of tricks, it's impossible to early-grab. My "cheating" style would be mocked for the next five years, but I had no choice. It was either ollie or stop progressing. It wasn't a logical innovation for me; it was simply an unfortunate (or so I thought at the time) solution to my problem.

Another way in which I improved was by watching experienced skaters at the park. Dave helped me out quite a bit. He was always nice to me, even though I'm sure I became a major headache at times. Skating with him had a monumental impact on my own skating ability. His support meant more to me than he'll ever know. I idolized Eddie Elguera, and I copied his style whenever possible. I mimicked the way he stood on his board and did tricks, even down to his signature tongue-in-cheek (literally) concentration face. Eddie was the most innovative skater at the time. I thought of him as the elusive grandmaster of skateboarding. He grabbed the nose of his board on airs, so that's how I learned them.

How the park locals stopped themselves from beating me up I'll never know. I could be the biggest idiot without realizing it. I'd watch people skate and say, "Wow! Did you see that trick that he did? I'd better try that!" Then I'd attempt it in front of the person who'd just done it. It would be safe to say I hadn't learned the art of tact. I wasn't trying to outdo the skater or show him up; I was just stoked and wanted to show him that I liked his trick. However, this always comes across as trying to outdo the person. Being on the other side of the fence now, I can tell you what an insult it seems when a skater does it to me.

I still had the same amount of energy, but I was more competitive with myself instead of others. I felt the full force of attempting to meet my standards. Even though my fury had become internalized, I still possessed a few of my old tricks and could be a bit overzeal-

34

HAWK

ous. My obsession with skating could black out the rest of the world. Once I practiced frontside rock 'n' rolls (same as a backside rock 'n' roll but you turn the other way, in the blind direction, so you have to look over your shoulder to see) on a small, tight transitioned section of Oasis for an entire day. Frontside rocks were my big trick back then. Many of the professionals couldn't do one, but I devoted myself to learning Eddie Elguera's signature move.

The secret to a frontside rock is that you have to keep your body facing the direction you're heading. If you try to do the trick using only your legs, your torso will underrotate or you won't turn enough. You have to pivot off your back toe. (Eddie was actually quoted in a magazine as saying, "The trick is in the back toe.") After hours of practice, I knew I could land one. It was getting dark, and my family had arrived to pick me up to go eat, but I wouldn't leave until I landed one. My brother called for me and I ignored him. It didn't matter to me that my family was waiting in the car. I frontside rocked, again and again, for over twenty minutes until I landed one. Then I climbed into the car and thought nothing of it.

I could get even more obsessive than that. I remember skating the big bowl trying to learn inverts. My dad came as I started my frontside rock routine, and I wouldn't leave. After an hour of waiting, my dad had had enough (occasionally he would act like the one in charge) and he walked into the bowl.

"Let's go, Tony. Your mom is at home waiting."

"Wait a sec, let me try this a few more times; I almost have it."

I fell on a few inverts, but I was getting closer. Twenty minutes later my dad walked back into the bowl.

"Okay, let's go. Your mom has prepared dinner."

I convinced my dad to give me a few more tries. We were now an hour and a half late. My dad demanded I get in the car. I ignored him, so he grabbed me and pulled me out of the bowl as I kicked and screamed. I managed to break away from him. I glared and uttered the most ridiculous argument of my life. "Dad! If you'd just let me try it five hundred more times I would have had it!" It made perfect sense to me at the time.

STAGE FRIGHT

I was eleven years old when I entered my first contest. I had heard about people entering contests, and I thought that's what skateboarders did. I decided I should take a chance. The second I woke up on the day of the contest, I started getting extremely nervous. The drive to Oasis seemed to take forever. During the entire trip, I went over and over my run in my head. I imagined all the different ways I could screw up, slam, and hurt myself in front of a huge crowd. I thought about saying I didn't want to enter or suddenly falling ill.

Oasis looked like Woodstock. There were hundreds of skaters practicing for the contest, clogging every available space. Spectators lined the perimeters of the skatepark. You couldn't skate around, because it appeared every other young skater in California was trying to. In my division alone, more than a hundred kids entered. I went to the registration desk and handed them my list of tricks. (You had to write your routine out and submit it to the officials. You could only do the tricks on your list.) I was so nervous that I fell on tricks I could normally do blindfolded. I probably placed somewhere around ninty-ninth. I never found out how I did, because the contest took so long that we left before the results were posted.

Besides having pictures of kids skating, *Skateboarder* magazine had skatepark coupons. It was like discovering a treasure map! I may have skated Oasis with the older guys, but I was still a young kid and didn't think outside a five-block radius. I had no clue there were skateparks all over Southern California. I came to the realization that within a two-hour drive I could hit ten of them, and I did.

My poor dad logged hundreds of miles every weekend driving me from park to park. Most were fun, but occasionally the locals could be intimidating. The top pros (Doug "Pineapple" Saladino, who was also a local hero; Eddie Elguera; Steve Cathey; Brad Bowman; Bert Lamar, and Dave Andrecht) were my heroes back then. I rarely saw any of them in person, so when I did I was psyched to watch them skate.

At Colton Skatepark, Duane Peters and Steve Alba, who both skated for Santa Cruz, a company with a rowdier image than other

skate companies, were skating the bowl. They were two of the hottest pros around during the early '80s, and both were known for their "punk" image. They were skating the snake run together, just goofing around and laughing. I tried to join in and laugh with them, hoping they might think I was in on the joke. Then maybe they'd like me and we could all skate together like I did with Steve and Dave back at Oasis. Duane saw me and walked over. I stood at the edge of the bowl and when I saw the look on his face, I stopped laughing. He definitely wasn't laughing. I was a scrawny runt who was trying to be friends with two of my heroes. Duane was at least eighteen years old and seventy pounds heavier than me. He spat on the ground next to my feet, and said, "This is punk rock, kid." I could hear Alba in hysterics in the background, and then Duane started laughing too. I was gutted, absolutely destroyed. As Duane walked away, I grabbed my board and walked to the pro shop to tell my dad I was done skating at Colton. I wanted to go home.

HELMET TESTING

Even though I skated for more than a year and slammed often, I didn't get seriously hurt. My dad would drop me off at Oasis and arrange to pick me up a few hours later. One day, I was skating the big pool alone and did a simple rock 'n' roll, just like I'd been doing for months. But on this one, I paid the price for being lazy. On my way in, I didn't lift the front of my board high enough to clear the coping and my wheels caught the edge. The next thing I remember is looking up in the pro shop at Doug "Pineapple" Saladino. I popped up like a jack-in-the-box and exclaimed, "Hey! You're Doug Saladino!" He told me to calm down as someone from the park arranged to drive me to the hospital. My parents were called and told to meet us there, because I had been found unconscious at the bottom of the bowl. Nobody knew how long I'd been knocked out.

Once in the emergency room, I puked all over the floor. The doctor just stared at me with suspicious eyes. I was eleven years old with scabs and bruises all over my body, my clothes were torn up, and my

shoes were held together with duct tape. To tip it off, I'd just vomited all over his floor. My parents arrived and the doctor sat beside me, looking at them.

"So, how did this happen?" he asked.

"Well, he was skateboarding at the skatepark," my dad answered. The doctor didn't believe him and looked at me for verification. I nodded.

"I think I just got lazy on rock 'n' rolls. I learned my lesson now." I had no idea he was insinuating anything.

"This injury occurred while you were skateboarding?" Doc asked, scanning me and my parents for telltale signs of child abuse.

"Rock 'n' . . . " I said as he stared at me.

I could see in his eyes that he was trying to give me a chance to say my parents smacked me around. He should have visited my house; if anything, I was the one beating them.

"I skateboard. Look, I fall all the time; that's what the bruises and scabs are from."

After a while, I had the doctor convinced I'd slammed myself all over Oasis instead of my parents slamming me all over the house.

Mike Vallely, one of the most popular street skaters today, told me a similar story. When he was sixteen years old he visited his family doctor, and the entire visit was spent trying to convince the guy that his parents didn't whack him around.

My dad freaked out because I'd knocked myself out, and therefore took the appropriate measures. I'd been wearing a Flyaway helmet at the time (they didn't cover the back of your head, only the top), so he bought me a Protec and insisted I wear a full helmet from then on. My mom told me to be more careful.

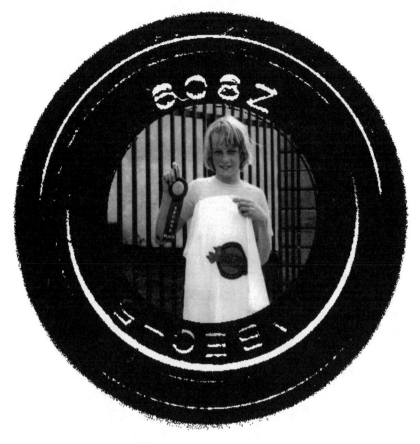

CONTEST KID

Association of Skatepark Owners (ASPO) was the major amateur association of the late '70s. They held contests at different skateparks a couple of times a month, and I entered them all. My competitiveness flared up, and I began focusing on strategies to do well. This was serious. Before every contest, I would skate the park and figure out what tricks I could do there. At home I'd draw the competition bowl on a piece of paper and then write a numbered list of the tricks I'd do. I usually saved a trick I'd invented for the end of my run—the backside varial. (It's a basic backside air, in which you do an air turning inwards but rotate your board 180 degrees and land with it facing backwards.) I'd place the numbers on the diagram to show where I planned on doing each trick. For a week I would visualize my run over and over in my head, etching it into my memory.

Frontside rocks screwed up a few contests for me, because in those days very few people could do them. Occasionally the judges watched me skate, saw my frontside rocks, and would bump me up a class. When my dad asked them why they did this, they explained that "a frontside rock 'n' roll is an advanced trick, and if Tony can do that he belongs in the more advanced competition." They didn't know that was the only advanced trick I had at the time!

As much as my mapmaking prepared me for competitions, it did nothing to calm my nerves. I was visibly scared before contests; my anxiety sometimes made me shake. It never really mattered to me if I won, but whether I'd skated up to my expectations. I'd get so pissed at myself for bailing a trick I wouldn't want to be around people. I obsessed about my mistakes and withdrew into myself. I'd sit silently the entire drive home, walk through the door, pick up Zorro, and retreat to my bedroom. I'd lie on my bed petting Zorro (for some reason he would always let me pet him), trying to come to terms with my self-loathing. My dad made it to every contest, but occasionally my mom and my siblings would be too busy. My mom told me later that she could never figure out how I'd placed in contests given my attitude. Sometimes I won, but if I didn't skate as well as I'd hoped to I was a grump. Other times I didn't win but skated up to my expectations, and I'd be euphoric.

By the end of my first year of competition, I managed to beat back my nerves and win my age group. A few months after that my dreams came true. I won a place on the Oasis Park Team.

OBSESSED

By the time I turned eleven years old I had a full-blown case of skate tunnel vision. I attended Farb Middle School, a mellow school that taught sixth and seventh grade. I had been frequenting Oasis for a little over a year and had started to skate decently. But I seemed to have an adverse effect on skating, because the more I liked it the less popular it became. The early '80s were the black plague of skateboarding. It was as if every skatepark had a black X painted on its

40

door. This booming business, with millions of participants, died almost overnight and nobody seemed to know why. Skaters dropped out of the scene with impressive indifference. One day I'd skate with a park buddy and the next week he would be gone, never to be heard from again. The dozens of nearby parks toppled like a stack of dominoes, ASPO limped around ready to die, and I was more hyped on skating than ever.

The numerous skateparks peppered along the West Coast had all closed down. My weekend road trips ceased, and I skated almost exclusively at Oasis. Through some twist of fate Del Mar Surf and Turf, a thirty-minute drive from my house, remained open. It was located next to the 5 freeway (but at street level, making it difficult to launch beer bottle grenades) and had a mini golf course, massive concrete skatepark, arcade, and High-Ball trampoline. Grant Brittain, who would later become the most famous skateboard photographer in the world and eventually photo editor of *Transworld Skateboarding* magazine, managed the park. I skated there a few times, but the main bowl was kinked. I had become used to Oasis, so I hated the place.

SPONSORED

My dad was indirectly responsible for my first sponsor. Since the sport was dying from lack of support, skateboard companies didn't have a ton of money to chuck around, so my dad invited Denise Barter to stay at our house during an Oasis contest. Denise was one of the coolest women I've ever met. In her twenties and a skater herself, she would come into town to watch the contests. She was the unofficial team manager for Dogtown and the surrogate parent to all the skaters while she was at the park. She was a punk rock mom who did whatever she could to help people out. Denise was close friends with the owners of Dogtown. After the contest, I was given a Dogtown Triplane deck as a thank-you. I rode that thing until it was little more than a splinter. When the Dogtown crew visited Oasis again, they saw I'd improved and put me on the team.

At the time, Dogtown and Independent trucks went hand in hand, so I received a set of trucks with my first officially sponsored board. I was stoked on the Dogtown team because two of my skater friends were on it. They were also two of the hottest amateur skaters at the time. Mark "Gator" Rogowski was to become one of the biggest skaters of the '80s. He later changed his name to Mark Anthony and became infamous for killing his girlfriend's friend and burying her in the desert. Christian Hosoi was known for his fluid style and high

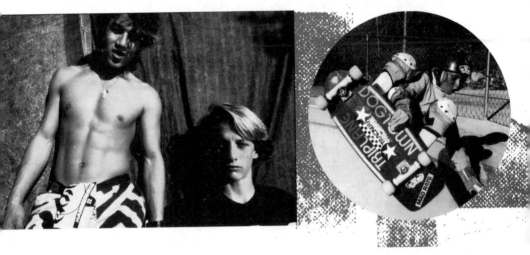

airs during the '80s. His life also took a sorry turn; he was recently busted for smuggling drugs into Hawaii. Even though I was technically on the Indy team, they'd never sent me anything. I ordered a pair of trucks, and after a few months they sent me a baseplate.

My dad, always ready to do anything possible to help his kids, organized the California Amateur Skateboard League (which still exists today) with four other people. ASPO was roadkill, and a new amateur series was needed. My dad charged into CASL like a kamikaze pilot and dragged my mom in to help keep score at events.

SCABS AREN'T COOL

I had progressed from scab collecting to scab *and* Ace bandage collecting. I looked like a B-movie mummy with scabies. Scabs ran

HAWK

the entire length of my legs, and my sprained wrists and elbows were wrapped tight with Ace bandages. At the skatepark this was considered normal, but at school it was a different matter. I became known throughout my sixth-grade class for my coagulated blood and passion for a dead "fad."

I arrived at school every morning a half-hour early, so I could skate the curb around the side of the building with the only other skater in the school. Sometimes the principal would walk out of his office, sit down, and watch us skate. Today he'd probably shoot us with his stun gun, confiscate our boards, and drag us into the guidance counselor's office. When the school bell rang, I would store my skateboard underneath a cupboard. After school I'd skate home, and my dad would drive me to Oasis to skate until 8:00 P.M.

My day started and ended with skating. Any school assignment with an open topic revolved around skateboarding. When we had to do a report on a fantasy invention, I created a gun that would turn ocean waves into concrete so I could skate them. On Thursdays one of my teachers, Mrs. Lisiak, would let a student teach her class anything he or she wanted. Whenever possible I jumped at the opportunity. My dad, who would get more excited than me, dragged in a film projector and played the numerous Super-8 films he'd shot of me skating. We "taught" the class the lost art of skateboarding.

By the end of the year, skating was obviously passé. My seventh-grade class realized it wasn't cool, and I began hanging out at the skatepark even more. All of my friends were skaters. From the sixth grade on, I can't remember having any neighborhood friends over to my house. Every weekend was spent either at Oasis or traveling to contests. A local newspaper wrote an article about my contest record and me.

I cemented my skate-rebel status when I quit playing the violin at the end of the year. I had barely played it since I'd started skating and refused to play beyond the required practice time. I'd skipped a few class band concerts in order to skate. I must have been quite a sight when I did participate in concerts, sitting on a chair in my torn clothes and scuffed sneakers, scabs and bruises peppering my arms and legs, an Ace bandage wrapping my elbow or wrist or whatever

I'd sprained that week. My teacher was comically upset when I quit. He told my mother I had a lot of potential. Looking back, I wish I had continued playing while skating; giving up the violin is a major regret of my childhood.

All the people who dropped out of skating were probably responsible for CASL awarding me the title of "most improved skater" of the year. It felt like I was one of the only skaters left, never mind most improved, and I never made it to the awards ceremony. I went to the hall early with my dad, who had to set up the tables, microphone, and other equipment. While we were waiting, my friend Chris and I decided to skate to the store. On the way I hit a crack and slammed on my head. I awoke on some lady's porch, and Chris skated back to get my dad. My dad brought me back to the hall since he still had to set everything up and announce, so I waited in the car. I periodically opened the door to vomit in the parking lot. My dad congratulated me and handed me my trophy as he got into the car to drive me home.

Skating was so unpopular that, for all intents and purposes, I became most improved of nothing. My parents decided to move to Cardiff, California—a five-minute drive from Del Mar. The timing was perfect, because Oasis was a ghost town and, as much as I loved it there, I liked skating with people better—kinked pool or not.

HAWK

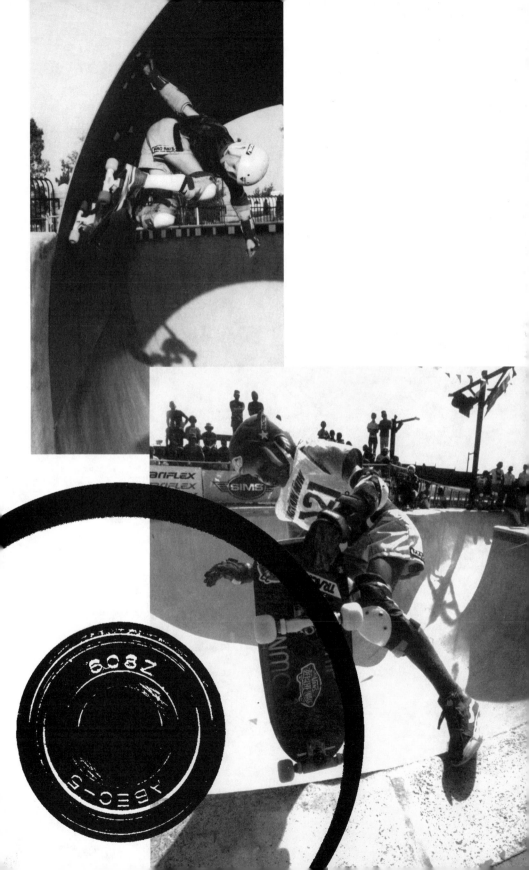

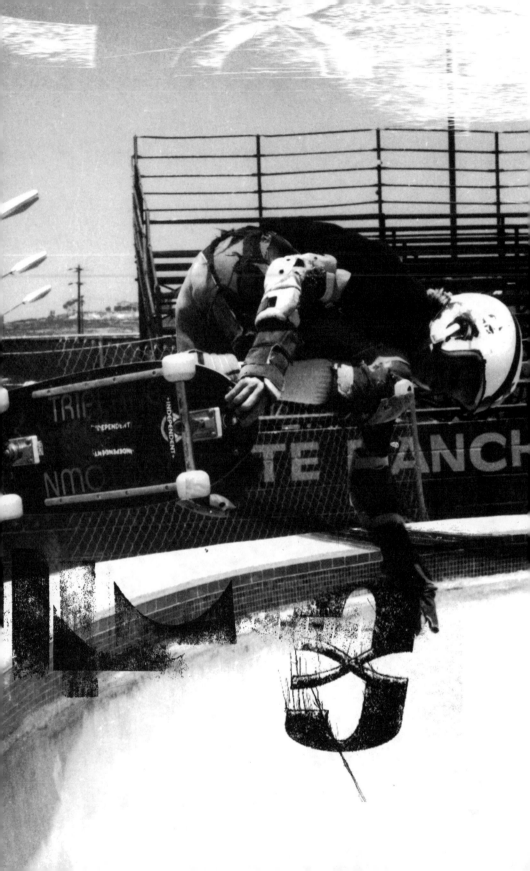

chapter

3

THE BONES BRIGADE

IN 1977, STACY PERALTA WAS the skateboard champion of the world. Whereas today there's only vert and street skating, back then skaters competed in slalom, freestyle, and other events like barrel jumping. Stacy could do them all with style. He's still one of the most stylish skaters who ever stepped on a board. Stacy was the Arnold Palmer of skateboarding, and everybody seemed to agree that he deserved the title. He ruled during the first wave of skateboarding, when skateboards were archaic compared to the boards today.

Skaters back then might as well have been living in Bedrock. Decks were basically skinny logs with grip tape that wouldn't even

be sticky by today's standards. Trucks broke constantly, and bearings would explode with no warning, spilling ball bearings everywhere, slamming the board to a stop, and making the skater eat shit. Skate shoes were no more than boat shoes, so your feet took a serious beating. Some people skated barefoot, a definite sign of insanity. Running out of a trick in your bare feet isn't skateboarding, it's some twisted way to prove your manhood. Why not just sit at home and dance on top of a cheese grater? The craziest part was the safety equipment—a clunky helmet that didn't fit, and cheap volleyball pads. Volleyball pads don't work for volleyball players; how could they work if you're falling ten feet onto your knees? It's insane to think that skaters lasted longer than a week under those conditions. To see what people like Stacy pulled off in those days is scary. But then, maybe in a few decades skaters will be looking back on us old-timers and saying the same thing.

After his pair of world championships, Stacy ended up breaking both his wrists and decided that it was time to move on from professional skating. He joined forces with George Powell and started Powell and Peralta, which most skaters simply called "Powell."

Skating for Powell were two *wunderkinder* who destroyed anything skateable, Steve Caballero and Mike McGill. They were both young guys compared to the rest of the pro world. Stevie was incredible, years ahead of other skaters. I thought he was the most innovative skater at the time, and I doubt you could find anybody to argue with me. He invented the Caballerial, a 360-degree ollie, which seemed impossible, ridiculous to even try back then. A 360-degree rotation without using your hands on clunky, heavy boards with no concave? And that was only one of his tricks. Mike was out of Florida and could power through any terrain. He also changed the face of skateboarding in the early '80s when he invented a trick: the 540 McTwist. Jay Adams, who had a surfing style similar to Stacy's; Ray "Bones" Rodriguez, who had the first Powell board graphic that would come to define the company, with a skeleton holding a sword; and Scott Foss, another old ripper, were a few of the last guard of the old school. Together they created the most interesting team in skateboarding at the time because of their variety of styles and personalities.

HAWK

The other big companies possessed more focused images. Santa Cruz, with Duane Peters and Steve Alba, was the hard-core punk team. Variflex riders like Eddie Elguera, Steve Hirsch, and Eric Grisham skated similarly; they seemed to concentrate more on tricks than style and became known as the "robot team" because of this. G&S had a clean, smooth style. Powell took a piece of each company's image and threw them in a blender.

As great a skater as Stacy was, I think his ability to spot talent was even more impressive. It has never been matched. In a few short years, Stacy recruited a team that would dominate skating for close to a decade. If you look at a lot of the top riders today, Stacy spotted the majority of them *before* they were recognized as superstars: Mike Vallely, Guy Mariano, Steve Caballero, Rodney Mullen, Per Welinder, Colin McKay, Bucky Lasek, Danny Way, Chris Senn, Chet Thomas, and Mike Frazier, just to name a few. These are skaters who are still ruling. Bucky is still winning contests; he won last year's X Games and has no problem dumping tricks like frontside Cab heelflips and Rodeo flips in his contest runs. Colin, along with Bob Burnquist and Bucky, is one of the most innovative vert skaters. For more than a decade, Colin has continually pushed the limits of vert skating. Danny is still ripping and may have bigger balls than any other vert skater. He holds the world's record for the highest air, at around sixteen feet. Stacy created the most contest-dominating skate team in history. No other team has come close.

Stacy was the most revered figure in skateboarding, and I didn't think he even knew who I was. I'd seen him from a distance at a few contests, but at an Upland contest he introduced himself and asked how Dogtown was treating me.

"Fine . . . I guess." I didn't know what to say. I didn't know how teams were supposed to treat a skater. All they did was send me product . . . sometimes.

"Good. I like your skating," he said, smiled, and left.

I received my last Dogtown board in early December. I didn't even know that they'd tanked until Stacy called me a few nights after they went under. It was definitely a weird situation; someone as important as Stacy calling me freaked me out.

"You know, Tony, Dogtown went out of business. If you could come up here to Marina, we could talk about sponsorship," he said when he delivered the news that I was officially unsponsored.

This would prove to be one of the defining moments of my life. Unbeknownst to me, Stacy had been watching me for the better part of the year. Years later he told me I'd caught his eye at an amateur contest at Marina Skatepark. I can't remember the contest at all, but he'd seen me do my run. I landed a few hard tricks without falling, and he was impressed. What really caught his attention was how I walked out of the bowl. He saw that I was furious with myself, and he couldn't figure out why. He called me "a noodle" and said he liked that I'd invented a few of my own tricks, like fakie to frontside rock. Stacy said my "fierce determination" made him want me on his team, The Bones Brigade.

That said, my being brought onto the team was also a huge fluke. Christian Hosoi, one of the hottest young skaters around, had bailed Dogtown to ride for Powell almost a year earlier. Now he had quit Powell after eight months, leaving Stacy with a vacancy on the team for me to fill.

A few days later Steve Cathey, now the team manager for G&S, called me and wanted to set up a meeting. He sent me a box with a deck and wheels. I was stoked—hey, free products again! Interest in me was coming from all directions. My dad had a long conversation with me and explained it wasn't fair to string two companies along. He told me I had to make a decision soon and stick with it. He didn't try to influence my decision at all; he let me choose what company I'd be more comfortable with. My dad, as involved as he was with my skating, never attempted to Little League my career from the sidelines. If I'd decided that I wanted to quit skateboarding, he'd have been fine with that.

I skated Marina as Stacy watched. I didn't really think of it as an audition, which I probably should have, because two companies were courting me. I wasn't cocky; I just wasn't stressed, because I didn't feel pressured to perform. Marina had a six-foot channel in their big bowl, and I spent a while trying to backside air the beast. Because I ollied into my airs, it made the jump easier than I had

HAWK

expected. I remember Stacy being stoked when I pulled it.

Stacy was cool and his team was impressive, but the thing that pushed me in his direction was that Kevin Staab, my best friend and fellow skater, was nuts about Powell. His biggest aspiration was to ride for them, and Stacy wanted to sponsor Kevin anyway, so I agreed to join. He gave me a few boards and T-shirts before I went home. It was a few months before my thirteenth birthday, and I ended up skating for Powell for the next thirteen years. My dad returned the G&S product to Steve Cathey, and I'll never forget how surprised Steve seemed. He wasn't shocked I said no to him, but that I gave the deck and wheels back instead of keeping them.

HAZING THE NEW KID

By the time Powell sponsored me, the older skaters on the team like Ray Bones, Teddy Bennett, and David Z had dropped out of the scene. At twelve years old I became the youngest member of the Bones Brigade. Rodney Mullen, another Brigader out of Florida, was two years older than me, but Stevie Caballero and Mike McGill, the undisputed stars of the team, were both eighteen. Five years' age difference isn't a big deal when you're in your twenties, but at age twelve these guys were straight-up intimidating. I was the Romper Room reject who'd managed to sneak into high school.

The first contest I skated for Powell took place at Whittier Skatepark, so Stevie, Mike, and I (the out-of-town skaters) crashed at Stacy's pad in Santa Monica. I didn't know Mike and Stevie personally, but I'd read about them in every issue of *Skateboarder*. These guys were the two hottest skaters on the planet! They were taking out the older skaters and changing the direction in which skateboarding was going.

In the late '70s Alan Gelfand invented the ollie, a no-handed aerial, the foundation for skateboarding as we know it today. Then Stevie, while still in school, invented the Caballerial, which was revolutionary. You could do tricks in the air without being tied down by early-grabs airs. The progression shot skating ahead light years,

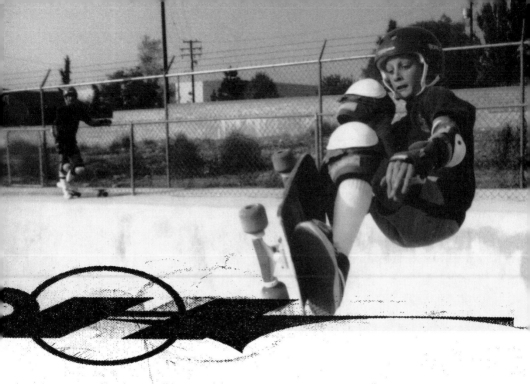

and the action began taking place above the ramp or pool rather than in it. Stevie wasn't simply a better skater than most, he was a natural innovator—exactly what I strove to be.

To say that I felt intimidated by Stevie and Mike is an understatement. They never did anything to make me feel inferior; I did it all myself. For example, the weekend when we stayed at Stacy's, I ran around like a monkey on a string trying to make them like me. One night we went into the hot tub, and Stevie accidentally dropped his gum into the water. Now, having a supposedly high IQ, I recognized my lucky break.

"What would you do if I ate that?" I blurted out.

Stevie and Mike stopped and looked at me. My brain was working overtime trying to make them like me. This, I was positive, would get me in with them.

"What? If you just chewed the gum? I don't know, maybe I'd clap," Stevie answered.

"You mean just chew the gum out of the water?" Mike said, shaking his head like anybody could do that. Well . . . they could, and I kicked myself for not realizing this sooner. I had to outdo myself and do a trick that nobody else would do.

HAWK

"No, I don't mean 'just out of the water,' I mean . . ."

"Out from between my toes," Stevie said.

"Yeah."

Stevie wove the spent gum between his toes like a spiderweb and stuck his foot in front of my face. I bent close, picked the gum out, and chewed it. Mike and Stevie winced and clapped, and I beamed. The monkey had entertained successfully.

Mike finally got married at the beginning of 2000 and Stevie e-mailed me about meeting up at the wedding. At the end of the message, he said he was bringing some gum for me to eat.

ALL I WANT FOR CHRISTMAS

Along with improving my skating skills, I slowly mastered the art of slamming. I could take an elementary trick like a backside 50-50, where all you do is grind both trucks on the coping, add a slam, and make it a work of art. One day in the Del Mar halfpipe, I did my 50-50 as a setup trick in the shallow end. My trucks stopped grinding suddenly and I face-planted on the concrete pool surface. I don't remember everything that happened, except that I tried to put my hands in front of my face two seconds after my face punched the wall. My two front teeth cracked in half, as though I'd tried to catch a bullet in my mouth, and my lips exploded like two water balloons. Grant Brittain, Del Mar's manager, said I walked to the front office with blood all over my face. I remember feeling my broken teeth with my tongue and the pain shooting through my mouth. Grant called my parents and they took me to the doctor, who sent me to the dentist, who capped the two stubs. No one ever did find the other halves of my teeth.

TOOTH TRAUMA

I'm never happy if I can't complete something. If I attempt to learn a trick and can't do it, I start to go nuts. Subconsciously, this stan-

dard must have seeped over into falling as well. A few months after breaking my teeth I was goofing around on the flatbottom of the Del Mar reservoir, where you have to be extremely talented to injure yourself. It's basically the safest section of the park, but I'm a professional. I tried to throw a shove-it, where you kick the board around 180 degrees, jump, and land back on it, and slammed on my face. I had a helmet on, so you have to appreciate my skill level to fall at such an angle that I hit my teeth again. Instantly, I felt my caps and part of my original teeth resting on my tongue like kernels of corn. I stood up with a mouthful of blood and walked over to Grant. I called my parents, lisping, and asked for a ride home.

DISAPPOINTMENTS

One of the main reasons the Powell team became so successful was because of the pride Stacy instilled in us all. None of us wanted to let him down. Surprisingly, on-team rivalry was nonexistent. Whoever won, we were all supportive. Rodney Mullen was a freestyler, practicing a style of skateboarding that has gone the way of the dodo. Skaters used small boards and did tricks on flatground. Freestyling was the ice skating of skateboarding, and it died in the early '90s. Rodney competed in different events, but we were always just as stoked when he wiped the floor with the competition (which happened 99.9 percent of the time; in eleven years of professional competition he lost only once). I was still an amateur, and because I was so much younger the team rooted for me even more—which made me feel like crap for letting them down when I sucked.

I sucked for a while. In the CASL contests I had only skated against Southern California amateurs. Once Powell sponsored me and began taking me to national contests, the level of skating shot up. My first out-of-town contest took place in Jacksonville, Florida. My parents had met with Stacy a few times and they knew he was incredibly responsible, so they had no problem letting him chaperon me for the weekend. I'll never forget the trip, because I stunk the place up with my skating and experienced my first East Coast storm.

HAWK

We were flying into Jacksonville and I was friends with everybody on the team by now, so we yapped about skating for the entire flight. I stopped my yapping as soon as we exited the plane. Rain poured in buckets; thick lightning bolts shot down constantly, accompanied by a drumbeat of thunder. Before this I had only witnessed West Coast storms, which are basically like standing in front of a sprinkler for twenty minutes.

We had to drive over an hour to the contest. I sat in the backseat with my white face glued to the window, waiting for an angry thunderbolt to fry the entire Bones Brigade. I may have seemed older than thirteen when skating, but I was definitely thinking like a thirteen-year-old during that storm. The hotel offered little reassurance, because I knew lightning would blast through the window and the thunder would explode my eardrums! I stayed awake most of the night, eyes open wide.

The next morning the storm was gone, but things went from bad to worse. I couldn't have skated more terribly if I'd tried. I was so out of my element it was brutal. Skaters from all over the country had congregated in Jacksonville, and skating was dead! If skating had actually been popular and I'd had to compete against more skaters, I think I would have cried after the contest. I almost did anyway. I didn't want to talk to anybody after my last crappy run. I can't remember who won the pro vert contest, but it was probably Stevie or Mike. They were hyper and talking during the ride back to the airport. I squeezed myself into a corner by the window and stared out, not speaking to or looking at anybody. I had assumed I would do a lot better than I did, but Stacy never said anything to me about my skating. I think he knew all along I wouldn't do too well, and that it would make me realize I had a lot more to learn. I couldn't wait to get home and lock myself in my bedroom and stare off into space petting Zorro.

The more contests I skated in, the more inadequate I felt. I remember walking around before a Gold Cup Series competition and overhearing a young skater talking to his coach (back then a lot of skaters had "coaches" who devised strategies and often screamed from the edge of the pool like Little League parents).

"Okay, now you're going to do a boardslide straight into an invert," the coach instructed.

"Naw," the skater shot back. "I'm going to save that for the finals tomorrow after I make the cut."

I freaked! These kids were positive they were going to make the finals. My anxiety mounted a blitzkrieg against my nerves, because I was constantly on the verge of missing the cut.

LAND OF THE LOST

While I was learning to adapt to the skating world, I was failing miserably in the real world. Doing your own thing during elementary school is one thing; nobody's going to really hassle you. But once you hit the big leagues of high school, it's a whole different ball game.

Forget that I skated (still not cool); because of my genetics I was doomed from the start. If you think I'm skinny now, you should have seen me in the seventh grade when I was growing! Birds could have used me for nesting material. Muscle tone was something I'd only read about. I was also so short, I could have shopped in Baby Gap. I was twelve years old, barely over four feet tall, and weighed in at a freakish eighty pounds (and that was after a big meal). I could have handled the eighty-pound deal if I'd at least looked my age, with some facial hair or a deeper voice, but I resembled an anorexic ten-year-old. I was a walking noodle.

My walking skeleton physique wouldn't have been so bad if I'd continued going to a normal school, but after Farb Middle School I had to cross the tracks and head into the bigger world of Serra High School, a notoriously rough place. I was the smallest kid in school. It was considered a high school, but it included eighth and ninth graders. I barely looked old enough to be in the eighth grade. I was a bottom-feeder.

I could no longer employ the crying plan that had worked so efficiently in preschool (don't think I didn't give it some serious thought), so I tried to recede into the walls. If someone had sold

HAWK

school camouflage, I'd have been his best customer. But no matter how much I tried to fade into the background, I was too glaring a target. Jocks picked on me nonstop as I walked by them in the hall. "Here comes the stud!" they'd yell. I just kept my head down and walked by as quickly as possible. My tattered skateboard attire (punk logos with lots of skulls) didn't win me any points either. "Nice outfit, junior, what'd you do, raid the Salvation Army?" echoed down the hallway as I walked past.

I think I may have a chemical imbalance, because once I entered the gym class I forgot about my stature and my overactive competitive gland took over. It must be as big as a grapefruit or something. My need-for-a-victory complex would flare up, making me temporarily insane. I focused on winning like I'd been focusing on skateboarding for the past few years. Never mind that kids in my class doubled me in body weight; I still needed to win. In basketball I'd run to the hoop like a torpedo, only to be flicked aside like a pesky fly. Once, in flag football, I was running for a touchdown with the class bully, a huge kid whose neck was about the same diameter as my thigh, chasing me. I scored the touchdown, stopped in the end zone, and turned around just in time to see him moments before impact. I tried to spurt out that I had already scored the touchdown and that technically this was "flag football," which meant no tackling, but the teacher wasn't looking and I was pretty much a bug on the guy's windshield as he slammed me. I lay in the dirt as he got off me and walked away. But at least I scored.

Skateboarding saved me. As humiliating as Serra was, my life rotated around Del Mar and other skaters. If I'd been dependent on school for a social life, I'd have been seriously depressed. My obsession prevented me from making scholastic friends, and life at the skatepark overrode any sort of school socializing. I maintained good grades and attended advanced math and English classes, but I usually just put my head down, did my schoolwork, and headed straight to the skatepark after school.

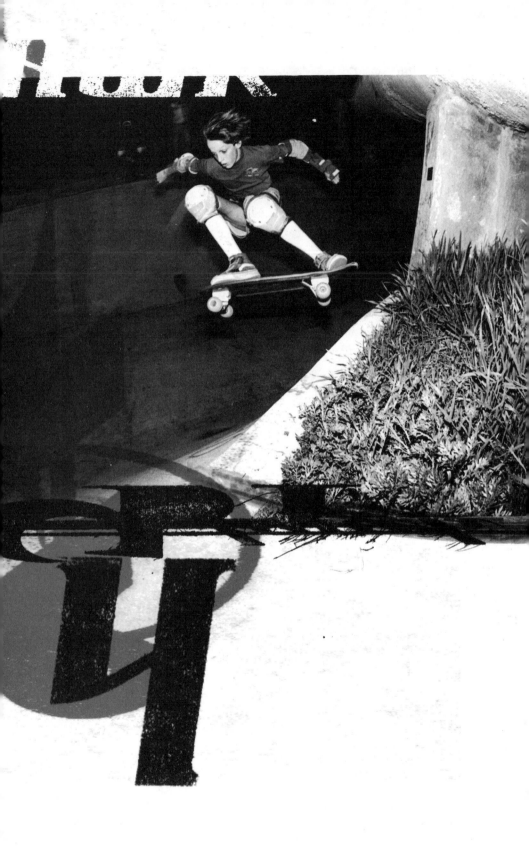

chapter

4

UNDERAGE PRO

IN 1982, A FEW MONTHS AFTER my fourteenth birthday, I turned pro for Powell. What was considered professional skating back then was vastly different from today's pro skating. There were perhaps thirty-five professional skaters instead of the hundreds that are floating around now. In "the old days," skaters worked their way up from the amateur circuit, and most of them, even though they ripped, were never deemed "pro material."

Today, it's almost unheard of for a decent amateur to stay an am, but you can see the difference in a lot of the top pros who matured (skating-wise, not physically) through their amateur career. Colin

McKay stayed am for so long that it seemed ridiculous, but Plan B's team manager, Mike Ternasky, had Colin's long-term career in mind, not a quick fix. Today, Colin is winning contests and popping frontside Cab kickflips, and he'll be doing more of the same for years to come. Danny Way, another Plan B (and Powell) skater, stayed amateur for years even though his bag of tricks overflowed with maneuvers most pros couldn't do. Buzz about Eric Koston and Andrew Reynolds, who are considered by many to be among the best street skaters right now, spread through skating like a flood when they were amateurs. Pat Duffy destroyed most of the pros as an amateur. He humiliated them! There used to be nothing worse than being bettered by an amateur—in the pro's eyes, that is. Coming out of left field and destroying the competition is also a good way to show you've got the goods. Bob Burnquist flew into Vancouver International Airport in 1995 an unknown Brazilian, and by the time he flew home with a first-place trophy, he'd left every skater picking his jaw up off the ground.

There may be too many pros today, but back in 1982, skaters had the opposite problem—there was practically nobody to turn pro. I'd win most of my amateur contests partly because the top amateurs, including Neil Blender, Billy Ruff, and Chris Miller, had turned pro that year. Stacy had hinted about turning me pro, but we'd never talked about it seriously. I didn't have a burning desire to; it wasn't like today or the mid-'80s, when being a professional skater meant you'd start getting paid serious money. In the early '80s a pro skater couldn't make a decent living, and I was only fourteen years old. I lived at home, didn't need a car, and couldn't find a date with a compass—what did I need money for? But Stacy felt I was ready, and the big event happened at a Whittier contest.

I received my contest registration form and sat at a table to fill it out. On the entry form were two boxes: one for amateur and one for pro. Stacy came up, sat beside me, and said, "Are you going to turn pro at this contest?"

I looked at him. "I don't know. Should I?"

"I don't want to tell you either way. It's definitely up to you."

I shrugged, said "Okay," put an X in the "pro" box, and that was

HAWK

that. It meant practically nothing. It's funny; I was so determined to learn tricks and progress, but I never set any career goals. I can't remember being super-hyped that day and jumping around with a massive smile stuck on my face. When I told my parents I had turned pro they said, "That's nice."

Since there were hardly any contests, most of them were Pro/Ams in which the amateurs and pros both had competitions during the weekend. One of my favorite parts of amateur contests was watching the pros skate afterwards. It didn't feel any different when I competed as a pro. The prize money was so insignificant (you might win $150 for first place, $100 for second, and maybe $50 for third—that's where the money ended) and skating was so unpopular, contests were more of a get-together than a hard-core competition. No one ever got angry if he felt he'd been ripped off. To put early '80s skating into perspective, imagine being a professional Frisbee thrower today—that's the equivalent of a pro skater fifteen years ago. In my first contest, I placed third. There were at least eighteen people in the stands watching my professional debut. I didn't win any money.

SAN DIEGUITO PENITENTIARY

While I was doing time at Serra High, I prayed to the U-Haul god every night and it paid off. My parents moved to Cardiff the next year, and I would attend ninth grade at a new school, San Dieguito High. However, my glee at attending a friendlier school was destroyed the moment I arrived at San Dieguito. No, actually, it was earlier. I knew I was in for more of the same torture when I arrived in my new neighborhood.

I lived on the edge of the school district, and only a few other students lived near me. So, why waste a regular school bus on us? I can remember exactly the way my gut tightened as the bright yellow bus drove down the street toward me. Something about it . . . it was too . . . it was *way* too short. I wanted to run in the opposite direction, to get as far away as possible. My grand entrance—as a professional skateboarder—into my new school was about to be made on a short

bus. All those jokes lame people made about being on the short bus, and here I was an actual passenger! Never mind that I now looked like I could *maybe* push for a whopping eleven years old if I didn't wash my face for a few days. Now I had the worst ride possible. To top it off, San Dieguito taught grades nine through twelve. I was the bottom feeder once again.

Every time I stepped off the short bus, the students walking by would laugh, point, and make the predictable jokes. Without fail, my fellow passengers bottlenecked in the doorway, starting a mini-riot in their determination to get as far away from the bus as fast as possible.

Once I walked into the school, and away from the evil bus, things rarely improved. As bad as Serra had been, San Dieguito was worse. I once walked down the hall past a pack of chatting jocks when a particularly large one reached down and picked me up, spun me around a few times, laughing with his buddies the whole time, and placed me back on the ground. Unoriginal sayings like "Nice clothes," "The elementary school's down the block," and my personal favorite, "Nice physique, dude," followed me over from Serra.

To make matters worse, I had started messing around with my hair. The punk and New Wave scene had begun to infiltrate the skate scene, and more than a few people had adopted the look. I kept mine short and let my bleached-blond bangs hang down over my face. It became infamously known as the "coif" or the "McSqueeb," as some writer in a skate magazine called it. I usually sported the Jeff Spicolli (remember *Fast Times at Ridgemont High?*) look of slip-on Vans, jeans, and a T-shirt with a skate logo plastered across it. But on a trip to Hawaii I scored a pair of Quiksilver Jams, shorts that—good God!—went past your knees. Hard to believe, but in 1982 these were considered too avant-garde, and my peers at school let me know it. They wore corduroy shorts so high that they'd have to tuck their boxers in, and so tight I'll bet that graduating class is sterile. I wore weird clothes, was obsessed with a "loser" sport, and looked like I'd got lost on my way to elementary school.

A weird thing happened when my family moved to Cardiff: I started to enjoy skating Del Mar Skatepark. The pools weren't perfect, but while there were a lot of problems with the physical properties of the park, it had a hard-core group of locals. Owen Neider could always be found skating, with his two-foot-high mohawk and bondage pants. Kevin Staab practically lived there, and wore so much safety equipment that he resembled a medieval knight. He could have been hit by a school bus and still walked away without a scratch. Adrian Demain was two years older than me and had one of the smoothest styles around. Mark "Gator" Rogowski managed to spend most of his weekdays at the park even though he lived forty-five minutes away. Del Mar simply became the center of my universe. All my friends could be found there. We understood each other and our love for skating, and we were all around the same age. It was more than just a place to skate. Even if you didn't feel like skating, you'd go to the park and see what was going on, hook up with people, and go eat, or to a movie, or a gig. We'd play hell games of skate-tag, whipping all over the place and running into each other at full speed. There was a Denny's nearby, which we all frequented because of the cheap plastic food. Del Mar was our clubhouse.

HAWK

My love of the place proved to be a curse it would take me years to shake. I could win any amateur contest at Del Mar, because after a straight year of skating there I knew the keyhole like the back of my hand. It wasn't the best pool by a long shot, and that made it harder for other skaters to adapt. My weight was still a problem, though now I'd at least grown from a splinter to a toothpick. My arms and legs poked out from my safety equipment (I continued to wear elbow pads as knee pads) like malnourished twigs. I was so weak at the time, I couldn't do a handstand.

"I was worried," Stacy said years later about watching me skate. "He was so scrawny that I thought he'd hurt himself. I had to look away sometimes because it was so painful to watch. He put his body through so much punishment."

My problem was getting speed. Once I achieved some, maintaining it became even harder. I was simply too light to create the momentum needed and I had to build up to it. That meant if I sketched out during a run, I had to spend the next ten seconds pumping up the transition to regain my speed. Other skaters had more muscle and mass and could easily generate speed. At Del Mar I knew every nook and cranny and kink, so I could devise little cheats, like where to pump, where to carve, to get speed. At different locations, I was lost.

When it came to my skating at competitions, someone else thought I was screwed too. I didn't find out until years later that my dad called Stacy after every contest and pleaded my case like an amateur Perry Mason. If I sucked at a ramp contest, he pointed out that "it'd rained the night before and we all know that Tony can't skate slippery ramps very well." Like anybody else could. If I simply sucked, and no physical excuse could be dug up, my dad said I'd felt sick before I'd left for the contest. Stacy says he never gave the calls much thought. He knew my dad was only making sure he wouldn't lose interest in me.

"I'd just sit on the phone and let your dad run his mouth off," Stacy once told me. "The thing with your dad was that you could see right through him. He just wanted the best for his son. The talks never bothered me, because I knew what you were capable of."

The funny thing is that I never heard about this or felt any sort of pressure from my dad. He never criticized my skating or attempted to push me in any sort of direction. He wanted to be involved, but he knew where to draw the line—well, for the most part.

Perhaps the reason I never felt pressured by my dad was because I acted like my own Little League coach. After getting my butt kicked my first time in Jacksonville and at a few other contests, I figured I'd better learn how to adapt. I hated the disgusting feeling I'd get when I didn't skate the way I'd expected. Luckily, the following year I

HAWK

grew a bit and gained a few pounds, and when I started concentrating on adapting to different terrain, I skated better in contests. I began winning for a change.

A huge event that eclipsed my losing contests was when I made the cover of *Thrasher* magazine doing a lien-to-tail at Del Mar. A few years earlier, my biggest surprise had been opening *Skateboarder* magazine and seeing pictures of young kids skating, and now I was on the cover of a skateboard magazine. The first time I saw it I freaked; I'd had no idea I would be there. I took the issue home and sat in my room staring at it, barely able to believe it.

SPITTING BACK

My second pro contest would be a lot more gratifying than any of the previous ones. It was at Del Mar, and I felt as comfortable as I could during a contest. There were a few more people watching than at my prior contest, so a crowd of twenty-four people saw me skate to my first professional victory. When I made it to the finals I had to skate head-to-head against pro skaters, and after two runs the skater with the best average won. As excited as I was about the win, it meant even more to me because I had to beat Duane Peters in one of my final match-ups.

Duane came from the old school. He was a raw, sketchy skater who powered through his runs, whereas I was the twiggy kid who flipped his board around and, more importantly to me, the kid he had spat at, pontificating what exactly "punk" was. I didn't realize until later that the contest was symbolic in another way, because it helped usher in a newer style of skating. More emphasis was placed on innovative tricks than on carving and pushing the basic tricks like layback grinds. From then on, the new-school skaters gained recognition.

CURSE OF THE KEYHOLE

I wasn't exactly loved in the professional skateboard world. From the start, I'd always skated differently from the rest of the skaters. I'd invent my own weird tricks like finger-flip airs and varial gay twists. Because of my flippy tricks, I became known as the Circus Skater. I hated my style. People ripped on it constantly.

I skated a little more lightly on my board than the power-carving speed skaters. I went straight up and down, so I could do my tricks back to back. I wanted to be a powerful skater but I was too skinny, which posed my next problem: getting height on airs. I still ollied into my airs, and my technique became openly mocked by other pros. In a magazine interview, Micke Alba said I was the biggest "cheat" in skateboarding. Micke was Steve's younger brother and a hero of mine, because he was so young (a few years older than I was) and a great skater. Reading his insult in print crushed me. I encountered a lot of similar hostility during my first few years as a pro.

According to more than a few pros, I skated like a geek; I ollied into my airs and could only skate Del Mar. It's not that I couldn't skate well at other parks (I had proven I could), but I could skate Del Mar in my sleep. Most pros back then had their own parks dialed, since they'd skate there every day. But I skated so obsessively that my knowledge of Del Mar was second nature. I skated much better there than anywhere else. Even though I'd made an effort to adapt to different terrain, I would always be known as the Circus Skater with the robot style who could only win contests at Del Mar.

My third pro contest took place at Kona Skatepark in Jacksonville, and things did not improve. I had sucked there at my first Powell-sponsored amateur contest, and I sucked all over again as a professional. I placed tenth. I flew home, did my Zorro/bedroom trick, and wondered if Stacy would ever send me to another competition.

At the Whittier Christmas Classic, I proved once again how poorly I could skate. I got sixth place in a park I thought I had dialed. It wasn't the shitty placing that bummed me out but rather the fact that I knew I was capable of skating better. Again, I didn't talk on

HAWK

the way home. Needless to say, the first half of my professional career didn't exactly put a smile on my face.

HOW TO WIN CONTESTS AND BECOME UNRECOGNIZABLE

Although I was a professional skateboarder at the time, it didn't help my scholastic popularity at all. The mainstream media rarely covered skateboarding events (a small newspaper might do a small story on a local contest, but that was it), so anybody outside of skating wouldn't have a clue about my profession. Some kids knew that "Tony Hawk" was a professional skater who lived in the area because a local news program had aired a story on me. But nobody connected the featured skater to their skinny classmate. I rarely spoke with anyone at school about skateboarding. Well, I hardly talked to anybody at school, period.

There was one time a nonskater sparked up a conversation with me about skateboarding. He saw me skating to school and stopped to ask if "I knew that Tony Hawk who skated at Del Mar Skatepark." I answered that my name was Tony Hawk. He backed away and looked me over. He scrutinized me for a few seconds before offering his evaluation, "Yeah? Really? Well, you sure don't look like that dude." Then he walked away.

A saving grace in the school was Miki Vuckovich, the only other skateboarder attending San Dieguito. I had a school friend! Unfortunately, my social connections ended there; a school girlfriend would have been nice. I nurtured a few crushes, but the fact that I looked like I still had at least five more years before I grew pubic hair, never mind that I was a skateboarder, defeated any urge I might have had to talk to them. I couldn't even consider going to any school functions.

I skated, and that was my focus. I never became seriously depressed about school, because I considered it a formality. Had I been going to a perfect school, I still would have been indifferent to the social scene. At that time, no matter what you looked like, or

how you tried to fit in, being a skateboarder meant you were an outsider. But in a sense I liked it that way; it was a secret club the rest of the world didn't know about. We were like the Masons, only with smelly pads and bruises rather than a weird handshake.

My entire school problem evaporated the moment I left the accursed place. Any difficulty I had could be solved through a good session at the skatepark. But I continued to study hard and keep up my grades. Back then nobody made a decent living from skateboarding, so I never counted on it as a career. I planned on attending college and majoring in physics. I was still in advanced math and a few college prep courses, and I had a B average.

The evil short bus became too much to take, so after a few months I started skating home. If I was looking for omens, I found one a few blocks from the school's property in the form of a drainage ditch that snaked downhill and ended, miraculously, almost at my front door. Miki and I would skate it home every day. It was a sanitation ditch, so it was dubbed "Sanolands."

Skating was banned on school property, and the teachers would confiscate our boards if they saw us even stand on them. A particularly overzealous teacher once grabbed mine and demanded my dad come in for a meeting about the dangers and negative influences skateboarding had on children. They wouldn't give my board back if he didn't show up. Bad move. My dad was my biggest supporter. He came in and told the school's administrators he didn't care what they thought about skateboarding and how idiotic he thought it was that he had to waste his time coming in to school to retrieve a skateboard. I sat back, trying not to laugh. Today, San Dieguito has a skate physical education program.

After half a year, San Dieguito began to wear me down. The vibe from the school remained unfriendly, and I didn't know if I could deal with another three years of lame jocks and teachers who confiscated my board. I didn't like the idea of having to fit into a school social system I despised to begin with, so I took the California High School Proficiency Exam for a high school diploma. But I needed a backup plan just in case I didn't pass. Because I lived on the border of the San Dieguito school district, I could attend the neighboring

Torrey Pines High School if I met with the principal and received his permission.

This was a huge deal to me. Torrey Pines was in a nicer area, and the school seemed to be full of people who were a lot more open-minded. They even offered surf classes in PE. My parents agreed to the switch, and my dad drove me to the principal's office. Luckily, the principal had heard of some of my skateboarding accomplishments, and because I had such high grades he decided to squeeze me in the following year. I went from having my skateboard confiscated on a regular basis to having the principal recognize me and actually think skateboarding was cool.

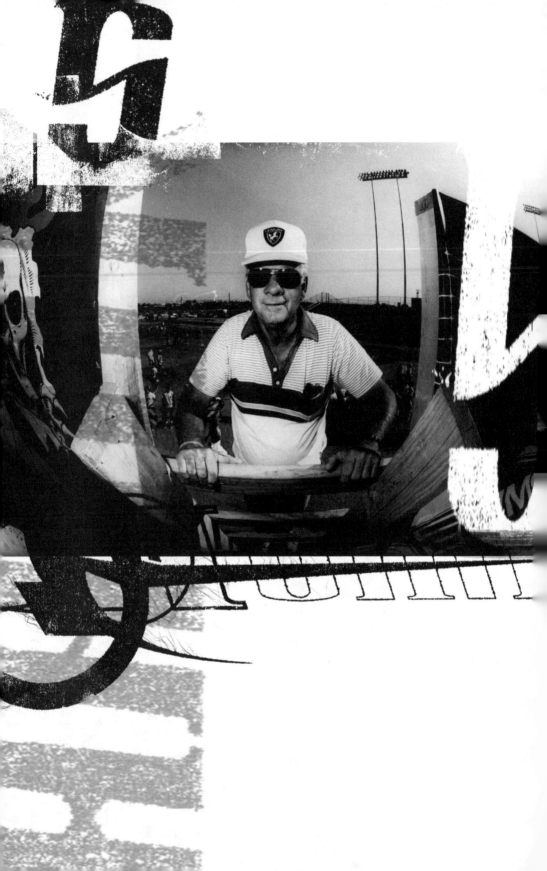

chapter

5

PREFERENTIAL TREATMENT?

I WOULDN'T CHANGE ANYTHING about my parents' involvement with skating, but I'd be lying through my two fake front teeth if I said it didn't cause me some serious discomfort. On the other hand, my dad organized competitive skateboarding and laid the foundation for contests as we know them today—whether you like that or not. It came naturally for my dad to do everything possible to help his kids, but he outdid himself when he started the

National Skateboard Association (NSA). In his mind, it wasn't anything different from what he'd been doing for the past twenty years. After the Korean War he'd started Little League Baseball in his neighborhood for Steve, and he was simply doing the equivalent with me.

In the beginning of 1983, Dad met with some companies, recruited some volunteers, and opened shop. This was the first unified organization that had the support of all the major skateboard companies. Before the NSA, contests were scattered all over the place, and there was no unified ranking system. As a member of CASL he was part of a group, so his participation didn't really seem tilted in my favor. Anyway, it was mostly young kids who entered the contest, though the NSA had older pros who cared a lot about contest results.

Although it was great that my dad started the NSA, it was bad timing for me. After screwing up in two of my three pro events, I obsessed about improving my contest skating. I placed fourth in my next contest, in Palmdale, California. Fourth place was decent, but I knew I had lots of room for improvement. The following contest was at Del Mar, and it was the very first NSA competition. Talk about things looking fixed from the start! The first national contest in my own backyard—in my favorite skatepark. I didn't know how to act around my parents, and in a way I felt violated. They were forcibly entering my private world. Skating was my utopia, where I fit in, and where I could solve my own problems. One of the reasons for this was because it wasn't accepted. It got me to think for myself, because there weren't the regular pressures from society. Now my parents had infiltrated my private world. It took years for me to become comfortable with their being at almost every contest I entered.

I was a teenager, so I didn't want to be around my parents anyway. I had some serious inner conflict raging inside: on the one hand I was grateful; on the other I wanted my space back. I avoided my parents at that first NSA contest. If I walked past the timing table where my mom helped, I pretended I was watching something else. I took great pains to stay away from them during each event.

I knew I was in for shit-talk before the first contest and that nothing could stop it. I won the event, and immediately rumors spread about its being rigged. It didn't matter to anyone that I had a reputation for

only skating really well at Del Mar or that I had won the last contest there. This time, it had to be fixed. Dad ran the contest, so his son won the contest. Conflict of interest, anyone? The last thing my dad would ever do was rig a competition. In fact, he had nothing to do with the judging, but things looked suspect because he was the man in charge. I appreciated what my dad was doing, and it was needed to ensure the longevity of the sport, but I was in for a long road of hassles.

My dad, you have to understand, didn't always help with my problems. Picture Oscar the Grouch from *Sesame Street* without the green hair but sporting a larger nose—that was my dad. Instead of popping up out of a trash can, he popped out of his green, early '70s Volkswagen van.

A few years later, in an article *Sports Illustrated* did about me, Christian Hosoi, my friend and main competition, said of my dad, "Frank represented authority to Tony's friends. Skaters had to listen to his dad. You can see what kind of position that put Tony in."

Dad loved all the skaters, with their energy and attitudes, but he knew that in order to run the NSA properly he had to lay down the law. He ran the association with what could be perceived as an iron fist. If a skater sneaked into someone else's practice, my dad would be at the side of the ramp hollering away at him. It was never personal—he yelled at everybody equally—but it didn't go over too well at first.

After a few years, skaters realized how much my dad loved skating. They understood that when he bitched at you, he was actually trying to tell you he liked you. His biggest problem was that he watched out for all skaters and naturally protected the more passive ones. I don't know if you could get any more passive at contests than I was. I never snaked anybody, or sneaked into another session, and snaking was the norm back then. My brother calls me "pathologically nonconfrontational." At most contests it began to look like my dad was favoring me. In the *Sports Illustrated* article, he actually confessed to being a bit sensitive at first. "It was very touchy," he said. "I used to embarrass him. If I thought he was being defaulted, I'd mouth off. If he got pushed aside on a run, I'd tell the kid, 'Do it again and you'll have to deal with me.' " The first year of the NSA was a nightmare for me.

PREFERENTIAL TREATMENT?

75

It didn't take long for my dad and I to explode at each other. The two most pigheaded members of the family had an NSA blowout while driving to the grocery store. I complained he was too much a part of my life and was smothering me.

"You know if you want me involved, I'm going to get involved," he shot back at me. "Don't fight me. I'm involved with kids other than you."

He told *Sports Illustrated* that, looking back, "I think now he would have rather had me out of it." The he, of course, being me. He also admitted to probably spending more time with his kids than he should have. But he said, "If they were into something that wasn't harmful, well, then we tried to support it and open doors."

Gradually skaters began appreciating my parents' devotion to the sport and became close friends with them. My parents helped skaters out whenever they could. They'd pick them up at airports, give them rides to contests, or let them stay at our house and feed them. We regularly had over twenty skaters staying at our house during local contests. Skaters slept in bathtubs, closets, the garage—our house would look like a skater bomb had exploded. Skaters loved my parents because you couldn't shock them; if you chopped your hair up and dyed it green, they'd comment on how much they liked the hue. You might walk into a restaurant and spot a few of the top pros enjoying a meal with my sixty-year-old parents. When my dad was sick with cancer in 1997, some of the skaters he'd yelled at the hardest visited and expressed their thanks, not for running the NSA but for helping them out with tough times in their lives. Cards, phone calls, and visits flooded in from the rawest, punkest skaters in the world. But the visits were years away from 1983, when skaters only knew my father as the yelling dictator.

I was still finishing my time at San Dieguito when skating had begun to regain popularity. Stacy informed me that I would have to design a board and graphics for my own pro model. I had a friend draw up an angry-looking hawk swooping down for a kill. My friend was a decent artist, but not professional by any means; he was only fourteen years old. I meant to give Stacy an idea of what I wanted, not dictate the graphic. But I obviously didn't explain

HAWK

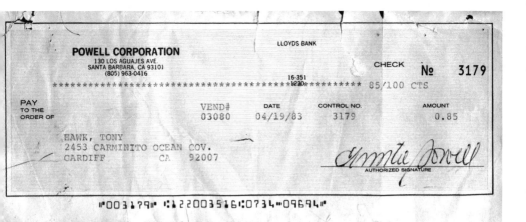

POWELL CORPORATION
130 LOS AGUAJES AVE.
SANTA BARBARA, CA 93101
(805) 963-0416

LLOYDS BANK

CHECK No 3179

16-351
1220

85/100 CTS

PAY TO THE ORDER OF

VEND# 03080

DATE 04/19/83

CONTROL NO. 3179

AMOUNT 0.85

HAWK, TONY
2453 CARMINITO OCEAN COV.
CARDIFF CA 92007

AUTHORIZED SIGNATURE

myself well and Court, the infamous Powell artist, just cleaned up the drawing. I had my first board graphic.

Back in '83, skaters didn't receive money from shoe sponsors, clothing sponsors, or any mainstream companies; their income was derived from board royalties or any product with their name on it. I made money off Tony Hawk stickers, shirts, posters—whatever they made. Today most pros get two dollars per board sold; when I turned pro, I scored a whopping 85 cents per board. It didn't matter to me; I was now pro for the most popular company in skateboarding with a brand new model. I assumed I'd be making some money. I checked the mailbox regularly for a royalty check from Powell. Nothing for weeks, and then it came—the magic envelope indicating how many people were stoked on my board. I ran inside, tore the envelope open, and stared at my check for 85 cents. I'd made less than a dollar in my first month as a professional skater. That means one person in the whole world bought my board that month, and he or she didn't buy a T-shirt or a sticker. I guess ollieing into airs hadn't caught on yet. I received another check a few months later for $4.25, so things were looking up financially. Five people had bought my board.

SUMMER OF LOVE

School was out, which translated into two solid months of skating. I spent the summer skating at demos in Australia, Europe,

Canada, and across the United States. Skating was ever so slowly gaining popularity, and the demo's crowd swelled from fifty to sixty spectators to more than a hundred. The weird thing was the Jekyll-and-Hyde lifestyle I lived; at San Dieguito I was mocked and abused, while in the skateboarding world I signed autographs, sold product with my name all over it, and actually began to generate some interest among girls (I was far too timid, though, to return their affection). I know their attention was mostly due to my position in skating, but beggars can't be choosers.

I worked hard on getting a contest run ready for my next competition, in St. Petersburg, Florida. This would become one of the most important contests of my career, because it marked the first time I won outside of Del Mar. I had a few "circus" tricks in my run that no other skater could do. I did one-footed inverts, which is a handplant in which you kick your back foot in the air, and Madonnas, a standard lien-to-tail in which you grab the nose for a frontside air and hit your tail on the way in but take your front foot off when you're in the air. I stayed on my board each run. After the contest I was on a high, and Stacy knew I was on my way to adapting to any terrain. I finally felt content after a competition.

The old-school skaters like Duane were no longer competing, and almost all the pro skaters were teenagers or in their early twenties. They were all a few years older than I was. The style of skating was also evolving; there wasn't such a distinct difference between my circus tricks and other skaters' tricks. The power carving and rawness was being overtaken by technical tricks, and while most skaters didn't do nearly as many as I did (it was practically all I did), the top pros were peppering their runs with them more and more. Even so, there was still a difference, and some people continued to mock me. I never felt like "one of the guys" at contests. I'd hang out with the Bones Brigade, but it didn't match the camaraderie I felt with my friends at Del Mar. The discomfort didn't matter too much, though; it only lasted a weekend, and then I knew I'd be back with the Del Mar crew.

I spent the summer living at Del Mar, which could get out of control a lot of the time. The cool thing was that Grant Brittain man-

HAWK

aged the park, and he was as bad as us! A true skater at heart, he'd host private parties after hours. The park was my family room. He'd let us skate early or late and let it slide if we were short on cash one day. He never complained when we hung 24/7.

As any kid knows, summer always comes to an end. I'd passed the High School Proficiency Exam, but decided to give Torrey Pines a shot. I knew my parents would be disappointed if I didn't graduate in the traditional way.

Over the summer I visited a community college. My mom felt that if I were about to bail high school, I could start earning my college degree. She never forced me to go, but I knew how much my family valued education. My mom was about to earn her doctorate, and all my siblings had attended college. The least I could do was check it out.

I walked around campus observing the big buildings and the older students, and it felt foreign. I was completely out of place. Starting community college early would mean starting once again at the bottom—below the bottom, actually. No, thanks. I planned on going to college after high school so I could actually amount to something— the money I had made so far was more of an allowance than a paycheck, and I didn't consider pro skating as a potential career—but this was way too soon. . . .

That summer Powell discontinued the swooping hawk. Stacy realized my board graphics sucked, and even though I'd received a check for over four bucks for my second month of board sales, we got rid of it. It never looked like a Powell board graphic. Their designs were loaded with skulls and snakes and dragons, and mine looked like a *National Geographic* picture. With nothing to hold him back, Court quickly drew what would become my most popular graphic ever: the Iron Cross, or as I like to call it, the screaming chicken skull. It's a screaming hawk skull with an Iron Cross design in the background. Don't ask me what it was supposed to mean, but I liked it immediately. So did everybody else at Powell. And according to my board royalty checks, so did a lot of other skaters. I instantly began making millions. Well, it wasn't exactly millions, more like $500 to $1,000 a month—serious cash to a fifteen-year-old in 1983.

PREFERENTIAL TREATMENT?

BONES BRIGADE VIDEO ONE

Not only did Stacy manage to pick the most contest-dominant team in skateboarding's history, but he started the skate video revolution. His Bones Brigade videos set a standard that's unsurpassed. (After his exit from skateboarding, he became a director in Hollywood.)

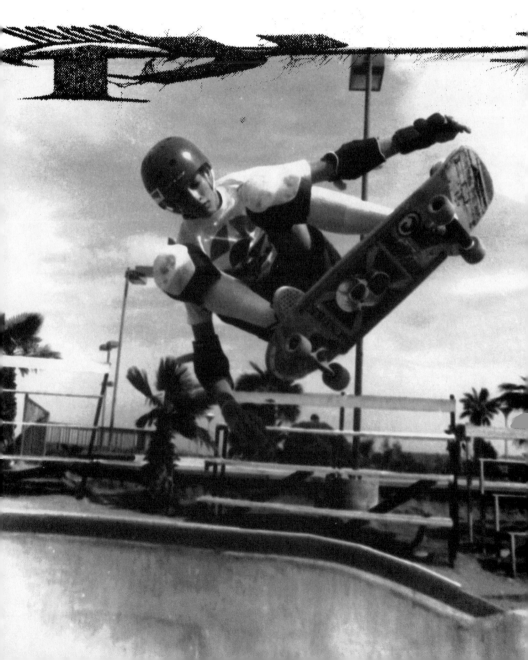

In 1983, Stacy began filming the first *Bones Brigade Video Show*, which is technically the second (the first *Video Show* is a rare, promo-only, fifteen-minute video with only a few members of the team). Most people didn't have VCRs when it came out. For all intents and purposes, it doesn't exist, and barely anybody saw it. By 1983, VCRs were slowly infiltrating most homes, and he knew it was time for a fresh video.

When I was a kid and we made a skate video, the shooting schedule usually lasted only a month. Today it can take a year for a skater to film a part. Sometimes the time is needed (someone isn't going to film ten big stunts in two days), but mostly it's because there seems to be a general lack of motivation among many of today's professional skaters. We didn't have a choice either way; Stacy was the director, and we catered to him. I'd make a list and practice for months just for the few days of filming. I'm sure the rest of the team did likewise. I'd try to have my tricks wired so Stacy didn't have to stand around or waste time and film shooting bail after bail. I wanted to impress him. I was always confident that he'd get the shot, and I trusted his artistic sense. He captured the essence of skating in his early videos. Even though that type of skating is now dated, the creativity and enjoyment of the sport still shines through in each video.

At the end of the year, the *Bones Brigade Video Show* premiered. Skating was still pretty unpopular, and we had the premiere at my house after a contest at Del Mar. My home was filled with the team and a pile of other skaters from the contest. We didn't know what to expect. We put the videocassette in and waited in anticipation.

A middle-aged TV reporter in a suit appeared on the screen with WEEKEND TODAY in the right-hand corner. "Hi, I'm Bob Burbanks," he said, "and welcome to *Weekend Today*. We're going to find out on today's show why protein may not be good for your dog's diet, and why that old sack food may in fact be better than the new gourmet canned food you can buy at the store."

Then a cut to comfortable Stacy sitting in his house, eating Chinese food, and watching this program.

"And we're going to take an exciting look at skateboarding. When I was a kid we used to take an old roller skate apart and nail it on

a two-by-four; nowadays you can walk into a sporting goods store or a drugstore and buy one of these [he holds up a cheap plastic banana board]. This is a skateboard."

A cut back to Stacy, pissed off now. "That's not a skateboard. We're going to have to do a little adjusting here." Stacy walks into the other room and returns with a pick ax. He smashes the television and picks away the broken glass. He pulls out a Rat-Bones (Powell's generic graphic at the time) skateboard. "Now this is a skateboard."

"Skate and Destroy" by Stevie's band, The Faction, blasts on and a collage of the Bones Brigade flashes onto the screen. Lance skates around Los Angeles and runs into Per Welinder (a freestyler who'd be my partner in Birdhouse Projects later) in Venice Beach; Lance reads a magazine with Rodney in it as we watch Rodney skate. Lance then walks into a skate shop and sees my board, which leads to a cut of me skating Del Mar. The rest of the video is filled with downhill sliding, pool skating, Lance's Ramp Jam (where three young ladies "oooh" and "ahh" at Stevie, Mike, and Lance's skating), and contest footage. It ends with clips of the team goofing off. Lance slams hard on a tricycle and I pop a freestyle trick on Rodney's board.

Bones Brigade stock rose after the video. All our boards' sales jacked up, and nobody was more surprised than me. I began pulling in as much as $3,000 a month.

COMING OUT OF THE CLOSET

Hello, my name is Tony and I used to be a freestyler. Ah, I said it, and it feels so liberating. Freestyle is an interesting part of skating, and looking back on it today is like partaking in an archaeological dig.

During the early '80s there were two main types of skating: vert (bowl, ramp) and freestyle. Vert took place on a ramp or in a pool, and freestyle took place on flat ground. They were as opposite as could be. The vert guys were generally more rowdy and made more money, because vert skating was more popular, and more exciting to watch, than freestyle.

HAWK

Then a new style of skating evolved as a hybrid of the vert and freestyle. People like John Lucero and Steve Rocco were slowly creating street skating and Natas Kaupas and Mark Gonzalez, among others, were just beginning to take it to absurd heights. But let's get back in the closet and explain freestyle.

Freestyle skaters skated on flat ground with a tiny board that had no concave. For contests, they choreographed two-minute runs to music. It wasn't exactly an aggressive style of skating, and I think that's why it eventually died. Skaters stopped constantly to do stationary tricks and skate around gracefully. I know it sounds like they should be wearing tights on an ice rink, but before we all laugh and point, let it be known that freestyle is directly responsible for street skating.

Rodney Mullen figured out how to ollie on the flat ground, and street skating wouldn't exist without the ollie. Every time you ollie, you should get on your knees and thank Rodney or take him out to eat if you see him skating around Los Angeles. The vert tricks done now, like a heelflip frontside Cab, wouldn't be possible without the heelflip, which thanks to Rodney comes from freestyle. The kickflip Indy? Rodney invented the kickflip. Ollie Impossible? Rodney. Rodney, Rodney, Rodney.

But I'm getting ahead of myself. Back in skating's prehistoric era, Rodney, Kevin Harris, and Per were members of the Bones Brigade and three of the top freestylers in the world. Freestyle was huge! I skated whatever I could from the start, whether it was freestyle or vert. I entered the professional freestyle contest in Oceanside (a five-minute drive from my house) and sucked! It proved beyond a shadow of a doubt that my dad didn't fix anything in my favor. As crappy as I could skate in a vert contest, I outdid myself freestyling. Truth be told, I didn't really care too much. Naturally, I wanted to win, but I never thought I would—it was more of a lark. But the casual contest acted like a valve for the competitive pressure cooker called my head. The anxiety I'd build up over vert contests was released through a contest I wasn't that serious about.

I have to admit I appreciated freestylers' tricks, because they influenced a lot of mine. That's why I got stuck with the circus skater tag—I did lots of flippy, freestyle tricks.

The freestylers turned out to be the more business-savvy breed of skaters. They went on to own the shoe lines eS, Etnies, and Emerica. They run the largest skateboard distributions in the United States, Canada, and Europe; they own companies like A-Team, Blind, and Tensor; and they're partners in Deca, Axion, and World Industries. Even my partner in Birdhouse, Per Welinder, is a former freestyler. The meek have inherited skateboarding.

STILL STRUGGLING

The next NSA contest took me back to Jacksonville. Once again, I disgusted myself. I couldn't stay on my board and sketched out in every run. Skating's popularity was growing steadily, and I still couldn't skate consistently at contests. I wasn't freaked out this time by any thunderstorms and felt at ease with the rest of the Bones Brigade, but I felt embarrassed to be with them after skating so poorly. Here was a team of contest dominators—they all placed in the top five in every contest—and I couldn't help but bob all over the results like a buoy in a storm. In the car on the way to the airport I sat and stared out the window, thinking of ways to improve my skating. Stacy never spoke to me about the contest. At home I grunted a hello to my parents and said nothing about it.

FAST TIMES AT TORREY PINES

Unlike my previous two matriculation moves, I could tell when I entered my sophomore year at Torrey Pines that this school was going to work. I'd struck out once again on the bottom-feeder grade, as Pines taught grades ten through twelve, but the stereotypical jock bullies gave way to surfers and spoiled rich kids who were too busy to bother me. Since it was a beach school, it seemed to mellow students. I was beginning to grow and actually appeared close to my age. I could tell it was going to be a better year.

84

My friend Miki had decided to bail San Dieguito and attend a military academy rather than endure another year of abuse, so I didn't have him to pal around with anymore. But I met Ted Ehr and Cory Federman. This year there was one more skater at school than the last! I'd bought my mom's 1977 Honda Civic from her for $1,500. My parents took it to Mexico and had it painted cherry red for my sixteenth birthday. The freedom the car awarded me was unimaginable; now I could escape from school faster. (But it was, after all, a '77 Civic, so I wasn't leaving *that* much faster.) I can count on one hand how often I stayed for lunch during my three years at Torrey Pines. Ted, Cory, and I would run the hundred-yard dash from class to the car and boot off to 7-Eleven or the local McDonald's for some sketchy food, which we loved. Anything was better than hanging out at school.

RELIGION AND PASSION

A month after I started at Torrey Pines, I attracted some attention outside the country. A Japanese television program called *Miracle Children of the World* invited me to their country to be featured on the show. My parents wrote a note excusing me from school and I traveled to Japan, chaperoned by a lady from the network. My parents had no problem letting me go without them, because (at least my mom claims) they'd raised their kids to be independent from an early age. They had always awarded us an amazing amount of freedom, and since we never abused the privilege, they never yanked the normal parental leash. My mom told me later she was more envious than apprehensive about letting her fifteen-year-old fly across the world without her. I'm glad they didn't go either; otherwise I wouldn't have been able to score for the first time with a girl.

If the *Miracle Children of the World* were really the ten kids featured on the show, the world was in a lot of trouble. Three of the other miracles were the daughters of a Christian family band who sang Top 40 cover songs. The family was staying down the hall in

the same hotel as me. They were hard-core Christians, praying all the time and peppering their conversations with biblical references. At an orientation meeting for the show the fifteen-year-old daughter sat beside me, and boy did she introduced herself.

"You're staying down the hall from us, right?" she asked.

"I think so."

"What are you doing later tonight?" she asked, while looking straight into my eyes.

"Um, I don't know, maybe eat," I said as I looked away and started fidgeting. I was constantly hungry, so it was an automatic answer.

"What about after you eat?"

"Maybe go shopping or watch some TV."

"Why don't we get together?" She put her hand on my thigh.

"And go shopping?" I asked, trying not to hyperventilate.

"No, not go shopping." She looked at me like I was a puppy that had just peed on the carpet. "I'll call you later tonight."

At a little past 10:00 that night, the phone rang.

"Hi, it's me," she whispered.

"Oh, hi," I suavely answered back. I'd been thinking about her all day and had my doubts she would even call.

"Why don't you come into my room right now? I'll leave the door open."

"Okay." What was going on? I'd always figured there would be more effort involved in this process.

I tiptoed down the hallway and saw her peeking from the door crack. She opened it slowly and walked me into her room. It was dark, but I could still make out the silhouettes of her two sisters sleeping in the bed next to hers. She grabbed my head in one of those bad-movie-love-scene holds, like she was trying to crush my skull, and began making out with me.

I had started hyperventilating, but I held my breath when I heard a muffled "Shwroooo" in the distance.

"Shhh," I whispered. "I hear something."

I could hear snoring coming from the connecting room. It was her massive father in the other room with only a flimsy, unlocked door

HAWK

between him and the perverted skater rolling around on the floor with his virginal (so she said) daughter.

"Your dad's in the other room!" I whispered nervously as I stabbed my finger in the direction of the door.

"I know," she said, smiling. "And my sisters are beside us." It was an aphrodisiac for her.

My brain told me to get out of there before the sisters woke up and Dad came smashing through the door like the Incredible Hulk ready to stomp my ass, but my hormones argued that everything was perfect. My raging libido was the clear victor.

She made it clear that there were no limitations as to how far we could go. I hemmed and hawed internally and all my raw fantasies ricocheted around my skull, but I couldn't make myself do it. I left shortly after, still a boy. By far one of the wisest decisions I've ever made.

Now that I think about it, perhaps the show was correct in picking this girl as a miracle. I didn't think it was even remotely possible to make a girl interested in me, and here was one I had to fend off.

The entire trip marked the beginning of my Japan addiction. I skated and went shopping. I couldn't believe all the gadgets they had in stores. We were living in the Stone Age back in the U.S. I blew all my cash and bought a Walkman and a Watchman. Ever since that visit, Japan is at the top of my list for vacations.

HARD TO GET

While I didn't get hassled at all at Torrey Pines, my interest in school failed to increase. I never hated school, but always felt detached from the normal crowd. Trying to fit in didn't interest me, because I had a whole other life outside of it. The only people I knew were connected to skateboarding. There was one exception, a girl in one of my classes who I had the hots for. She became the sole girl I ever dated with no connection to skateboarding—but that's because I learned my lesson with her.

I initiated a few conversations with the girl during class and we

had a project together, so she was forced to spend time with me. After a few months, I tricked her into thinking I was worth dating, and we went out. I had to meet her parents before we could actually "date." That event was pretty painless, and we hung out a bit at school. Every day, the minute school ended, I bailed for Del Mar, but in between classes we saw each other. I think we went to a movie once too. We kissed a few times, but she was constantly aloof for some reason I couldn't understand. After a few weeks of this game, I just stopped calling her.

Once I'd ended the relationship she flipped personalities, cranked up the heat, and began trailing me. She'd wait for me outside of class and follow me to my next class, trying to get back together. One time I didn't see her after class and made it safely to my car—or so I thought. As I backed up she blindsided me, stuck her head in my window, and started making out with me. The more I tried to run, the faster she chased me. Eventually she backed off, or maybe I became paranoid enough to finally elude her consistently.

After my *Fatal Attraction* incident, I started casually dating a girl a grade behind me. She occasionally hung out at Del Mar and watched us skate. It was refreshing to find girls who thought skating was cool instead of some sort of infection. I officially had my first girlfriend.

I knew I'd really hit the jackpot when Ted and I discovered independent studies. According to the school board, a student could outline a course and, if the board deemed it suitable, could substitute the course for a class. It was like a corny fairy tale in which the skateboard fairy comes down making everything happily ever after. Ted and I spent days creating an outline for "Skateboarding Physical Education." Of course much of it was fabricated—you can't treat skateboarding like a school class. We wrote that we wanted to perfect our rock 'n' rolls, and that we had to do certain "drills" repeatedly to perfect our "art form." By the time we were finished, the report was at least ten pages long with graphs, charts, timetables, and a schedule that we'd follow. Halfway through our junior year we got the okay from the school board. No more PE, and we were allowed to leave school every other day at 11:30 to do what we

HAWK

would have done anyway—skate. Grant signed our sheets verifying that we actually followed our curriculum.

NEW WAVE ROCKER

New Wave hit like a tsunami in 1983, and I was on the crest of that wave. This isn't something I'm exactly proud of, but when I look back at pictures of me from that time, at least I get a good laugh. I *loved* it back then. Let me give you a brief description: my "coif" had exploded into Flock of Seagulls territory, my bleached platinum-blond bangs drooped over my face, and my clothes employed every neon color imaginable. Stubbies, a surf-based clothing company, sponsored me and made pastel pink, green, and blue tri-band shorts, which I couldn't get enough of. I made a scary sight: skinny body, huge poof-ball of bleached hair, pastel shorts, T-shirt with Powell graphics on it (usually skulls or dragons), shins covered with scabs, and a pair of trashed Vans or Converse Chuck Taylors adorning my size 11 feet. I resembled a scabby lollipop sprayed with pastel paint. While I didn't look like a fifth-grader, I was still skinny as a twig.

My hair was so different that I didn't trust a local barber with it. I made bimonthly pilgrimages to Hollywood with a few friends to have my hair bleached and cut by a specific stylist my sister Pat (singer in a band) used. As funky as the 'do was, it became popular in the skate scene. Andy Macdonald told me he saw a barbershop in Massachusetts advertising "Tony Hawk Haircuts" in hopes of attracting the younger crowd. Tom Green reported recently that he asked his barber for the exact same style (he even brought in a picture), and masqueraded as me once in awhile. Kevin, Ted, Cory, and I would cruise Melrose afterwards buying clothes and hard-to-find albums (The Cure, The Cult, Heaven 17, The Chameleons, New Model Army, Ministry, Missing Persons, Dead Kennedys, Depeche Mode, Adicts, The Mission U.K., Haircut 100, Wall of Voodoo, Bad Brains, Howard Jones, Toy Dolls). "Alternative" music before it was labeled alternative.

SKATEBOARDING IS NOT A CAREER

Skating's popularity was gaining momentum and, even though it was only in a subculture-like way, people inside the sport could tell it was growing. As different as I looked, few teachers (or students) knew what I did outside of the classroom. When they found out, most of them were supportive. During my sophomore year, I probably averaged two demos a month and a contest every other month. I'd occasionally miss a Friday or a Monday at school due to traveling. Most of my teachers were extremely understanding about my "dilemma." Since I continued to get good grades and wasn't a pain in class, they worked with me and let me catch up when I returned. I could hand assignments in a day late, and they'd let me do group projects on my own.

But there's usually at least one teacher in your scholastic life who seems fixated on your failures, and my careers teacher happily took that job. He was like those coaches in bad college football movies—buddy-buddy with the football team while scorning anything not having to do with touchdowns. I'm sure the only reason he taught careers class was because he was forced to teach something else besides gym to fill his schedule. He favored the jocks in class; it seemed like they were all he could relate to, all he knew. And I looked about as un-jockish as possible: weird hairdo, skinny as a pencil, strange clothes, and I had no interest in sports other than skateboarding.

The class bored me out of my skull; it explained a bunch of careers and attempted to prepare you for one of them. You were assigned a project in class that graphed what your skills were and how much money you could make, and obviously skateboarding wasn't listed as one of the skills. I didn't mention skateboarding in that class or even out loud during school. The textbook instructions for the project were incredibly simple; my seven-year-old son could have done the project. But the teacher was walking us through it step-by-step as if we couldn't read instructions. I worked ahead and finished the project halfway through the class. In the process I made a small mistake, but I corrected the problem. The teacher, after walking around

90

HAWK

droning nonstop, finally realized that some of the class was working ahead. He took it as a personal insult. He wigged out and began checking everybody's papers to see who the disobedient parties were. Besides myself, four other students were declared guilty. He saw that I'd made a mistake, and it didn't matter that I'd corrected it. He wanted to make an example out of somebody, and he obviously wasn't going to pick on his gang. He announced to the class I was never going to succeed if I couldn't follow instructions and work within a group. Blah. Blah. Blah. He continued to yell at me, telling me how I wasn't going to go anywhere in life by defying authority and that my future looked pretty bleak if I continued on my path of disobedience. I just sat there and smiled, which pissed him off even more. I realized at that moment I was probably making as much as, if not more than, he made.

My relationship with Mr. Career worsened after my brother visited. As part of a project, we had to invite a professional in to speak to the class. Steve was a reporter for the *Orange County Register* at the time, so I invited him. He came in and gave a speech. Mr. Career walked him out, thanking him. He mentioned to my brother that I didn't seem too interested in his class, but that I had "chosen" journalism as a career. Steve was shocked that my teacher had no idea I skated and filled him in on my "career." After Steve left, Mr. Career walked back in and announced in an exaggerated voice, "Whoa! Look out, everybody, it seems as though we've got a celebrity in our class."

MCOBSESSION

Besides the 900, one of the hardest tricks I ever learned in my life had to be the 540 McTwist. It's one and a half rotations with a flip thrown in the middle. You go up the ramp, grab your board, spin, and flip around so that you're coming back into the ramp facing forward. Mike McGill spent the summer in Sweden teaching at a skate camp and, so the legend goes, invented the move in an hour when everybody else was at lunch. I have no doubt that he did learn it in

an hour; it seemed to come naturally to Mike, though it continues to be one of the hardest vert tricks for any other skater to learn. Learning 540s became one of the most frustrating and scariest experiences of my life. At first Mike kept the trick a secret, but while nobody saw him do it, word of his invention had got around instantly and everybody was trying to figure out what exactly it was. At the next Del Mar contest he popped the trick in his run. Everybody freaked! It was the trick of the decade. It opened the door to an entirely new direction in vertical skating.

I managed to win the contest only because Mike fell during his run, but everybody was blown away by the trick. That day the entire vert section of the Bones Brigade immediately went their separate ways and attempted to learn the 540. Lance Mountain, who became a member of the Brigade a few years after me, told me about some of his first attempts. He had a ramp in his backyard and started trying them the day after he returned home. The weirdest thing about pulling a 540 is that you have to pull off the wall and flip as you spin. If you don't commit properly or pull off too hard, you're in serious trouble. Lance pulled off the wall as hard as he could, too hard, and opened up halfway through his spin. He found himself staring at the open sky, in the middle of the ramp, fifteen feet up in the air. He couldn't turn around to see where he was about to slam and dropped straight onto his back. Nobody can slam and make you laugh about it later like Lance.

Like the rest of the vert world, I was having my own problems with the 540. I obsessed about it like I'd never obsessed about anything before. In school I'd find myself absentmindedly doodling. I'd look down and see I'd just written *I have to do the McTwist.* I'd race from school to Del Mar and start spinning. I couldn't do it! The spin seemed impossible to complete. I'd chicken out every time. I'd get closer, and closer, and closer—so close that everything else in my life shut down to focus on this one trick. Finally, after two months, I landed the stinkiest 540 you have ever seen in your life. I squatted like a frog. My feet were hanging all over my board and I leaned back so far I looked like I was skating a La-Z-Boy chair instead of a skateboard. But I was the happiest guy in the world. I could have

92

rammed into the other wall and knocked my head off, and as I died, I'd have been wearing the biggest grin you'd ever seen.

The 540 was a dividing point for a lot of vert skaters. You almost always had to land one in your run to win a contest. It was the first time I can remember vert pros all concentrating on learning one trick. Later on, the kickflip Indy would create another division, testing the survival of the fittest. If you couldn't adapt, it was as though you were stuck in the Stone Age and were on your way out.

I could pull back and focus on other things after I began flipping 540s regularly, and I finished the school year with a B average. I spent the summer skating in contests and demos around Europe and the U.S. and spent five weeks on the Bones Brigade Summer Tour. The Tour was five skaters jammed into a van, bombing across the States and skating at skate shops. The end of summer always approached like a black cloud of doom sweeping over the horizon. I was living the life, traveling, partying, skating with my friends, doing well in contests, and then I'd get slammed back to school. At least a few of the Torrey Pines girls liked skaters.

THE BADLANDS

The last contest of 1983, the Upland Turkey Shoot, took place in November at Upland Pipeline, a skatepark so brutal it was nicknamed "The Badlands." Upland housed the dreaded combi-pool, a square and a round pool connected, and I think everybody would agree that it was the scariest thing to skate on the contest circuit.

Two years later it was the setting for the most notorious slam in skateboarding, when my old amateur buddy Chris Miller whipped a backside air around the square corner and locked up his trucks coming in. He shot ten feet straight onto his head and landed in a limp pile. It was as though he'd dove into the deep end of a pool with no water. A film crew videotaping the contest caught the event for prosperity, and you can't help wincing when you see it. The tape soon became infamous. People still pass it around. After the slam, Chris, still in a pile on the flatbottom of the pool, tried to lift his hand, and you can see it twitch—not cool. There weren't exactly a lot of skaters eager to skate after that.

The combi-pool had coping that protruded like a set of buckteeth over the ten-foot-deep bowls. I regularly rode up the wall, planning on doing an air, only to have my board ripped out of my hands. The flatbottoms of the pools were so rough that they resembled a gravel pit. If you slid the wrong way, your kneepads could be ripped off violently. Skating connecting bowls made adapting—at least for me—extremely difficult, and at The Badlands the locals ruled the park more than anywhere else I've ever skated. Skaters like Micke and Steve Alba lived nearby and dominated the place. Out of all the parks in the NSA circuit, it was the rawest.

Upland hosted the last contest of 1983, and I was ready to show Stacy and myself that St. Petersburg wasn't a fluke. I felt like I skated to the best of my ability and placed fourth. The top four read like a Bones Brigade roll call: Lance Mountain, first; Steve Caballero, second; Mike McGill, third; and me following in fourth. I was stoked on my showing, because at least fourth showed that I could hold my own in the gnarliest pool around.

HAWK

More important, I knew I'd solved my lack-of-speed problem, because if you couldn't create massive amounts of speed, you simply couldn't skate that place. I didn't lock myself in my room when I arrived home. I'd skated up to my expectations, so I was happy whether I won or not.

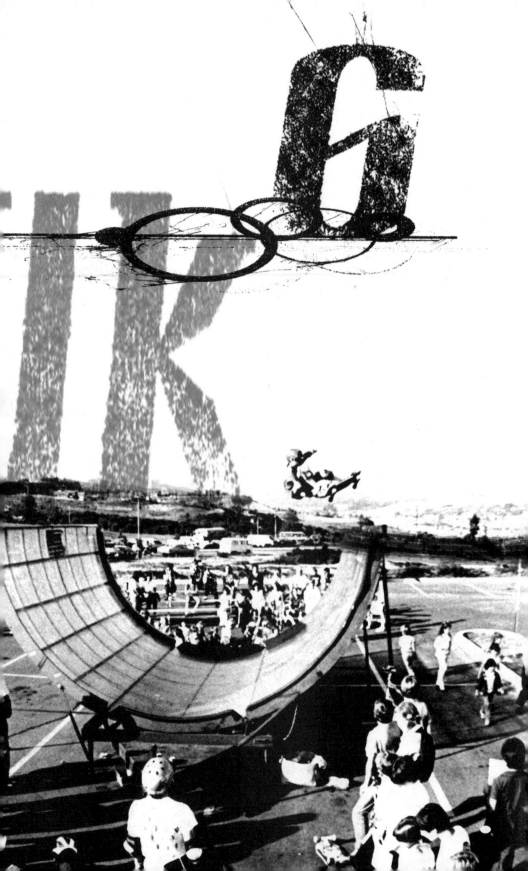

6

WORLD CHAMPION

EVEN THOUGH I BOBBED all over the contest results, at the end of 1983, when the numbers were tabulated, I was declared the first National Skateboard Association world champion. I'd won three contests, placed fourth in two, and placed sixth in the remaining one. All the title meant was I had the best point total, or that I may have entered more contests than Stevie, Mike McGill, Christian Hosoi, or another skater shooting up the ranks.

Christian was a hot young skater my age and the polar opposite of me; he had a fluid style, a huge personality, and could go higher

than anybody else. He was a crowd favorite, and a really nice guy. We always liked each other. There was no award ceremony (I can't even remember receiving a trophy) or party for the championship title; I think my dad just announced it at the end of the next contest at Del Mar. I didn't think much of it, because it wasn't something skaters strove for at the time.

CLEANING UP AT TAHOE

The first NSA contest of 1984 was the Tahoe Massacre, a ramp contest in the forests of Tahoe. There weren't a lot of contests in the winter; most were jammed into summer and fall. I didn't stay on during the contest and sketched into third place, not exactly something I was happy about. But I did learn a survival technique that would help me out fifteen years later when I filmed my part in *The End* in Mexico: what to do when you run out of toilet paper.

There were Porta Potties at the Tahoe contest, but they were always occupied and stank all over the place. Besides, green trees surrounded us, as did chirping birds and curious squirrels. I was in nature and I wanted to be one with it. I'd been practicing, when the need to lay some cable hit me. I took my pads off and walked a safe distance from the ramp, at least a quarter of a mile away.

I found a nice tree to squat behind and did my business. I was halfway through when the realization that I hadn't prepared very well hit me. No toilet paper. This nature stuff sucks! I finished and frantically tried to find a solution. I'd heard about people wiping with leaves, but it didn't seem like it would work too well, and I was afraid of picking the wrong plant. I didn't want to end up in the hospital with a case of itchy ass. After a few minutes I knew I had two options: one of my socks or my T-shirt. My math skills came in handy here, as I reasoned that if I didn't finish the job with one sock I'd still have to use the other one—that's essentially two articles of clothing for a job that should only take one. Another factor figured into the equation, because at the time I always got athlete's foot and socks were worth their weight in gold.

98

HAWK

I mentally apologized to Lance Mountain, whose shirt I was wearing, because even though I liked his graphics, there was a job to be done. I have often wondered if anyone was suspicious about my entering the woods fully clothed and returning half-naked.

Actually, someone did notice, or maybe I told Kevin that night. There isn't much in this world as funny as potty humor. The next day Kevin found himself in a similar predicament; the porta-pottie had a huge line and he was in no position to wait.

"I've got to go," he moaned to me. "I'm going to pinch a loaf in the woods like you." The only problem was that Kevin was wearing an Adicts T-shirt and there was no way he was going to wipe with it. In part to atone for my sins of the day before, I gave Kevin a brand new Tony Hawk T-shirt.

I don't know if there's ever been a better wiping utensil than that.

I THOUGHT YOU WERE DEAD

Summer was nearing its end and I was starting to get bummed about having to revert to my boring alter ego, school nerd. I was skating in a ramp contest called the Booney Ramp Bang when I almost got killed. I was standing on the deck waiting to take a few practice runs when Neil Blender stalled an invert in front of me. He stalled it too long and tipped over onto the deck right before me. The Booney ramp was sketchy to say the least, and it was built with four-foot-wide decks, sans rails. I stepped back to avoid being kicked by Neil when I realized, much like Wile E. Coyote, I'd backed into thin air. Neil saw me about to fall and tried to grab my leg to pull me back, but couldn't hold on, which flipped me over midair. I fell ten feet straight onto my back, into a dirt pile. My chest flattened to the thickness of a sheet of paper. All the air was sucked out of me; it was like somebody had rammed a Hoover down my throat. I turned my head to the side and saw a glass Gatorade bottle a few inches away. If I'd been a little more to my right, I would have been picking chunks of glass out of my back.

I'd gone to the contest with one of my best friends at the time,

Lester Kasai, a pro for Sims. He told me later he thought I was dead for sure and that we'd have to go home. He was worried they might shut down the contest. Falling ten feet on my back turned out to be my lucky charm, though. I won the Booney Ramp Bang.

ROBOT STYLE

I did wonders on wiping out my "he only skates well at Del Mar" image during the next contest at Del Mar. Christian Hosoi won that day. The chasm between my style and that of others had widened. Christian could flow and he, along with Chris Miller, had the smoothest style in skateboarding, but I had the wacky tricks and my "robot style." I wasn't bummed on finishing second to Christian, because I skated as well as possible.

Skating is such a subjective form that judging seems almost ridiculous when you think about it. It's like having a paint-off between Van Gogh and Picasso and declaring a winner at the end. That's always been one of the problems with skateboard contests—they're not exactly a true reflection of who's the best. Skating is not like gymnastics or figure skating, with predetermined points for tricks. *How* you do a trick can be just as important as the trick itself.

I moved into Del Mar during the summer. My daily ritual if I was in town was to get up, eat, skate Del Mar, eat, goof off, eat, skate, eat, and maybe go to a movie or gig. The eating took place at the Denny's next door to Del Mar. I ate chicken fried steak and eggs religiously. The goofing off usually consisted of sneaking into the neighboring trailer park and using their pool. Imagine a herd of scabby, stinky skaters overtaking your pool. We'd always get the boot, but at least we'd rinsed off. Then it was back to the skatepark, where we'd crash the miniature golf course and play a few free rounds. We did the same for a free High-Ball session, and then more skating. Denny's and swimming in a trailer park; it was white trash heaven.

That summer I returned to Kona Skatepark and actually skated decently. Three was my lucky number. After two miserable professional showings, I won there. I started to get comfortable skating

outside of Del Mar. I spent the next two months skating, inventing my own weird little tricks, and entering contests. I entered a street contest in San Francisco and skated into seventh place. I skated The Badlands again and almost won. This excited me more than anything else, because it proved to me that I was solving a lot of my skating problems. If I kept punching away at it, I could skate anywhere and meet my expectations.

SKATEPARK ROMANCE

During the summer of 1984, a new girl started working at the concession stand at Del Mar. They sold your regular concession-stand hot dogs and overpriced bags of potato chips, and I found myself ordering food eight times a day. Her name was Sandy, and she lived with her grandparents in the trailer park next to Del Mar (the one with the pool that all the skaters infiltrated). She had a rough life. I never knew the deal with her parents, but at sixteen she'd been Ping-Ponged back and forth between relatives. She was cool, extremely attractive, and liked skaters—perhaps by default, working at the snack bar of a skatepark. The last girl I'd dated from school had come to watch me skate sometimes, but the relationship had never amounted to anything serious.

The relationship with Sandy was perfect: I could skate and hang with my girlfriend at the same time. It barely disturbed my lifestyle. Sandy was my first real girlfriend. Over the next few years we established a pattern of breaking up and getting back together, like a Lego set. If something in my life didn't revolve around skating, I had a hard time figuring it out.

BACK TO SCHOOL

My junior year was almost a carbon copy of my sophomore year. I skated and attended school, but skating was beginning to blow up and my demo schedule began to demand more weekends. The last

contest of the year was in September and took place at Del Mar. I won. My dad figured out the math, and once again I was declared NSA champion. I think I actually received a trophy for that one, though I have no clue where it is now.

Back then, and for the most part now, trophies sucked! They were cheesy, plastic things with a bad gold-painted skater on top doing a kickturn. The skater was early '70s, with a tiny board and wearing volleyball pads. The only decent one I remember was the Upland Turkey Shoot trophy, which had an overweight gold-painted turkey on top of it. I put some of the trophies in my room. But when I wanted a television and a stereo system the trophies got the boot, since back in the 1980s a stereo took all the space in your room. I put them in a cardboard box in the garage and throughout the years I'd drive into it by accident, or drop something on the box by mistake. Somehow or other they'd end up getting smashed. I'd just throw them out after awhile.

I was never really into my car, so I bought a new white Honda Civic wagon. I sold my old car to my friend Matt, who promptly blew it up on a highway.

Nothing changed with my school social life, but I did make my sole attempt to attend a school function that year. The band Oingo Boingo was going to play the senior prom. Now, being a New Wave aficionado, the chance to see one of my favorite bands overpowered any instinct to avoid nonskating social events. Owen Neider was a close Del Mar buddy, and his girlfriend at the time was a senior at Torrey Pines. Owen was a punker; I knew he didn't give a crap about Oingo Boingo or a prom, so I asked his girlfriend if she'd take me. I told her I'd just go to watch the band and then split. And she agreed, but at the last minute she took Owen. That's the only time I was bummed about being an outsider at school.

CIRCUS SKATER AT THE BADLANDS

Skating was getting even more popular, and I was averaging at least four absent days a month due to traveling to demos. The first

HAWK

contest of 1985 took place at Del Mar, and I won. But that didn't matter too much to me; I was preparing for the following contest at The Badlands.

I'd continued growing, and I was six feet tall and probably weighed 135 pounds, a vast improvement over the year before. My skinniness only bothered me when it hindered my skating. "Rage at The Badlands" was one of the hardest contests I've ever skated, and probably the most important of my career. I had to push myself harder than I'd ever done just to keep up with the locals and other pros who adapted easily (nobody adapted better, or adapts better today, than Stevie Caballero). I had to skate better than I ever had before and won the contest. I was stoked, to say the least. By winning at Upland, the rawest skatepark anywhere, I put a lot of the criticisms to rest. How could a weak circus skater skate *that* place? Even if I had skated like I did and landed in last place, I would have been the happiest guy at The Badlands.

KING OF THE MOUNT

My next contest, the "King of the Mount" at Trashmore (the ramp was built on a retired city dump) in Virginia Beach, would be remembered for a number of reasons. The first, and the one I cared least about, was that I became the first professional skater to ever win three contests in a row. The second, which had far more impact on me, was that I lost my virginity.

I'd broken up with Sandy, or she'd broken up with me; and when we were together, we'd never gone all the way. But at Trashmore I had become known as the top skater in vert contests, which meant girls who didn't know me actually liked me. It was a strange feeling, but I wouldn't have changed a thing. Meeting girls outside of skating would have taken a massive amount of effort and way better looks. I know I would have simply given up on trying.

Luckily, I won a few skateboarding contests, and an attractive girl sparked a conversation with me after I finished practicing. We arranged to hook up later that night for dinner. We went out to eat

with the Bones Brigade and Stacy, and then headed to my room. One thing led to another and in a few minutes (this is including undressing) I entered manhood. I remember thinking, "Wow, here I am finally—" I was done. A run in a vert contest lasts forty-five seconds, which was approximately twice as long as I lasted. I apologized and explained it was my first time, but she wouldn't believe me. If it had been a contest, I'd have placed dead last.

I won the aptly titled contest and went home with a bigger smile than usual.

DEMO DATING

In October of 1984, I did a weekend demo in Fresno, California. After I skated I met Cindy Dunbar, an attractive girl whose parents owned a local ice-cream shop. We just hung around as friends. We never even held hands. But we stayed in touch for some reason (I didn't realize then that we would someday end up getting married), writing letters and filling each other in on our love lives. I wasn't lusting for Cindy, but I liked her a lot as a friend. Not that she wasn't somebody you'd lust over. Far from it.

CHEST PAINS

It started out as a regular night at home. We ate, and my mom went to a college class after dinner. People accuse me of being understated, but they've got to understand I learned from the master. I was watching TV when my dad walked into the room, holding his chest and taking deep breaths.

"Um, Tony?" he asked as if apologizing for interrupting my viewing. "I think I'm having a heart attack. Maybe you'd better call an ambulance."

I popped out of the chair and started running around like a chicken with its head cut off. I dialed 911, and they told me to calm down; an ambulance was on its way. I had Dad lie down on the sofa and

got him some water. I was freaked. This was his second heart attack, and the guy wasn't exactly taking care of himself; he'd been gorging on steaks a few nights a week. As he lay on the sofa clutching his chest, I opened up to him. All of a sudden, all the stupid problems I'd had with his being involved in my life seemed so selfish.

"Dad," I said. "I want you to know that I love you." This was my *On Golden Pond* moment! Dad and son opening up, and erasing any doubt of their omnipotent love. The world would explode from the power of our love.

"Yeah, I know," he said, nodding. I waited for him to open up and emit rays of love, bathing the room in glorious warmth.

"Dad, I said 'I love you.'"

"I heard you. I know you do."

"I want to thank you for all you've done for me."

"Okay. You're welcome."

"Dad—"

"Hey, did you say that the ambulance is coming?"

The ambulance came, and my dad spent a few days in the hospital. When he was released he had to pop nitroglycerin pills. But he went back to his workaholic schedule running the NSA, designing ramps for people, and never deviated from his weekly appointments at Sizzler.

SHAVING EYEBROWS

I ended my junior year with a B average and bolted from the country to teach at a summer camp in Sweden for five weeks with Rodney Mullen and Lance Mountain. The camp was out in the sticks, over fifteen miles from Stockholm, but at least it had a beach nearby.

Within a couple of weeks, Lance and I got cabin fever. The skaters who came into the camp only stayed for a week, but we were stuck there for the whole five weeks. It turned the camp into a Siberia. We never did anything remotely related to teaching; we skated with the campers and would give advice if someone asked. The only way we

could get to town was if we tagged along with a counselor, and they rarely went into the city. So we bought a car, a Peugeot 909, for around $500. I paid for a little more than half of it, because I was way more hyped about getting transportation than anyone else. I don't think Lance really even cared if we got it, though he loved it afterwards. In fact, he got the most enjoyment out of it.

The car ruled. It was a white four-door, pretty plain-looking until Lance spray-painted it with the Rat-Bones Powell logo and some other designs. We drove it around camp like stunt-car drivers, with no insurance. But that doesn't mean we didn't love our car. We lent it to one of the guys in the camp, someone we actually trusted, to go into Stockholm for supplies. He in turn let another guy (whom we referred to as "Schvantz") drive the car back, and Schvantz dented the rim. He smashed into a curb or something, no big deal, but he didn't tell us when he returned. We were pissed Schvantz didn't have the decency to tell us. We were going to trash the car anyway, but you don't dent someone's car and then try to hide it.

When we confronted Schvantz, he just played it off. He never acknowledged the accident; he just laughed his little Euro-laugh. Lance and I, bored anyway, immediately hatched various plans of revenge. Schvantz had the disturbing habit of sporting Speedos at the beach— very nasty. They were small and left nothing to the imagination. This fact about him bothered us enough, without his crashing the car.

One night Lance sneaked into his room and very quietly, careful not to wake the slumbering Schvantz, cut the front out of all his Speedos and underwear. Then he folded them up and put them back exactly as they'd been, so everything would look normal. Schvantz never said anything to anyone. I also don't remember seeing him at the beach anymore.

Lance's true appreciation of the car began when we drove through the nearby wheat fields and the forest. Bombing through the wheat fields, you couldn't even see two feet in front of you. Lance would just blaze through the forest. It was like the scene in *Throw Momma from the Train* in which Danny DeVito and Billy Crystal are driving through the forest and Danny says, "It's just like the Flintstones' car wash." It was, in fact, exactly like that.

In the forest we slalomed between trees, got air bouncing down hills, and bottomed out over humps. Occasionally we'd get wedged between two trees, and we'd have to gun it and inch our way through. We never got in a bad accident, though, because Lance was a good driver. He'd grown up in Los Angeles. I wasn't scared of the ride; I was scared that we were going to get in trouble from the camp director. We solved this problem by making him a participant. He screamed and laughed as we dodged trees and flattened wheat. He thought it was funny, but said we couldn't do it again.

We'd only taken the director into the wheat fields and forest, so technically that's all he'd banned us from doing. We'd never taken him to the beach.

One day we were driving alongside the beach when we saw a pack of attractive girls sunning themselves. I was only sixteen years old, and they probably were too, so it was perfect! But we spoke only English and they didn't, so how did we get them to notice us? We started chasing them down with the car. They were giggling, so obviously they thought it was pretty funny. They saw us as a pair of stupid Americans spraying sand everywhere. We ended up making a bit of a mess after ten minutes of spinning doughnuts and Rockfords, and the girls didn't like us that much, so we headed back to camp. A little more than an hour later, the cops showed up. They were really mad, demanding to see the two idiots who'd messed up their Swedish sand. We played the situation off like the stupid Americans we were. After the cops realized where we were from, they thought that's what we did in America—drive on the beach. They wagged their fingers, "No! You cannot do this in Sweden!"

With our driving privileges temporarily suspended, we took to other activities to amuse ourselves. One day we played ticktack tag in the gym with the campers, a typically mellow game. Boring, in fact. This one Italian guy (hereafter referred to as Guido) started cheating and pushing people off their boards (if you fell off your board you'd be It). There were mops in a closet, and everybody grabbed them and started using them as lances, jousting each other and sticking them under wheels so people would slam. Soon skaters started gathering ammo they could throw at each other. "Tag" had

turned into search and destroy. We all raided the equipment room and pilfered volleyballs and hockey sticks. We knocked each other around a bit and before we knew it, someone went into the room and grabbed some spare tires. Immediately, radial tires launched across the gym. Skaters would be skating one moment, and the next a tire would hit them from behind like a cannonball. People were spinning around on their boards in order to get up enough momentum to launch the rubber missile. Lance got nailed with one and after picking his spleen off the gym floor, we realized that it was pretty dangerous. We stopped.

Guido was always doing something sneaky. He constantly schemed to cheat in some way. Guido had the craziest monobrow I've ever seen in my life. It looked like somebody had laid a patch of carpet across his forehead, and Lance wanted to shave half of it off. So we sneaked into the guy's room late at night. Lance wrapped an electric shaver in a towel to keep the noise down, but every time he leaned in close and turned the shaver on, Guido would stir. Lance even tried to wrap it in a pillow, but to no avail. We couldn't stop laughing.

The last day of camp, we tried to figure out what to do with the car. Mofo, a skateboard photographer for *Thrasher*, jumped on the car and body-slammed the hood. Then he belly-flopped onto it. In a few minutes, a gang of people joined in the abuse. Our car was almost totaled. In the middle of the night, Lance and some other skaters pushed it a mile to the dealership we'd bought it from and left it there. A couple of months later I heard from the directors of the camp that the dealership had fixed the car up, punched out the dents, painted it, and were trying to sell it again.

When we actually skated, Sweden was the perfect place. It was isolated, with fewer distractions than in the States. I learned 720s during my tenure, and surprisingly they weren't that hard to master. Lance and I were skating, and I did a higher-than-usual gay twist and overrotated. He suggested I try to spin another rotation. I tried it for less than an hour and landed one squatting like a frog getting the bends. While 7s were fairly easy to learn, it proved to be a night-

HAWK

mare to land a respectable one. I'd land squatting out of them for the next few years, until I finally landed one standing up years later during the shoot for *The Search for Animal Chin*.

FUTURE PRIMITIVE

The success of the first Bones Brigade video let everybody in the skateboarding industry know that videos would play an important part in the future of skateboarding promotion. Two years after *The Bones Brigade Video Show* was released, Stacy began working on *Future Primitive*. This video was more ambitious, with a series of skits running throughout it. Looking back and comparing the two videos today, it's amazing to see how fast and how far skating had advanced. I'm not bragging about the talent on the Bones Brigade; I'm talking about skating in general. Skating was getting more attention, and street skating was becoming popular.

Future Primitive premiered in Los Angeles in the fall at a mechanic's garage, which Stacy would convert into a temporary club (he always had a sense of style). Drinks flowed, food was served, industry people mingled—it resembled an art show. No little TV screen this time; *Future Primitive* was a real movie.

It begins with KRAT-TV going off the air. The national anthem plays, and an American flag flaps against a blue sky. The image is interrupted by a distorted signal and *Future Primitive* appearing on the screen in archaic writing. A manic montage of the Bones Brigade flashes for a minute.

"Two hundred years of American technology has unwittingly created a massive cement playground. It took the minds of twelve-year-olds to realize its potential." This message scrolls across the screen as Tommy Guerrero skates around San Francisco. More pool skating, more contest footage (this time from Trashmore, where I skated in a hot pink skateboarding skeleton T-shirt and Mike rocked in knee-high checkered socks), and a fingerboard session in which we pretend to train. A lounge singer croons "Skate and Destroy" as

clips of us slamming play. Per crawls out of a sewer and freestyles while people in bad Jimmy'z chef hats skate a pool.

The skating is interrupted by Stacy talking with a sports spazz as they watch some skating. "I say it's time we moved these kids out of the backyards where nobody sees them and into the shopping malls!" In all his videos, Stacy supplied commentary on how he felt about skating. The spazz continues, "Run it like a dog in a pony show, something like that. Little League was to the '50s what skating is to the '80s—these kids need uniforms!"

Cut to an actual pro contest at a mall in Sacramento. *Future Primitive* ends with everyone skating down the street, goofing around and launching off a jump ramp. I, naturally, am the only one that slams, going off the ramp. I'd gladly have taken the slam if only I could have frontsided 540s for this video like the one I did in the video at Del Mar. I have lost that trick completely.

Future Primitive was a huge success. Everyone agreed it was better than the first video, and the Brigade skaters were all stoked. I was always proud to be a part of a video of that caliber; everybody from skaters to industry people regarded Stacy as the leader of video producing.

I began receiving fan mail from skaters who wrote how much they liked my part in the video. I was extremely self-conscious about my style and my tricks, and to have people telling me how much they liked it bumped my confidence up a little. I felt like I could exhale a bit, because I'd become a basket case over my lack of style. I knew I couldn't change it—you skate how you skate—and after awhile I began hating it.

Years later I spoke with Stacy, and realized how much effort he'd put into marketing my style. He knew I had an image problem, but he emphasized my differences instead of trying to manipulate them into something readily acceptable. When Powell sponsored me over four years earlier, Stacy had been trying to solve the problem of how to market me. What he saw as my strengths, others saw as a weakness. My entire career would have been different if Stacy hadn't had the confidence in my skating to pull us both through the rough

HAWK

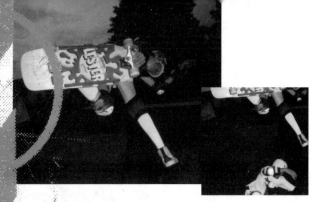

times. If not for him, I might be asking you if you wanted paper or plastic right now.

Every skater on the Bones Brigade reaped the video benefits, and board sales shot up. We all started making close to $7,000 a month.

But the money we reaped from the video wasn't what psyched me out. While Stacy filmed my segment of *Future Primitive* at Del Mar, he let me know how he felt about my skating. I had my list of tricks—Airwalk, Switcheroo, Saran Wrap—and started doing them for him. These were tricks I didn't do in contests yet, because I wasn't comfortable enough with them. He hadn't seen a lot of them. We probably bagged ten tricks before lunch, and he took me out to eat with the film crew.

"You have the talent to win any contest you want from now on," he said as he picked at his sandwich.

I just stared at him. I'm not what you'd call an emotive person, and my insides began scrambling up when he said that to me. It was a heavy thing to say—gnarly for anybody, but even more so for Stacy, who was a straight shooter. I was going nuts inside and didn't know what to say. I just stared at him. From that moment on, I wanted to keep improving.

I ended the calendar year with two victories, one at Skateboard Plus in Little Rock, Arkansas, and the other at Shut Up and Skate in Houston, Texas. For the third year in a row, I won the NSA championship.

chapter

7

FREEDOM

MY GRADES TOOK A BEATING during my senior year. Millions of people in California alone were skating, and I was one of the most popular skaters in the world. Requests for demos would pour in every month, and I had commercial shoots for companies like Mountain Dew. I dropped my advanced calculus and physics classes and took only what I needed to graduate. I bailed from school at 11:30 every day because of the classes I'd dropped and Skate PE. Almost all my teachers understood my situation. Mr.

Carlton, my English teacher, helped me mesh my two worlds. He'd loosen up due dates if I had a contest around that time; he'd let me do a group project solo because I didn't have time to meet with other students. Other teachers helped out too. I sank to a C average, but it didn't bother me too much because skating was exploding.

At the beginning of the year my parents moved from Cardiff to Carlsbad. I didn't want to switch schools when I had it so good, so I drove to Del Mar (Torrey Pines) every day. The commute, which was smack in the middle of rush hour going in the direction with more traffic, could take me up to forty minutes. I averaged six school absences a month, and I was constantly late for my first class. My grades dropped as if they had an anchor attached. My life was getting too hectic; if skating had boomed a few years earlier, I would have taken advantage of my High School Equivalency Exam results and left.

At least I was doing really well skating. I placed second in a contest in Houston, Texas, and a month or so later won a contest in Mobile, Alabama.

Midway through my senior year my sister Pat, who did my taxes, recommended I buy a house, because I was paying way too much to the IRS. She told me I needed write-offs. I had close to $50,000 in the bank and was making around $70,000 a year, and had nothing to do with it except blow it on electronic gadgets at the Sharper Image. I looked around for awhile and found a new four-bedroom, two-and-a-half-bathroom place I liked in Carlsbad for $124,000. My mom was sad to see me leave, and she tried to talk me out of it. She told me how much she'd miss me (I was maybe five minutes away) and, more important, how much she'd miss my skate friends.

My mom loved all my skate friends and embraced the subculture, and they loved her. Kevin would show up with his New Wave hair and Owen with his mohawk; skaters proudly showed her new tattoos and talked with her about their lives. She seemed her happiest when the house was full of skaters. My dad was never as open about his affections and would gripe about the skaters always being around, but they were smart enough to see through this. He was always there to talk to if they had problems at home. My parents

114

HAWK

loved having my friends around, and they loved hanging around my parents.

My dad had to co-sign my house loan, because I was only seventeen. A few months before graduation, I moved in. Now I was an eighteen-year-old with my own bachelor pad. I skated all the time and had many distractions from school. Ted moved in with me and a skater's girlfriend took another room. Skaters from Del Mar camped at my place after sessions, beer flowed, and we all sat in the hot tub. I usually dragged myself away from the partying in the early morning so I could have at least a few hours of sleep before I would pound the snooze button a few times times and arrive late to school.

ZERO TO HERO

A weird thing happened during my last month of school: I became famous. The Mountain Dew ad aired on television in heavy rotation, and it seemed that all my schoolmates saw it. Word got around I'd bought a house, and people began coming up to me in the hallways and started conversations with me. It felt like an acid trip; this was a different school from any I'd experienced. I hung around with older skaters who'd been out of school for at least a few years, so living alone and traveling on weekends seemed normal to me. I was still shy outside of skateboarding, though. I found out later, when I'd bump into people from school, that a lot of classmates thought I was stuck up, because I didn't start conversations with everybody at school. It didn't matter to them that I'd never done that before, but after I got famous it seems it did.

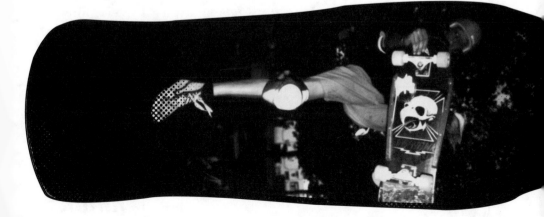

A girl I knew was on the yearbook staff and she pushed for a special feature on me. My high school annual devoted two pages to me. It had pictures of me at Del Mar and a brief history of my skating career. I think people who didn't skate (most of the school) didn't understand exactly what I did until the annual came out and they saw pictures.

I wasn't around much toward the end of the school year. I missed three of my final exams because of an out-of-town contest, and had to jump through some hoops to make them up. I won the contest and passed the exams.

I never bothered finding out when the senior prom was and didn't even know it had occurred until a few days afterward. Even if I had known, I wouldn't have known who to ask, except maybe a girl named Rebecca, who knew something about skating. She was a year behind me, and we'd date casually when the Sandy thing wasn't working out.

I did go to graduation, though. I was reluctant to, but my mom was hyped on the idea and I didn't want to let her down. My entire family showed up with a pack of my Del Mar friends. Kevin, with his hair dyed blue, sat beside my mom. The previous year the graduating class had become a bit rowdy, so the Torrey Pines administration took precautions to make sure their activities wouldn't be repeated. At the end of each row of seats sat teachers in dark suits wearing dark sunglasses—Secret Service wanna-bes. I remember checking for earpieces. Some students performed songs during the ceremony, and it was brutal. I didn't know who they were, but I felt myself getting itchy and ready to bolt after the second senior started singing some weird song about children of the world.

I was a big fan of *The Breakfast Club*, and when I received my diploma I jammed my fist into the air like Judd Nelson does at the end of the movie. It probably didn't look as cool as I had hoped.

But the day only got better once we left the formality. I had a few extra hours before I was due to have dinner with my family, so I skated Del Mar with Ted still dressed in our graduation costumes; our gowns flapped after us as we dorked around in the keyhole

HAWK

pool. My parents picked me up, and with a car stuffed full of Hawks we made our way to a fancy Japanese restaurant we all loved.

I had a graduation party at my house. All my Del Mar friends brought their friends, and the few friends I knew from school attended. By 9:00 P.M. the house was maxed out, cars lined the streets, and my neighbors, who were still trying to figure out what my deal was, were less than pleased. Sandy had dumped me, or I'd broken up with her. Whatever the deal was, I was single for a bit. I hooked up with another girl and because all the rooms were occupied, we crawled into a closet. The whole party seemed to crowd around the outside of the closet heckling us as I tried to create a romantic mood for my "date."

When we finally emerged from the closet in the morning, my house looked like Jonestown for skaters. My friends were passed out and covering every inch of anything soft, like chairs and sofas and piles of clothes. I took a deep breath and inhaled the disgusting stench but couldn't help smiling at my first day of freedom.

BONES BRIGADE TOUR

A week or so after school ended, I went on the Bones Brigade Summer Tour. "Summer Tour" translated into a cross-country five-week endurance test of demos. I love demos compared to contests. There's less pressure, you already know what you'll get paid, your expenses are covered, and if all the planets are aligned a few girls would come out to meet you. When I was eighteen, demos translated into girls, skating, and parties.

Tours differ from regular demos because you're on the road for weeks, sometimes months, without a break. A strange, warped sense of time and place takes over like an evil fog—most likely a survival instinct—and after a few days you lose track of the date, what time zone you're in, or where you are. The skating conditions are worse. You have to skate ramps that are falling apart on parking lots covered in gravel in blazing heat. The 1986 Bones Tour was low-budget

compared to modern-day tours; Per Welinder, Steve Saiz, Tommy Guerrero, and I stuffed ourselves into a huge van, with all the street obstacles stacked in the back like Tetris.

But it's fun. Skaters usually don't mind things being a little grubby. It's skate, party, attempt to pick up girls, wake up, drive to the next demo, and repeat. I think Kevin Harris landed the horrid job of tour manager. The job is similar to baby-sitting, and the tour manager is occasionally sarcastically referred to as "Dad." He's usually the actual team manager or a responsible (and older) skater who isn't the focus of the tour. "Dad" has to drag the skaters out of bed every morning, perhaps even track them down at a local girl's house, pay for any hotel damages caused during the night, and do the majority of the driving for the tour. For some skaters, "Dad" does everything but wipe.

The monotony of touring is what kills you. I always zoned out with a Walkman and read. Partying was the strongest tour antidote. But we'd occasionally be cheated out of that piece of paradise. If we had to do a demo in a city some distance away, we'd drive through the night instead of party.

As busy as we were, the summer still provided plenty of opportunities for "romance." In Maryland, a girl zeroed in on me as I signed autographs after a demo. She was seventeen, really pretty, and she kept asking me to do something with her that night. She slipped me her number and told me to call her when I got back to my hotel.

I called her that night a little after 10:00 P.M. She lived with her parents and it was too late for her to go out. I was still awake, and bored, so I went for a stroll around midnight. I walked around the boardwalk for twenty minutes before I saw the girl walking toward me in her pajamas and bare feet. She told me she'd sneaked out her window and walked a few miles to the hotel. I didn't think any girl would put that much effort into trying to hook up with me. Her feet were hurting, and she asked if I wanted to go back to the hotel. There wasn't anywhere else we could go with her still in her pajamas.

It wasn't always so romantic. Once I liked a girl who had been following the tour and wanted to hook up with her, but I roomed with Tommy Guerrero and he was watching television, so she and I headed

HAWK

to the van. It smelled like a locker room, with stacks of dirty ramps in the back. We consummated our relationship on a flimsy mattress on a tipped-over ramp. I wrecked any chance of a second date by being so grubby. Word of advice: it's never the same after you hook up in a smelly van.

I returned home to bad news: Del Mar was closing down. I don't think Del Mar ever made any money; as far as I can figure it was a write-off for the miniature golf course, driving range, and High-Ball courts. I heard something happened with the insurance and it became too expensive to keep the park open. Vert skating had evolved over the past few years from skatepark bowls to backyard ramps. Del Mar was outdated.

In Fallbrook, about half an hour east of Carlsbad, Ray White, who supported his son Tobin's skating, built him one of the best ramps I've ever skated. Mr. White was a contractor, so he knew how to build a solid ramp. He poured a foundation and reinforced the ramp's structure so that it felt like concrete. In other words, it was fast. I'd begun skating Fallbrook more than Del Mar during my senior year. Basically the Del Mar posse migrated from the skatepark to Fallbrook. Even though we continued skating together and the ramp was better, the skatepark vibe died with Del Mar.

THRASHIN'

Just when I began to miss Del Mar, an opportunity popped up to skate it again. A second-rate movie was being filmed to cash in on the growing skate craze. *Thrashin'* was about a skater, Corey (played by Josh Brolin), who moves into a new town and, naturally, has to battle the evil skate goons to win the pretty girl. Oops, I just gave away the whole plot. I wasn't in the movie, but was hired as an extra for the contest segment filmed at Del Mar. (The hero has to compete against the goons.) I was a glorified extra but didn't care; I got to skate Del Mar for two days because the film studio carried their own insurance. In the movie when they announce my run, they don't even use my real name.

The movie tanked. Surprise, surprise. The best part of it was the movie poster: Corey stands in full skateboard gear staring out moodily, looking as heart-throbbish as possible, but he's wearing his wrist guards backwards. You notice it the instant you see the poster.

THE SEARCH FOR ANIMAL CHIN

After the tour, the entire Bones Brigade blocked close to four months off our schedule to film Powell's third and most ambitious video yet, *The Search for Animal Chin*. The big finale for the *Chin* video was set on a vert spine ramp built in the boonies in Oceanside, California. It took a week to build and resembled nothing else in skateboarding. We filmed the ramp sequences first, for five days. Stacy sat in a wheelchair and was pushed around to get smooth shoots; he climbed on ladders and shot from every angle possible. On the last day of filming, Lance, Mike, Stevie, and I were doing a quadruple run and Stevie and I messed up. I was going up the ramp and he was coming down—that was all planned—but somehow I came up and saw him coming straight at me, instead of to my side. We both were going so fast that we couldn't stop and hit like two trains. Some part of Stevie hit my thigh, and it felt like it exploded. An instant stomachache swelled inside my gut, and I could barely move my leg. I hobbled to my car and drove home and slept for three hours. When I awoke from a super-deep sleep, my leg felt perfect. I drove back to the ramp, ready to finish skating, but by the time I arrived they were taking the ramp apart. If you ever see the video, this is why I am missing from the "tunnel" footage.

We traveled to Hawaii to skate a ditch and then to San Francisco to street skate, but shot the bulk of the video in Los Angeles. We were staying on Sunset Avenue when I looked out our hotel's bedroom window and saw a billboard for *Thrashin'*. There I was, doing an invert, taking up half the billboard. I didn't even know somebody had taken my picture. I was stoked. I probably made $300 from the entire deal, but at least I got to skate Del Mar and appear anonymously twenty feet high on Sunset.

HAWK

OCCUPATIONAL HAZARDS: THE 900 WON THIS BATTLE.

FROG BOY ON A BOARD.

THE HUMAN PAD GOES FOR BROKE.

RESEARCH AND DEVELOPMENT FOR MY FIRST SIGNATURE BOARD.
IT WORKED GREAT, BUT IT DIDN'T SELL.

LANCE AND I MANAGED TO SKATE A BIT BETWEEN
DEMOLISHING CARS AND SABOTAGING UNDERWEAR
IN SWEDEN, 1985.

THE INFAMOUS
PEUGEOT.
WE TESTED THE
DURABILITY OF
THOSE EURO CARS.

ERIN AND I AT OUR WEDDING, 1996.
RILEY KEPT INTERRUPTING OUR VOWS
TO ASK ME IF HE COULD TAKE HIS
DRESSY SHIRT OFF.

THE HAWK FAMILY, CHRISTMAS 1999.

QUALITY TIME WITH THE FAMILY.

CLOSE, BUT NO CIGAR.

TOM GREEN WAS A HARDCORE SKATER
IN THE '80S. NO, HE'S NOT THAT
CRAZY OFF CAMERA.

MARK MCGWIRE IS HUGE.

"BUT, OFFICER, WE'RE MAKING A FILM!"

MY LAST RUN OF
THE 1999 WORLD
CHAMPIONSHIPS IN
MÜNSTER, GERMANY,
I ONLY DID TRICKS
FROM THE 1980S.
FRONTSIDE INVERT—
TIME WARP.

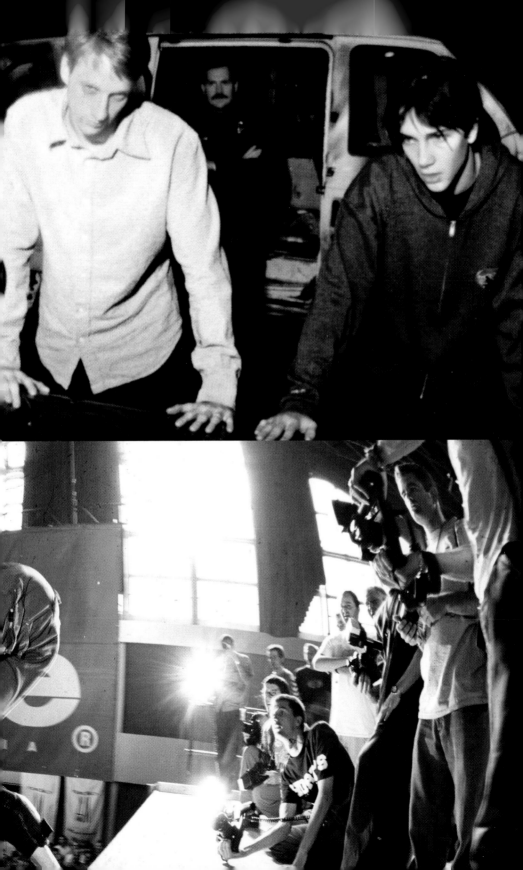

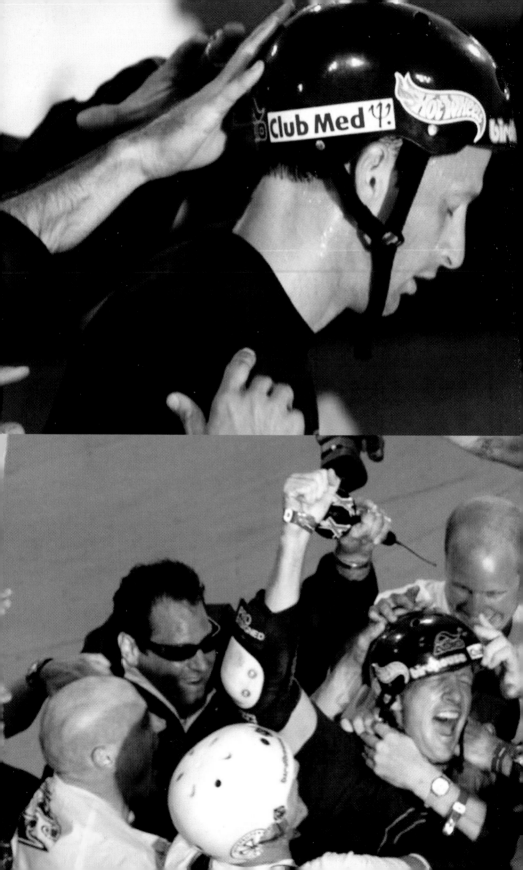

I BARELY NOTICED THAT ANYONE WAS AROUND ME
WHEN I TRIED TO LAND THE 900.

FINALLY! I LANDED IT.

OGRAPH SESSIONS ARE A LITTLE OVERWHELMING THESE DAYS.

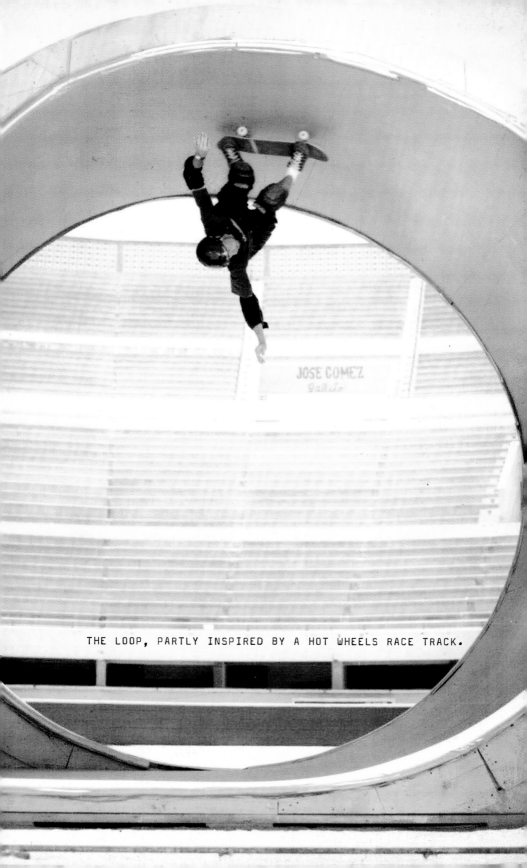

THE LOOP, PARTLY INSPIRED BY A HOT WHEELS RACE TRACK.

MTV SPORTS & MUSIC FESTIVAL, LAS VEGAS, 1999. THIS WAS THE TALLEST RAMP EVER BUILT (18 FEET) AND WAS MADE FOR BIG AIRS.

Stevie had a girlfriend, and she brought her cousin along for company. I started hanging out with the cousin while we were in Los Angeles. (Being on a billboard you could see for miles around probably made me a little more appealing.) We'd skate, drink beer, and hang out with girls—the rock star life of Sunset Avenue.

We were living like rock stars, and we were whining like them too. We were like a pack of babies sometimes. We'd get bored and start complaining to Stacy. We'd have to skate when we didn't want to and we'd moan. We'd have to sit on a set for forty-five minutes waiting for a cue on the walkie-talkie and we'd bitch. We'd complain because we weren't getting paid (although because of the video, our board sales would increase). Finally one day, Stacy just left. We were getting ready to skate a ramp in Bakersfield, and when we turned around we saw him driving away. He never said anything to us afterwards, but I felt like a prima donna and the whining stopped.

The Search for Animal Chin starts like *The Bones Brigade Video Show*: the same reporter appears on *Weekend Today*, and Stacy eats Chinese food and watches the show. "Hi, I'm Bob Burbanks and welcome to *Weekend Today*," the reporter says. "We're going to find out on today's show why those ten-minute oil changes may in fact be giving your wallet the lube job, and we're going to take an exciting look at the fad of skateboarding. When I was a kid, the skateboarding industry was a nickel-and-dime affair, but nowadays it's a multimillion-dollar proposition. With me is Alan Winters, the largest mass merchandiser of skateboard equipment in the world." A cheesy man in his late forties wearing a suit and sunglasses sits next to Bob. "Alan, I don't want to open a can of worms here, but I think the kids want to know: is this skateboarding thing just a fad, or what is going on with skateboarding these days?"

"About three hundred million a year," Alan replies.

"Skaters?"

Alan lifts his sunglasses and shoots Bob a dirty look. "Dollars, homeboy."

They continue their discussion, mentioning that Alan's product is manufactured in Taiwan.

This opening sequence was Stacy's commentary on Taiwanese

manufacturers producing cheap skateboards. The big fear in the '80s was that they'd flood the market with shoddy product, take the money, and offer nothing in return. They didn't sponsor skaters or involve themselves in the industry and would only dilute the companies that were providing the structure of skateboarding.

Alan continues his conversation by poking fun at Powell's board graphics controversy (overzealous religious people interpreted Powell's skull-and-dragon imagery as the Bones Brigade's way of attempting to convert their children into devil worshipers). He explains his job: "I'm in charge of marketing research; I take market research surveys to create what the creative creation department uses to create a product." Alan holds up a board with a hilariously bad graphic of a long-nosed monster screaming and a pistol in the foreground. Bob asks him what the youth of today really wants. "Well, you know, it's . . . it's this gore type of blood and bullets, death and being crushed and brains coming out the ear, and that skull with a dagger through and the snot—you know what I'm saying. The death-gore-dismemberment type of thing; after all, that's what skateboarding's all about."

HAWK

Cut to Stacy getting angry and asking, "Ever done a taildrop, guys?" before throwing his television out the window. He sits back down, relaxed now, and opens a fortune cookie. He unravels the paper: "Have you seen him?"

That message sent, the video begins the saga with a scrolling history of the elusive Chin. "In the beginning, a man named Won Ton 'Animal' Chin bolted skates onto a two-by-four and became the first skater. He had fun. Others followed and a transportation revolution was born. But one day, dark forces began to invade the skateworld. Animal Chin was forced to go underground. Hard-core skaters mourned his absence, and true believers sought out the missing master. Among these seekers were a group known as the Bones Brigade."

The Brigade travel to Hawaii; San Francisco (where we skate a wall ramp and everybody lands nicely arcing wallrides and I fall on my butt); a backyard ramp in Bakersfield, California; the Pink Motel Pool, where we purchase a 1959 Cadillac and saw the roof off; and then Vegas, to see Johnny Rad play a club (actually the garage where the *Future Primitive* premiere was held). Johnny finishes his lounge show and gives us directions to find the Chin ramp, "between two junkyards." We skate around for a few days and finally find the ramp. Lance, Mike, Stevie, and I skate it and then roast wieners and marshmallows in the desert into the night. We talk about our search, and Johnny voice-overs the true meaning of "Chin": "They wondered if they'd ever find him—or if it mattered. After all, they'd skated some unreal spots and met a lot of great people—that's the pure fun of skating, and as long as skaters keep looking for Chin they've already found him."

"Chin" was Stacy's way of warning skaters (and the industry) that times were a-changing. Skating seemed to be heading in a direction that emphasized being sponsored, being better than others, being pro, and making money and being famous over having fun.

ROAD RULES

I skated a few contests between the tour and *Chin*. I returned to Virginia Beach and starred in my own soap opera when I ran into the girl who had turned me from a boy into a man. I didn't think she was interested in me anymore (we hadn't communicated since that encounter), so I hung out with her friend. I ended up messing around with her in a cornfield. When her friend found out, she went wild and yelled at me throughout the weekend. I fell during my run and skated into second place. Virginia Beach wasn't the Eden I'd experienced the previous year.

Vancouver, Canada, on the other hand, was fun. The contest took place on the Expo '86 fairgrounds. The place was packed tight with attractive Canadian girls, and you only had to be nineteen years old to drink in Vancouver. But I was only eighteen, which meant I got to watch all the other skaters drink. Occasionally, I wouldn't get carded at a restaurant and could sneak in a few beers. It was a fun contest with a huge crowd, and I skated into first place.

A funny thing happened at Vancouver, because Michael Jordan wasn't, well, Michael Jordan yet, and most Canadians are hockey crazy, so I earned the title the "Wayne Gretzky of skateboarding." *Sports Illustrated* did a story on me called "Chairman of the Board," and it was the first major mainstream coverage I received. Stevie told the reporter, "Tony is the best skater around. He's consistent, never falls, and does moves that no one else can do." I was stoked, because Stevie had always been, and continues to be, one of my heroes in skating.

The Expo contest took place smack in the middle of *Chin* filming, so immediately after the contest the Bones Brigade returned to the shoot.

Sandy moved into my house after the *Chin* shoot, but the situation was awkward. I was an idiot and wanted more freedom (read: I wanted to meet girls on the road). I spent more than half the year on the road, and trying to maintain a steady relationship at home proved too hard. It was entirely my fault; I had asked Sandy to move

124

HAWK

in because I'd thought it would be cool to have a companion around all the time, and then I was too immature to deal with the relationship. I didn't want the responsibility of including someone so closely in my life and have her involved on all different levels. After a few months, Sandy moved out.

Toward the end of the year I skated a contest in Tempe, Arizona, and won. After that I sucked at the Holiday Havoc contest in Anaheim, California; it was the worst skating I'd done in years. At least I got to see the Red Hot Chili Peppers play a concert on the ramp that weekend. It wasn't exactly the best way to end the year, but I'd done well enough to win another NSA Champion of the Year Award.

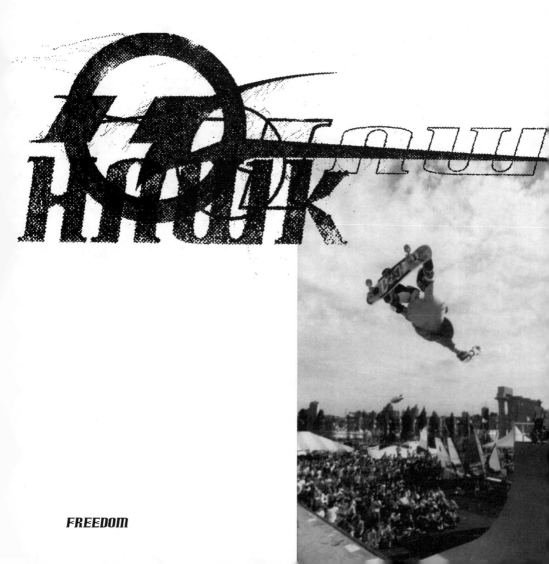

FREEDOM

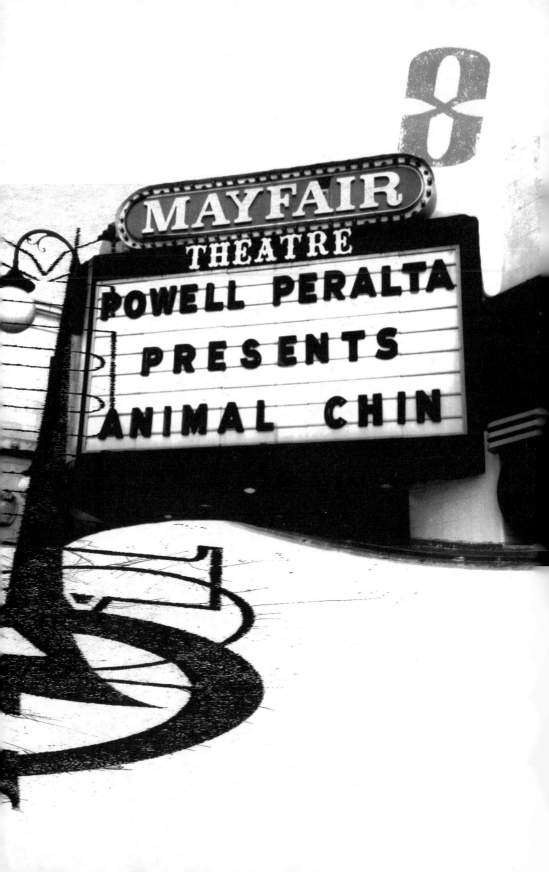

chapter

BIRDHOUSE

TONY HAWK

8

ROCK STAR BURNOUT

SKATING FLARED UP like an angry Japanese monster in 1987. *Chin* premiered in May at a theater in Santa Monica. I was doing a demo overseas, but I heard people really liked it.

Powell was the most popular skateboard company in the world, and my signature board was among the bestsellers. I started cashing royalty checks that averaged $15,000 a month. That was just from Powell. Combined with other sponsors' salaries (Stubbies clothing, Tracker trucks) and contest winnings, my earnings usually increased

dramatically. But the ridiculous sums of money I was being paid didn't do anything to help my skating-style self-esteem. Skaters had stopped bad-mouthing my dad and claiming that the contests were rigged, but people still talked about my robotic style. No one ever said anything to my face, but I'd hear or read about it later. Stacy pointed out a little subconscious trick I did before a contest: I got angry. I'd get mad at the judges, thinking they didn't like my skating, or at a kink in the ramp, or at something that was wrong with my board—anything to get myself worked up. It was mostly internal; I didn't walk around with a frown muttering to myself, but I'd stoke the internal fires every time.

I had other, more serious problems, it would turn out, besides

other people talking shit and figuring out ways to make myself mad: I began to hate skating in contests. I went past mad and headed directly into depressed. I don't mean the tension or precontest jitters stressed me out too much; the pressure of winning became seriously unbearable.

I'm not sure if I created my problems, or if other skaters influenced them. I had a hard time feeling like "one of the guys" with my fellow pro skaters. I might have felt a little off-kilter because I won a lot of contests yet still skated in my own unique way. I had my own pack of close friends, like Kevin and Lester, but on the whole during contests I felt like I didn't fit in.

I started getting wary of contests and even began dreading them.

HAWK

The capper came when a pro walked up to me on the deck of a ramp and told me, "I don't even think about winning, Tony. I just want to get second." He meant it as a compliment, but it gutted me. I talked to Stacy about it and he understood what I was going through. In a lot of people's eyes, if I didn't win an event, then I simply lost. I just wanted to do my best and enjoy the skating, but the incessant pressures made me want to quit competing.

My soul-searching couldn't have come at a worse time. Contests were drawing up to twenty thousand people, and money was being thrown freely at the top skaters. I skated in a contest in Georgia and won, but it felt like I was just going through the motions. I skated a contest in Toronto, Canada, and grabbed a first-place trophy. I won

another contest in July in St. Louis, Missouri (and a huge $7,500 in prize money, the most for any contest up to that point), but they all felt a little blank to me. I was getting seriously depressed about competing, and all this was from a skater featured in the *Chin* video, which emphasized the "fun" of skateboarding.

After the St. Louis contest, a demo in São Paulo, Brazil, almost did me in, both physically and emotionally. Cindy and I had gotten closer and had begun dating when we both became single. She came along for the trip. I was supposed to do a week's worth of demos, but on the second day I ate a gut-destroying plate of spaghetti bolognese at the hotel's restaurant. A few hours later, the evil food wanted out. Apparently the bolognese wasn't choosy about what exit was

available, because it used them all. I sat on the toilet while shakily holding a trash can in front of my face as my stomach contents blew out my nose and mouth with equally impressive force. Nothing is worse than having food poisoning away from home.

Every twenty minutes I'd repeat the process. The following day and night, I provided more of the same entertainment for Cindy. For three days she took care of me in a room that stank like a sewer. It wasn't quite the romantic Brazilian vacation I had envisioned. There was no way I could skate the demo; I couldn't even walk more than twenty feet without the floor spinning. But the promoter wouldn't have any of my problems and got mad at me, demanding I not screw up his production. "These skaters are here to see you!" he bellowed. Was this guy an idiot? Couldn't he *smell* how sick I was as he stood in my hotel room? He demanded I travel to the demo site and announce to the crowd I couldn't skate, because he wasn't about to do it. The place was packed, and the crowd of four thousand turned into an angry mob. They started chanting "Son of a bitch!" at me in Portuguese while I attempted to explain my situation. Ah, the perks of a professional skateboarder.

The next day I felt worse. The idiot promoter took me to a "doctor" who worked out of his apartment. He gave me a shot, and I passed out right there. The following day, which happened to be the day of the press conference, I awoke with a form of lockjaw. At times, my jawbone would clench shut involuntarily and I couldn't pry my teeth apart. I went to the press conference and sat at a table in front of a room full of reporters. Then my mouth, entirely on its own and against my will, began to curl into a sinister grin. I had a Joker smile, like Jack Nicholson in the *Batman* movie. No matter what I tried, I couldn't stop the rise of my lips. I fought a losing battle with the corners of my mouth.

The smile eventually receded, and I skated later that day. Nobody was more surprised than me. I don't know if it was food poisoning after all, because it was too gnarly. It might have been some form of cholera. Who knows? Unfortunately, I have not yet had the opportunity to return to Brazil since then, which is disappointing because their skate scene is now huge.

HAWK

DUEL IN THE DESERT

No contest burned me out more than Duel in the Desert in Tempe, Arizona. In the finals my old friend from the amateur days, Chris Miller, and I skated against each other. Chris is an amazing skater, and one of the most stylish skaters to ever step on a board.

I knew I'd have to skate my hardest to beat him. Chris burned the ramp up with his run. He was amped, and it showed. It was one of the best contest runs I've ever seen. Everybody freaked out. Almost all the pro skaters started chanting "Miller! Miller! Miller!" and jumping around beside the ramp cheering and clapping. I stood on the ramp by myself looking at everybody, and realized this was the last place I wanted to be. It was hard not to take it personally. Chris killed the ramp and everybody knew it. Most of the skaters were my friends and were stoked on Chris's run, but they seemed even more stoked on the fact that I might not be able to beat him.

A few years earlier I'd had a similar incident during a Del Mar contest. During my run, a pack of San Francisco skaters jeered at me nonstop. They wanted Christian Hosoi to win. If I fell or sketched out, they screamed fake laughs and called me Bony Cock, instead of Tony Hawk, for forty-five minutes.

At Duel, I fell during my run and Chris won. Even if I'd stayed on, Chris probably would have won. I was happy for him, stoked to see anybody do a run like the one he'd skated. I congratulated him. To me it was great.

Today I ride for Chris Miller's shoe company, Adio Shoes. Our wives hang out together and our kids play in the same soccer league. I recently asked Chris about this event, because I was curious to find out how he perceived it. He laughed at me and said, "You never gave me any attitude, but you seemed indifferent. Whether you won or lost, you were indifferent. I've seen you win and you look like you don't care. When I won I had this natural high—all my adrenaline was flowing."

RETIREMENT

It's only natural to want a team or person who wins a lot to lose. I saw it with the Chicago Bulls when they were on top. I spoke with Rodney about my problem. He was the only other skater who had it even worse than I did: he'd lost only one freestyle contest in his professional career before it died.

"All the people get so psyched on someone coming through," he said. "You understand that they're not rooting for you to go down, they're rooting for the other guy to go up—they act like you're about to be dethroned."

Since 1984, people have told me that I "lost" a contest if I didn't come in first. Some of the magazines and skaters, and even the head NSA judge, Bryan Ridgeway, thought I was being judged against myself rather than other skaters. If I did a trick no one else did but had done it in the past three contests, it didn't count as much and wasn't as impressive as the first time. If another skater did the same trick I did, he scored higher. Bryan told me that even though he instructed his judges to erase all their expectations of skaters, he felt

if I did a trick like a 720 in competition, it counted the same as somebody else's 540. I grew sick of skating in contests and having people only pay attention to how I placed. It got to be so mundane—not for me necessarily, but for everyone else involved. I'd had enough.

I did a lot of soul searching before I spoke with my brother about my depression. We planned a solution. I was going to retire from competitive skateboarding at age nineteen. I would write for skateboard magazines and continue to skate, just not in contests. I wasn't ever disheartened with skating, just the way people juxtaposed contests and me. I called Stacy and asked if we could talk.

Steve and I drove to his house. It was a huge deal for me and I didn't speak the whole ride up. When we arrived I could barely talk to Stacy; I exhaled a lot, spoke in a small voice, and stuttered. Yes, it sounds like a scene from a cheesy soap opera, but up to that point it was the most important decision of my life. Skating was my whole life. I couldn't even look at Stacy. (Later he told me I looked like I'd just returned from a concentration camp, extremely traumatized and in a daze.) He'd had no idea I was going through any sort of struggle; no one did. I'd just brood about it privately.

Stacy was behind me all the way. He said he completely understood and had, in fact, retired at around the same age. Considering the loss my quitting competition would mean for Powell, he was incredibly supportive. I had the best-selling board on the company and was covered in almost every magazine each month. If I bowed out, Powell could stand to lose a considerable amount of exposure and money. But Stacy knew I needed competition. He told me years later, "You have to have something driving you all the time—that's one of the first things I noticed about you as a kid."

Stacy did offer me one piece of advice if I ever decided to enter a contest again: "Go to a contest, barely practice—don't let anybody see your run so they won't know what to expect, and then don't hold back at all when your run comes up." I think he knew that if I decided to skate in contests again, I needed something to make them interesting. During the drive home, I was more relaxed than I'd been in years.

Stacy wrote me the following letter a week after our talk:

Tony, congratulations on a tremendous year! I'm stoked you and Steve came up last week. I do think it's healthy what you're feeling right now. Taking a break, reflecting and observing and not taking on anymore duties should help to cool you off as well as re-stimulate you. You've been in a pressure cooker too long.

There is a reason no one has matched your contest record and I think you are beginning to understand why. It takes a person with much inner strength to accomplish what you have. But at the same time, accomplishing this much can be overwhelming and demanding. Sustaining the intensity which is required can wear you out.

Tony, I have a great deal of belief in you and I will stand by whatever decision you make. From my own experience I see what you are going through as a natural stage of your career, not an easy one at all, but a necessary one. It's time to take stock and reevaluate. The important thing though is to allow yourself this time, be patient and know that everything will get sorted out and that you will come out of this healthier and ready to tackle the next stage.

Tony, you are a great skater and have so much to be proud of. Enjoy the hell out of yourself. Keep in touch. Stacy.

I accepted another NSA champion award and took three months off. I skated sometimes and played on my computer, a state-of-the-art (back then; now it looks like a Flintstones prop) Amiga 1000 that I loved. I bought a typing tutorial and learned to type—the exciting life of a pro skater; I hung out with Kevin, Chris Black, Ted, and my fellow computer geek and pro freestyler Greg Smith.

Chris had a talent that entertained everybody for months. He could "suck-fart" (an incredible physical feat in which a person inhales air *into* his butt). Once he opened a can of Zorro's cat food, bent down low over it, and "inhaled." Then he walked into another room and exhaled. A cat food fart rivals all other stenches.

134

HAWK

Another event that helped me sort out my life occurred when I asked Cindy to come down from Fresno and move in. It was the first time I'd even thought about entering into a serious relationship. Cindy and I always got along well, and it was enlightening to finally have such a high level of closeness and comfort with someone. She moved down in March while I was in the middle of looking for a new house.

I'd been skating the Fallbrook ramp a few times a week, and during the forty-minute drive a friend pointed out a house that her mom, a real estate agent, was selling. It had four acres, with no close neighbors. I could build a ramp—wait, I could build multiple ramps in my backyard. I instantly knew I wanted it, and began the seemingly eternal escrow process immediately.

GLEAMING THE CUBE

Stacy worked in Hollywood occasionally, and a film company hired him to be the second-unit director (he shot all the skating footage) for *Gleaming the Cube*. The movie revolves around a skater who has a foster brother who gets killed when he stumbles into a weapons smuggling operation at work. The cool dude—naturally, a skateboarder—recruits his posse of skate bros and tracks down the evil murderers. And skates some stuff along the way. The best part of the movie is that the hero rides a skateboard constructed out of a manhole cover. That would be fun to ollie with. Stacy helped to cast the Brigade as the skate buddies. Mike McGill and Rodney Mullen doubled for Christian Slater, the star of the movie. I actually acted and played a character named Buddy, a Pizza Hut delivery boy, who pontificates about burning down a house to make it possible to skate the pool in the backyard.

How they came up with the name of the movie has boggled the minds of skaters for years. What the hell does it mean? Nobody's heard of it. In an old *Transworld* interview, Garry Davis, the editor, asked somebody, jokingly, "Have you ever gleamed the cube?" Apparently the writer's, or the director's, or the producer's son was

a skater who saw the interview and thought it a perfect esoteric title.

But bad titles aside, *Gleaming the Cube* was fun to work on. I rented my sister Pat's father-in-law's guesthouse in Culver City during the three months we were shooting. One of my first jobs was to teach Christian Slater to skate. I met him at a high school, and we rolled around the parking lot for awhile. He actually picked the basics up quickly, and all he had to do was roll in front of the camera a few times. He seemed like a nice guy. Lance had to teach him once too, but all he remembers is Christian not wanting to skate and trying to convince Lance they should go eat.

Once we started filming we enjoyed the perks, mainly the craft services table. Craft services are the magnificent thing about being in movies. The table is covered with junk food, soda, and little snack things that you can eat all day long. And we got paid to skate a good backyard pool and hang around each other.

Like any movie set, though, it gets boring; almost every day started at 6:00 A.M. and didn't end until late at night. But a few things happened that livened things up. Max, an actor in the movie who was also a skater, and the rest of us all went out one night skating. He jumped off a guy's car onto his skateboard during the session. A stupid move, but it seemed harmless enough, and the car was unscathed. Somehow, though, the owner of the car found out who Max was and where he was filming and showed up on the set. We didn't know who the guy was, and neither did Max. In a few seconds he had Max on the ground and was punching him. After a few shots he stood up and left. Max was bummed because we didn't do anything to help, but the fight was so quick we didn't know what was happening until it was over.

Sometimes skating events all mush into one big collage for me. I honestly can't remember the movie's premiere except for one episode involving a disgusting excretion. I was in Hollywood signing autographs before the movie started, surrounded by a horde of kids. Suddenly an awful stench enveloped the area. I'm talking really bad here, up there with the cat food farts.

"Oh, my God! That smell!" one kid exclaimed as he cupped his nose and shook his head violently to rid it of the stench.

HAWK

"What is that?!" another one moaned as he turned and quick-walked away before getting an autograph.

"I'm going to be sick," a girl said as she looked at me. "I'm not kidding. Somebody here has intestinal problems. It's disgusting."

I, naturally, pretended to be extremely offended.

Cindy was so traumatized by the event that she brought the subject up on the ride home. "Jesus, Tony, did you smell that . . . that thing while you were signing autographs?" It was a "thing" now; it had taken physical form.

I started laughing, and she looked at me accusingly. "That was you?" she shook her head laughing. "I should have known."

POLICE ACADEMY 4

Toward the end of 1988, Stacy got another directing gig; this time as second unit director on *Police Academy 4* in Toronto. It would turn out to be the only job I was ever fired from. I was supposed to be a stunt double for David Spade and apparently nobody bothered to compare our heights, since I am almost a head taller than David. But for some reason, they didn't get a replacement for me for a few weeks. Eventually they hired Chris Miller, who was the perfect height. That's him and Lance launching over the cop car in the movie.

We got to hang out with Bobcat Goldthwait and David Spade. David bought a skateboard and skated around with us. We still talk occasionally. But the other star of the movie, Bubba Smith, didn't seem to like us too much and spent most of his time in the trailer.

The Bones Brigade did get some good street skating sequences in, along with some great Hollywood effects (they put flint in our trucks so that there would be a shower of sparks when we grinded). We received some serious recognition at the end of the movie. We all got to skate down a hill in slow motion past the camera. You can see us as our names fill the screen. I made a little over $5,000 before getting fired.

FALLBROOK

Stacy was right: I had to compete. Just giving myself the option to quit contests and taking a look at them from the other side of the fence gave me perspective. At the beginning of 1988, Cindy and I moved into the Fallbrook house. The main reason I bought the property was to build ramps in my yard. I explained to my dad what I wanted, and we spent a month designing the different ramps. Near my house I wanted a seven-foot-high mini-ramp with a spine. Atop the hill that crested my property, I wanted a forty-foot-wide, twelve-and-a-half-foot-high spine ramp that connected with a seven-foot-deep bowl.

My dad loved building things. The chance to spend a few months in the Fallbrook heat swinging hammer and spraying sawdust seemed to excite him rather than fill him with dread (I had the latter feeling). He was one of those guys you always see at Home Depot wearing a baseball cap, a toothpick hanging out of his mouth, a worn plaid shirt with small tears in the elbows, and work pants. He was a Home Depot local; the cashiers knew him by name. He built the corners for the bowl in his garage, and I think he may have been the first person to figure out how to correctly build corners on ramps.

Ever since I can remember, my dad was busy building some weird invention for his beat-up old boat or devising a new way to close in a patio. He would have made a great contractor, except I think he had a tough time working for people he couldn't boss around. He always seemed to enjoy jobs that gave him a certain amount of freedom and lack of supervision.

I hired a few ramp-building skaters I knew from Toronto and we went to work. Massive trucks brought hundreds of two-by-fours, and there were sheets of plywood stacked ten feet high. We used at least twenty boxes of nails, and that was just for the ramp at the top of the hill. I still traveled all the time, so I'd be gone for a week, return, build for four or five days, and then go somewhere else.

According to my dad, the skaters who were helping us were more motivated when I was working with them. I'd get an earful of grumblings every time I returned. But my dad would have done that

regardless. The craziest part about the whole ramp-building experience was how hard my dad worked. We couldn't keep up with him. Here was a sixty-seven-year-old, overweight, double-heart-attack victim and diabetic who was doing laps around us. We'd work for five hours straight in temperatures over 100 degrees, and he'd bitch at us when we sat down to drink water. His complaints were never legit; they were more of a buddy-buddy kind of communication. If he didn't complain constantly I would have started to worry.

By the time the last nail was pounded, the ramp weighed in at $30,000. A little more than I had planned on, but it was exactly what I wanted. Stacy kicked in $10,000 and told me not to tell any-

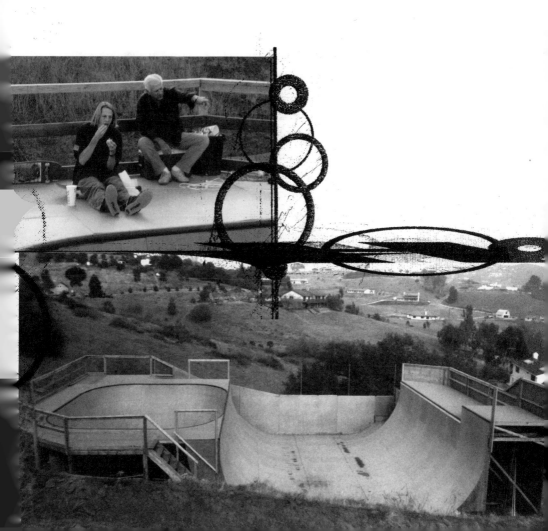

body (he didn't want to show any favoritism in the Bones Brigade). He only gave me the money because he intended to use the ramp in a future video, which we did when we filmed *Ban This*. Near my house we built another spine ramp, a seven-footer.

While a virtual skatepark in my backyard was a dream come true, I quickly began to question my rationale in moving to Fallbrook. At the time, Fallbrook was infamous for being the home of Tom Metzger, the grand wizard or head pu-bah of the Ku Klux Klan. Not something or somebody I want to be associated with. I'd tell people where I lived and they'd say, "Oh, isn't that where that KKK guy lives?" The town wasn't full of racists, but Metzger had given it a bad reputation.

The actual city of Fallbrook was a ten-minute drive from my house. It had only one Italian restaurant and a decent deli—that was it for food, and there was no movie theater, no club, not even a busted-down karaoke bar. There was one gas station nearby, and it took ten minutes to get there. I was in purgatory. The saving graces were the ramps and having Cindy and Joe Johnson, the pro skater, live with me. Almost every day a train of skaters would migrate to my ramp, and we had some seriously fun sessions. Sometimes it reminded me of a private Del Mar.

I was basically living in the desert (roadrunners, tumbleweeds, and coyotes regularly ran across my front yard), but the sole advantage of having no neighbors wasn't even available to me. I lived acres away from my nearest neighbor, but he immediately complained about the ramp. I think he spent his retirement finding things to complain about, and we were a perfect target. The guy started sniffing around while we were building the ramp, and since I wanted to play the nice neighbor, I explained what I did for a living and what the ramp was for. A week after the ramp was completed, Ogre (our nickname for him) came knocking on my door.

"This is going to have to stop," he explained in a patronizing tone. "My wife is an artist and she works at home, and your ramp has been driving her crazy. This is how we make *half* our income, and it's beginning to affect her work. If it keeps going like this you'll have to stop riding your ramp altogether."

HAWK

He proceeded to pull a list out of his back pocket. "Here is a list of rules that I've come up with and if you obey them, we shouldn't have any problems:

> No more than six people skating the ramp at once.
> No teaching on the ramp (for income).
> No renting out the ramp.
> Only skate from 11:00 a.m. until 3:00 P.M."

I was barely twenty years old, and the only reason Ogre thought he could treat me this way was because I was still a "kid" in his eyes. Being extremely nonconfrontational, I just shrugged, mumbled something, and said goodbye. I didn't plan to follow any of his rules; I just didn't want to have to look at him anymore. I'd installed acoustic paneling and used an extra layer of plywood to muffle the noise, and the ramp was quiet.

A week later my two nephews came to visit, and we skated the ramp. Ogre must have had a telescope locked onto it, because he came walking down the hill from his property to mine. It was a good five-minute walk, and I could see him approach with a determined strut and stand beside the ramp.

"I thought we had an agreement that you can't teach skateboarding on this ramp," he said, as though he were my parent. I could never figure out why he had a problem with my "teaching." He droned on about his talented artist wife.

Luckily my dad was there at the time. As nonconfrontational as I am, he was the polar opposite. He blasted the guy with, "Listen, I don't care what you think or what your wife does." Ogre wasn't used to dealing with somebody who talked back, and he retreated a few steps. My dad continued, "My son is an artist, and this is how he makes *all* of his living—not half. We're not bothering anybody here, which is one of the reasons he bought property here. You live acres away and you're going to tell me this is driving you nuts? The road [our houses were actually poised next to a two-lane highway] is twice as loud as any noise from these ramps."

Ogre shut up after that and walked back up the hill. But he was far from finished. He never came by the house again, but he tried to get my other next-door neighbor to sign a petition against my ramps.

ROCK STAR BURNOUT

141

Luckily, my other neighbor lived a few acres away as well and told Ogre the noise didn't bother him. I never heard from Ogre again, but I did hear that he and his artist wife split up shortly afterward.

ON THE ROAD AGAIN

I skated a contest in Irvine, California, and placed second, but my attitude was different, more relaxed now. I skated purely for myself and I had nothing to prove. I returned to Toronto and won a vert contest there. I spent the entire summer on the road. Five weeks were spent on the Powell Summer Tour, but this time we did it in style. Powell built a portable mini-ramp that must have cost over $50,000 and paid a rig to follow us on tour and pull it. The ramp unfolded hydraulically and was ready for skating in a matter of minutes. The worst thing about skate shop demos is that you never know what the conditions will be. I've skated in some pretty crappy areas, but with the Powell mini-ramp we could have skated on a grass field and still been able to put on a good show.

Skating was the most popular it had ever been, and Powell was the best-known company at the time. It showed during the demos. The crowds averaged four thousand people a show, and we'd spend at least three hours signing autographs. A few times we made appearances at skate shops located in malls, and they always blew out of control. The cops would have to form a security bubble around us in order to get us out. Parking lots would be filled with skaters; malls were packed like sardine cans with skaters overflowing out the doors. We filled concert halls and turned down demos that didn't have a large enough area to handle the crowds.

A week before I went on tour, Kevin Harris, our baby-sitter, told me about a full-scale riot in Hollywood during the very first demo. Tommy Guerrero, Jessie Martinez, Jim Theibaud, and Kevin drove from Santa Barbara, where Powell was based. On the way their fan belt broke, and it took an hour to fix. Kevin called Val Surf, the store they were demoing at, and explained they'd be an hour or two late. When they were a few blocks from the shop, they knew some-

HAWK

thing was going on. A police helicopter was circling above and the streets were rampant with over five thousand skaters. Traffic almost stopped, and a dozen cop cars filled the surrounding area with red and blue lights. Loudspeakers barked, "Clear the area. Clear the area." Kevin thought he should talk to the shop owner and see what was happening.

Tommy, the most popular skater in the van, was spotted by the mob and they encircled the vehicle. Kevin was wading through the crowd of fans toward Val Surf when someone from behind grabbed him by the neck. It was a cop screaming in his face, "Get the fuck out of here! Now!" The cop escorted Kevin back to the van and cleared an area for the Brigade to exit. By now it was getting hairy. Skaters had begun smashing the cop car's headlights and were trying to tip it over. Kevin, seeing that it was out of control, thought he could calm the crowd down if he could get to a mike and explain the situation and ask everybody to mellow out. He parked a few blocks away but didn't make it more than a block before kids saw the Brigade and swarmed them. Instantly the group was split up. So many people were thrusting paper, decks, and pens and shooting flash photos that Kevin couldn't tell what direction he was going in. It didn't matter, because suddenly he was grabbed from behind and taken to the ground. A cop dragged him across the street and threw him into a cop car.

At the police station, the cop put the team into an interview room. They obviously didn't like skaters and did their best to provoke them.

"Aren't you losers a bit too old for a little kiddy thing like skateboarding?"

"Why would a bunch of kids want to see a bunch of drug addicts like you guys?"

Jessie, not exactly known for his even temper, exploded and was taken away almost instantly. After twenty minutes of this abuse Kevin, who could be the mellowest person I know, couldn't take it anymore. "Just so you know," he said, "this is what we do for a living and everybody in this room probably makes ten times what you're making right now." This didn't seem to placate the officers.

The cops looked up every skater's name and police record; if anything showed up they made the team member explain, in detail, why it was there. After they were through, they escorted the Brigade until they were just outside the Hollywood city limits.

There were no riots during my time on tour, but at least once a week I thought we were on the verge of one. Girls would bribe hotel workers to find out what room we were in and then camped out in our hallways. My XXX tour days were now rated PG-13, since I had Cindy waiting for me at home. At autograph sessions, everyone would have at least a dozen phone numbers slipped into his hands. I didn't get into any trouble, because I was happy with Cindy.

After the five-week grind across the U.S., I spent four weeks in Europe and two weeks in Australia and New Zealand. I lived vicariously through the exploits of my tour mates. Regarding girls, that is; raging any other way remained perfectly acceptable. The long months of traveling seemed even longer now that I was deprived of a key form of release. Lance had married years ago, so we could relate to each other's misery.

One day, while we were stuck in the purgatory of another endless drive through somewhere in Europe, Lance decided to stick his hand down his pants and scratch himself. He later forgot where his fingers had been and when they made their way to his nose, he had a sniff. We had skated all day, sweated like pigs, and jumped into the van for another long drive, so we didn't smell too great. After everybody laughed at Lance's disgusted expression they, naturally, did likewise and compared scents.

Ray hit pay dirt with his aroma. After much speculation from the Bones Brigade Ball Sweat Connoisseurs, it was decided that his "scent" eerily resembled that of a girl's intimate area. On a tour that stretched into months, it was a discovery of immeasurable importance. For the rest of the tour, we badgered Ray with requests of "Ray—give me a hit!" Home was just a whiff away.

HAWK

PLASTIC SHORTS

Later that summer, Lance and I made a trip to Naples, Italy, to skate on a television show that featured a barrage of strange acts. Recalling the experience is like trying to explain an acid trip. The show featured a chainsaw juggler, hacky-sackers, skateboarders, and dancing roller skaters. It was fun because it was so rotten. We stayed for a little over a week and the excitement began as soon as we exited the plane. At the airport, we saw a guy getting his ass kicked by the cops. Naples seems like a gnarly town, or at least the area where we were staying was. Wherever we went we saw policemen with machine guns walking around.

Our hotel locked its doors at 9:00 P.M. We naturally became bored and tried to climb down out of our rooms. We knotted bedsheets, secured them, and hung them out the window. But we were five stories up. We made it down a few stories before we decided we'd rather die another way. We were miserable.

It got worse once we saw the studio where we were filming. The ramp was a joke. The plywood was too thin, and they used a two-by-four for coping.

Everybody involved with the show only spoke Italian, so we couldn't communicate at all. We did our bad sign-language routine and sort of got our points across, but we had a special communication problem with the wardrobe department. When we walked into the dressing room, the male costume designers started pulling our clothes off. They were stripping us, pulling our pants down, and we had to fight to keep our shorts on. They wanted us naked. My pupils expanded when I saw what one of them had in his hands: two pairs of plastic shorts that you could see through. One was blue and one was yellow. Blue offered a little more shading, so Lance snatched them quickly. I got the yellow pair. At the time I had a thing for not wearing underwear, and there was no way I'd sport a plastic baggie looking like I was sporting a shrink-wrapped sausage. I didn't care what they were paying me. I made up some excuse and bolted back to the hotel to put on a pair of swimming trunks, so I wouldn't be doing skate porn.

Lance bailed a 540 and his knee went through the ramp. I slammed and my board missiled into the wall, which happened to be covered with wall-to-wall mirrors. The producers freaked and wouldn't let us skate live; we had to record the skating first. The chainsaw juggler got to do his act live, but not us. We ended up skating for about five minutes in the end. When they finally did the live show, they had the crowd pretend to watch us and gasp in amazement while they ran a tape of us skating earlier. Lance and I sneaked into the audience and cheered for ourselves live on television.

PUBLIC DOMAIN

Stacy wrapped up his next video, *Public Domain,* after the summer. It starts off with him racing through some barren California landscape in a 1940-ish hot rod convertible. He's shifting gears, hair blowing wildly, and totally alone. Dry brown dirt and a few tufts of weeds and telephone poles are all you see. In the middle of the road sits a vintage television. Stacy swerves to avoid hitting it and crashes into a telephone pole with a poster for *Public Domain* stapled to it.

Public Domain is filled with the usual skits involving the Bones Brigade (a cop hands out tickets for skaters doing weak ollies) and wafted with Stacy surrealism (carnival announcers yell hyperbolized accounts of skateboarding). This video introduced Bucky Lasek and Danny Way, and it's hilarious to watch it now and see how small they were. What's even crazier is how, for such young guys, they tore the ramp apart in Bakersfield.

The Bones Brigade had discovered Bucky on tour the year before in Baltimore. We skated a ramp after a demo, and this runt of a kid who looked like the Michelin Man, covered head to toe in the largest pads possible (Pro Design), made the team stop and just watch. You could tell instantly Bucky had the potential to rule vert skating if he wanted to. The funny thing is how different Bucky's style was back then. A "vert mongrel" is how he described himself. He had a sketchy style that was exaggerated by his massive pads.

Today Bucky has one of the cleanest, if not *the* cleanest, styles

HAWK

going, in both skating and in his appearance. You'll never see him resembling that grubby, dirty-looking kid. He's the most anal-retentive person I've ever encountered. When he used to stay at my house, I often found myself staring at him in disbelief. He unpacked his clothes and carefully lined them up on the floor as if he was laying tile, straight lines between his stacks of T-shirts, socks, and underwear. When we eat fast food, he arranges his food on the tray so no food group touches the other. He washes his car a few times a week, and even washes mine sometimes because he can't stand to see it dirty. If you spill drops of water in the sink after he's cleaned it, he thinks you've "made a mess."

My part in the video was okay, and skating was so huge at the time that the video sold in record numbers. Toward the end of the year I placed third in a vert contest in Louisville, Kentucky, and won the second professional mini-ramp contest (the first took place at Kevin Harris's skatepark in Richmond, Canada, which I missed due to a demo). I finished the year by winning the last two vert contests in Seattle and Dayton, Ohio. My 1988 was surreal; I retired and then changed my mind, skated the summer in front of thousands of people, and made over $100,000 by the end of the year.

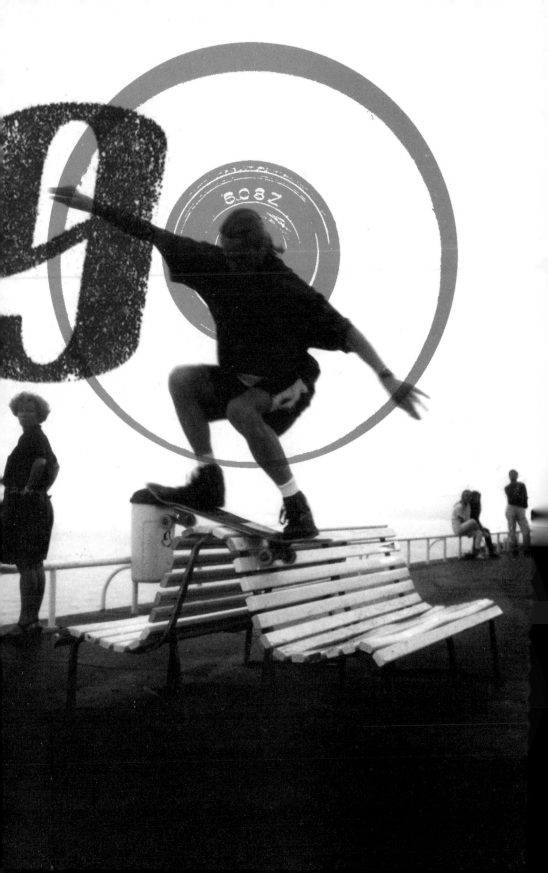

chapter

9

THE COMING DEATH

OVER THE PAST TWO YEARS skating has become increasingly popular. When I first started to skate you could freestyle or skate vert, but in the early '80s a new style of skating emerged and immediately exploded onto the scene: street skating. It started when skaters didn't have a skatepark nearby to skate (or the funds to skate there); instead they combined vert and freestyle tricks on the street.

Back then almost every vert skater I knew street skated, but we just regarded it as goofing around. Mark Gonzalez was the first

street skater I saw who made it a distinct type of skating. Rodney invented the ollie on flatground, but used it only in freestyle. "The Gonz," as Mark became known, brought it to the street and started ollieing all over the place. (He actually ollied an unbelievable gap, which was a set of stairs and a walkway at the Embarcadero in San Francisco. It seemed so impossible to ollie that no one before Mark had ever tried. Skaters named the place "The Gonz Gap" in his honor.)

Mark was a sixteen-year-old kid from the outskirts of Los Angeles who'd show up at contests and skate at a level years ahead of almost everybody else. Natas Kaupas was another who skated at Gonz's level. Gonz did the first handrail in the mid-'80s. According to Gonz, Natas told him he'd ollied onto a handrail and landed it, but that it was into sand. It sounded suspicious. Who skates into sand? He was trying to trick Gonz into trying it, and after a demo one weekend Gonz did his first rail. Pretty much from then on street skating accelerated, and by 1989 it had begun to overtake vert skating in popularity.

I street skated for fun, but I never felt as comfortable or as confident on the street as I was on a ramp. I enjoy it, but I have to work harder at street skating. I remember slamming over and over trying lipslides down a handrail. I felt like I was eleven years old again and learning tricks at Oasis. I'm also afflicted with vertosis, a disease street skaters diagnose quickly and harshly: vert skaters have a "vertish" style (not a lot of pop in their kickflips, a little more heavy-footed on tricks, etc.) when they are street skating. But it also works the other way around: most street skaters look odd and squirrelly trying to pump on a ramp.

Street skating also wrecked my body in ways that vert rarely did. In 1987 I was skating a bench at the local mall when I missed my ollie and rammed my shin into the corner. It was a marble bench and, well, it hurt. My shin had a gaping hole two inches wide and you could see the white of my tibia. The doctor had me sit on the examining table as he stuck his finger into the puncture and felt the base of my shinbone.

"I just want to make sure that you didn't chip your bone," he said as his finger danced around under my skin.

HAWK

I've won a few street contests, but doing a 540 on a quarterpipe is not something you would ever see done on the street. They call them "street contests," but they're really "obstacle contests."

When street skating's popularity finally started overtaking vert in 1989, it changed the way the entire industry worked. The biggest change came at the end of 1988 when Steve Rocco and Rodney started World Industries. Up until then, a few big board companies controlled skateboarding (Vision, Santa Cruz, Powell, Sims, Independent) and they all shared a relatively similar ideology. The big guys worked together to create a healthy skate scene and industry; it was their vision. People like Steve Rocco and Rodney had a different take on skating. When World Industries started nobody thought they'd last longer than a few months, maybe a year. But it slowly became obvious that small companies like World and H-Street, a new company started by Tony Magnusson, had their ears to the ground. They knew what skaters wanted, which was an anti-establishment attitude, and Powell had a corporate image. World and H-Street couldn't keep up with the demand for their product. Kids liked the outlaw, punk image these two companies were creating. They made the big, clean-cut companies look like dinosaurs, too big, lumbering, and slow-moving to adapt, while the little guys ran underneath their feet.

Rodney leaving to help start World Industries was the first visible chink in the big companies' armor—it was unheard of for skaters to leave Powell during the '80s. Everybody knew no skaters had it as good as Powell riders. Why quit for something lesser? But it had become apparent that Powell was getting left in the dust of these smaller, more hard-core companies.

World and H-Street turned skaters pro without making them work their way through the ranks. They'd pick insane skaters who weren't well known and hadn't won a lot of amateur contests. When I started skating, you had to work your way up from the amateur ranks and gain respect from skaters, and it usually took years. These two companies were turning kids pro who were better than most of the street pros out there—who cared if they hadn't won a contest? If they could produce enough breakthrough skating footage for a video part, then they could earn the title of professional. In the early

'90s Frankie Hill was a talented skater who could do some of the biggest gaps (ollieing stairs, ledges, anything a skater can pop over), but he couldn't place well in the contests he skated because he was more of a stunt skater. When Powell turned Frankie pro, I realized they were trying to adapt to the new era of skating. Frankie didn't fit in with the old Powell image. Up until that time, Powell was all about dominating contests. They knew they couldn't do that with Frankie, and for the first time they didn't try.

In a matter of a few months our clean-cut image was as passé as it could get. World riders were anarchists, and the kids loved it. Their ads were smart-assed and poked fun at, almost picked fights in print with, the bigger companies. H-Street was raw and filmed their pros getting kicked out of skate spots, mouthing off at security guards, and slamming so hard that sometimes you had to look away from the TV.

H-Street, a raw team of unknowns who instantly caught the skating world's attention, emphasized the beginning of the end for Powell's undisputed reign of skateboarding. They produced a mediocre video in terms of filming quality. Many of the shots were of dark, splotchy, blurry skaters doing tricks nobody thought possible—skaters loved it. Stacy recognized that Powell had to adapt or it was doomed.

THE NEW BREED

When I started pushing on my little fiberglass board, I never expected anything to come of it; skating merely fulfilled me, and that was enough. Today, it seems as though a lot of skaters pop out of the womb aiming for sponsorship and forgetting about having fun. They act like they're owed something. I often see extremely talented kids skating around, but they look so unhappy. They will land a difficult trick and not even smile. They don't enjoy themselves; when they ollie a massive gap you'd think by the look on their faces they'd just been diagnosed with something terminal. When I started skating everybody who skated was part of a whole; there was a closeness due

152

HAWK

to being outcasts. Being a skater was enough; you didn't have to be good or wear the right skate gear. By 1989 that had changed, and a bit of the "too cool" mentality had crept in. Being a skater wasn't enough anymore; you had to be a cool skater.

A new breed of extremely creative vert skaters had started to appear in the late '80s, and I'm not sure if it was a magazine or the skaters themselves that created the "us vs. them" mentality. "Them" meaning people like me, older skaters, who'd been at the top of skating for the past few years. The Davids vs. the Goliaths.

Danny Way, Alphonso Rawls, and Colin McKay were the kids that killed vert as we knew it. They took it in an entirely new direction with street-oriented tricks. They had a lighter style. Danny and Colin never failed to impress me when I saw them skate. Danny lived in Rainbow, which is next door to Fallbrook, so he'd come over to skate my ramp every once in a while. He was definitely the most impressive vert up-and-comer at the time. He was young (probably fourteen at the time), and just standing next to him on the deck I could see the talent and the tricks fighting to get out. Danny was a little kid and extremely competitive, which most skaters aren't—or if they are, they try to hide it. Even though I was ranked number one in the world, I never thought I was "the best in the world." I'd grown up winning contests and having people bash my style, so I knew a lot of people didn't think of me as the best skater. Because of my rank, the fastest way to get to the top would be to take me out, so the magazines and other people took the preexisting rivalry between us and turned it into a soap opera. I stepped up my skating, or at least tried to. I never hated Danny; I'd been in the identical position when I was his age, so I could understand his eagerness to succeed.

Danny skated for Powell before quitting to ride for H-Street. Another Powell deserter—things were not looking good for The Bones Brigade. Street skating was huge, and these two small companies began winning the war with guerrilla tactics. It was skateboarding evolution and it had to happen, simple as that. I'm surprised it didn't happen sooner.

The one thing that did bum me out was the negativity that began

THE COMING DEATH

infecting skateboarding. Up until then it didn't matter what team you rode for; you were all friends. I hung out with Kevin Staab, who quit Powell and turned pro for Sims; Gonz and Joe Johnson, who both rode for Vision; and Ray Underhill, who rode for Powell. We wore each other's shirts, toured together, and partied together. The new companies, with their "us vs. them" mentality, brought about a separation between skaters. Skating began to resemble high school (which is ironic, because most skaters hated high school and felt like misfits), with little cliques that didn't associate with the other, "lesser" skaters.

Things only got worse for me when I demoed in Japan. For me it's usually a place where nothing can go wrong: if the skating sucks, at least I can go shopping for electronics. But this time I squatted out of a 720 and felt my knee pop. I didn't think much of it until later; while shopping for new toys, I knelt down to look at something and was unable to get up. I crawled into a hallway of the department store and managed to maneuver my knee in a way that unlocked it. I had to use a wheelchair through the airport on my way home the next day. I'd been pretty lucky regarding my knees, because most vert skaters blow a knee out one way or another during their career.

I visited a doctor when I returned home and Barry Zaritsky, the head sports trainer/medical technician at NSA contests, moved into my house to help me rehabilitate. After an MRI, it was determined I'd torn my cartilage and it was getting stuck under my kneecap, causing it to lock in bent position. I would need surgery. I couldn't believe it; this was my first major injury in almost a dozen years of skating. I knew healing after the surgery would take me out for at least three months. Since I'd started skating, I'd never spent that much time off my board. I had temporarily stopped competing before, but I'd always skated regularly. This time, after the surgery I wasn't supposed to skate. I was stressed.

Even with my knee torn up, I could sort of walk, even skate. And if I didn't fall on it too hard, the swelling wasn't that bad. Occasionally my knee would lock. I'd have to stop, walk like I had a peg leg off the ramp, and manipulate my knee until the wandering piece floated out, but it was getting worse.

HAWK

I entered a mini-ramp contest in Hawaii for two reasons: I loved skating mini-ramps at the time and it would be the last NSA contest my mother and father would be involved with. My dad was sixty-six years old and had been experiencing some health problems. He'd decided to lighten his load. I think he was also confident he'd built a strong skateboarding organization that would last for decades (on that, he couldn't have been more wrong). My knee locked once during my practice, and I never quite got it back to its "normal" state. Despite not being able to completely straighten my leg, I placed fourth, and Dad was given an award ceremony.

They cleaned out my knee and it wasn't too bad: a few hours in surgery and back home the same day. Barry instantly restricted me to a ridiculous health food and rehab regime. I love eating. I love eating more than—well, let's not get too crazy here, but eating is one of my top priorities.

Barry's diet was straight out of an impoverished commune. I had to eat granola that wasn't like any substance I've ever tasted; I think he peeled it off a tree. As if eating bark-cereal weren't enough, he made me eat it with orange juice instead of milk. After a few weeks I was biking around my property to build up my quads because, as anyone with a wrecked knee will tell you (any vert skater), the stronger your quads, the tighter your knee.

After four months of eating rabbit food and beating Barry at games of twenty-one on the hoop in my driveway (he'd actually get mad if he lost, which to me made the winning even more enjoyable), I felt my knee was tight enough to skate. It meant a lot to have Barry fix me up, and I've never had any similar problems with my knees. (I'm knocking on wood right now.)

I skated a vert contest in Orange County sponsored by Vans and placed second. A month after that, I collected two wins in Denmark—one in vert and one in street. From there I went on to Germany and won the Titus Cup for vert and placed second in street. I missed most of the Powell tour due to my peg leg, but did get to end up spending almost a month in Europe skating around with the team.

In a two-week period I skated two of the worst ramps ever con-

structed, both in front of crowds in the thousands. One was a dark orange ramp that was four feet tall and four feet wide. Those are the types of ramps that you kill yourself on—an accident waiting to happen. The other was a tilted piece of plywood with a broom handle as coping. No kidding. I can't imagine what people thought when they showed up and saw that, that . . . thing in the demo area. It was as if the guys were trying to make some artistic statement on minimalism and recycling.

In Savannah, Georgia, a week after I returned to the U.S., I placed second in a street contest that had a corner wall/ramp that must have been fifteen feet high. How many times do you notice fifteen-foot-high skateable walls as you're walking down the street? I won another pair of equally un-street contests in Chicago and St. Petersburg. While in St. Petersburg, I also won a vert contest.

Luckily, I'd been a gimp during the four months there were no contests. I might have missed one, but it wasn't enough for me to miss out on being awarded another NSA championship.

BAN THIS

Ban This was the sixth Powell video, and I think most people regard it as the end of Powell's reign. I know I do. It's fitting, because up until filming *The End* for Birdhouse, I was proudest of my skating in that video. We used 35-millimeter film. We filmed the skating for the video at the Fallbrook ramp, and also on the ramp in my backyard. Stacy hired a lighting specialist to light my ramp with different colored lights and we shot throughout the night for three days, but the project almost didn't happen.

My house was near the Palomar Observatory, and the stargazers complained the ramp lights messed up their stargazing. In fact, I'd originally had lights on my ramp, but after a few days of night skating the observatory ordered they be taken down (one of the unforeseen problems of living in the boonies). Stacy concocted a story about our filming an antidrug commercial at my ramp and applied

156

for a special permit. Many highway drivers stopped during those nights, thinking that a UFO had landed on the hillside.

Ban This was the polar opposite of what H-Street and World were producing. There were some funny bits in the video, and everybody had an amazing part. After Kevin Harris's part, the video halts abruptly and we see Stacy in the editing bay. He stops and speaks to the camera.

"You know, I'm asked all the time how do I get these skaters of mine to perform such great maneuvers, such great feats of physical talent? I must say, on my part, that it's an extremely physical task for me to get them to do this."

Cut to Stacy on top of a ramp, sitting in a director's chair with a bell, ordering skaters to do tricks. He rings the bell. "Backside air!" Bucky does a backside air. "Oh! You blew it. That's very weak. Can we get a stunt skater in here?"

Commercials for Rector Reke cologne (playing off the awful B.O. smell of Rector skate pads, which every skater wore) and skate-cart races with surreal bunnies and gladiators peppered the video. Powell's big-budgeted, wholesome image was becoming the geek in a school full of cool kids. We made a skit about skaters being harassed by cops (clean-cut kid skates down a street filled with hookers, crack dealers, and thieves only to be the one chased down by a cop who ignores the illegal activities), while H-Street and World showed the real thing. (World made an ad out of an actual ticket for skateboarding.)

Ban This had amazing skating, but the skits felt a bit flat and redundant. Stacy seemed to be upset with internal struggles and the decision makers at Powell. I could tell he was burning out; he didn't attack skating with the same energy that he always had. We could all read the writing on the wall. For the first time since I began skating for Powell, they seemed to be doubting themselves. They had become followers rather than leaders.

Even with all the changes in skating I had an amazing year, the last one I'd experience on Powell. I finished the year making over $150,000.

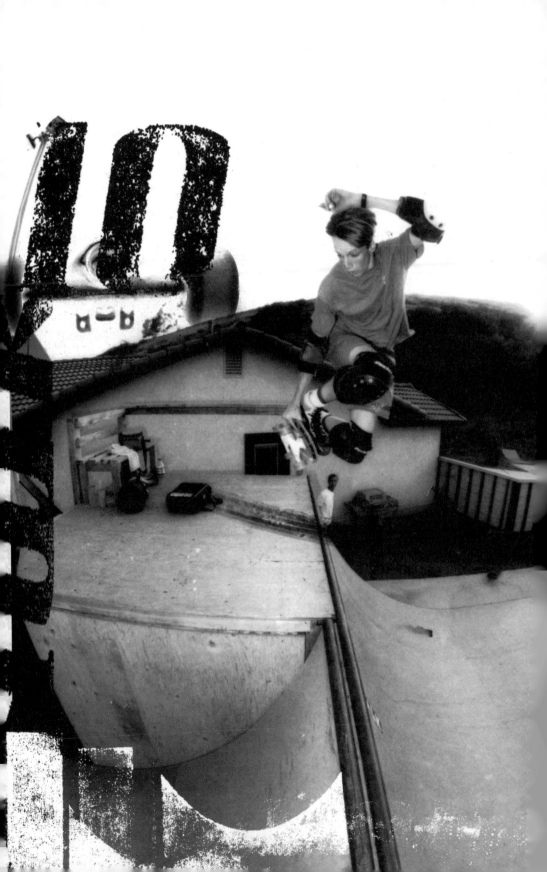

chapter

10

AN UGLY DEATH

BY 1990, EVERYBODY INVOLVED WITH SKATING began looking up to see when the sky was going to fall. For reasons nobody has ever been able to fully explain, skateboarding's popularity goes in cycles of roughly nine years. Since the early '70s it has exploded and then fizzled out at the beginning of every decade. It died shortly after I started skating in the late '70s, then kicked back into gear in the mid-'80s, and then died again in the early '90s. It seems as though we've broken the cycle this time around, because this year skating is more popular than ever.

But in 1990 the industry felt the weight of rapidly declining sales, and suddenly skaters weren't everywhere you looked. Skating wasn't dead—yet—but we were all worried about the future. The sport seemed to have had its day. The outlaw image, the difficulty getting insurance for skateparks, and the lack of mainstream exposure was helping to lead to its demise.

I was worried, because if my income shrank I would find myself in a financial hole. I had two mortgages to pay and hadn't exactly been thrifty with my money. If I wanted to go to Hawaii with my friends and they couldn't afford tickets, I bought them. I ate at restaurants three times a day and purchased electronics like I had a disorder. New television—I have to buy one! New VCR—give me one! New Discman, even though I'd just bought one two months ago—I want it! During the mid-'80s I'd been known to blow almost a month's worth of royalties, which was anywhere from $3,000 to $5,000, at the Sharper Image. I was never too worried, because skating was still popular; it was just going through a "phase." I didn't believe it could completely die off.

THE NEW YEAR

I had a New Year's Eve party to bring in the new decade, and the house was filled with close to 150 skaters and girls. It didn't take long for things to get a little crazy.

Tats, a manager for another skateboarding team, made my party go down in infamy. First, he went into my bedroom and dressed himself in Cindy's lingerie, which was obviously too small to keep everything hidden. He then came out and danced around with everybody in the living room like nothing was wrong. After twenty minutes of this, he strolled into the kitchen and noticed how sexy the uncut ham roast looked. Naturally attracted to this piece of meat, he began to violate it. Nobody could stop laughing. People peed their pants from laughing. Everybody retreated to the living room, and Grant Brittain provided commentary for all of us from the kitchen doorway.

160

"He's humping the roast!" Grant would yell to us.

"He's really getting into it now!"

"He's done, I think, he's dropped the roast. Wait . . . oh my God, he's peeing all over the kitchen."

Tats's date—I should probably mention it was their first date and he hadn't had any alcohol the entire night—seemed to take it in stride.

He often pulled hilarious pranks. Once, during the Hawaiian mini-ramp contest, some skaters sat at a fancy hotel bar that had a window into the pool. Tats excused himself, and minutes later the entire bar was given an underwater strip show, complete with pressed ham on the window.

FULL HOUSE

Sean Mortimer, a Powell skater from Richmond, Canada, moved to Fallbrook that January and, with four people living in it, my house was officially full.

We'd skate all day and rage at night. Every other night was a party, with packs of skaters hanging around after a session skating and drinking. I can't believe Cindy handled all this commotion in the house without freaking out. The only thing she got bummed on was when the place was a mess.

I attempted to solve that problem by hiring a maid to come in once a week. However, I lived in the sticks and the only maid I could get didn't drive. I had to pick her up at 8:00 in the morning and, before I had my two sons, I was not what you'd call an early riser. Since Sean had insomnia and would be up by then, I would wipe the sleep out of my eyes and try to bribe him to pick up Maria, the maid. Sometimes it worked. He would go to pick her up, but he never accepted any money I offered.

Driving to Maria's house and back to mine took twenty-five minutes. It was a pain in the ass, but we had a clean house—at least for the day following Maria's visit.

MARRIED LIFE

One day when Cindy and I were shopping in Los Angeles, we strolled into the diamond district. We'd talked about marriage before, and Cindy had looked at a few rings, but I'd never formally proposed or planned anything. We found a ring that we both liked and drove home from Los Angeles with it, engaged by default. I don't think it was quite the romantic proposal that either of us had imagined.

The wedding was a little . . . different. We had the ceremony in our backyard. For some reason, there was some miscommunication as far as what time the wedding was supposed to start, and almost half of our friends showed up just after the ceremony. They didn't miss much. Neither Cindy nor I is very religious, so we hired a Justice of the Peace to marry us. She showed up late, and once the procedure got started asked, "Andy, do you take this woman—"

"Tony," I stage-whispered. She gave me an empty stare like I was trying to confuse her. "My name is Tony. Tony," I said louder.

"Tony, do you take this woman to be your lawfully wedded wife?"

I said yes, Cindy agreed to take me as a husband, and we were married there beside the pool and the trampoline.

SKATE COMA

Mid-year, the popularity of skating dropped at an alarming rate. My monthly checks were halved every other month. It was scary how terminally ill skating was, and how quickly it started to fall apart. The beginning of the decline was like a snowball being thrown down a mountain; by the middle of the year we could all hear the avalanche rumbling onto us. Whoosh—demos and touring dried up; money evaporated from the most popular skate companies, and they began tightening their belts.

The reverberations were felt all over the skateboard world. Contests dried up and the NSA began to flounder. Whatever anybody thought of my dad, they had to admit he'd worked his ass off

for the organization. He didn't take a regular salary until a year or two before he retired, and even then it was only $4,000 a year—far below the poverty line. My mom, the primary breadwinner of the family, constantly tried to convince him to at least recoup his expenses at contests. Now, after he had left, the association was quickly losing money.

I can't remember why I only entered two contests, but I won them both: a vert contest at the Del Mar Fair, which took place a few miles from the old skatepark, and a street contest in San Francisco.

Touring that year was a joke. I felt like a member of a traveling vaudeville act touring Europe during the plague. Lance, Bucky, and I did a demo in Japan, and fewer than thirty people sat in the audience. Crowds everywhere were equally thin. Skating worldwide had stopped completely almost at the same time. There was no staggering or delay in other countries that would let us at least slowly eke out a living.

It wasn't just Powell that felt the impact; all skate companies felt the pain. But Powell and the other huge companies were hurt worse than the smaller guys like H-Street and World, which didn't own massive buildings or employ hundreds of people. Powell began changing the way they paid their riders. Previously, we would get a salary and royalty checks from any product with our name on it, such as stickers, T-shirts, and boards, but with Powell hurting, our salaries were cut and our royalties restructured. This happened a few different times, and I lost track of what I was getting paid for and how much per item I was getting, though it wasn't much. I can't remember if the NSA had an awards banquet, but I think I won the last Vert Champion of the Year Award.

By the end of the year I had made somewhere around $75,000, the bulk coming from the few positive months at the beginning and companies that had to pay out on contracts. By the end of 1990 I was worried. I knew next year would be much worse.

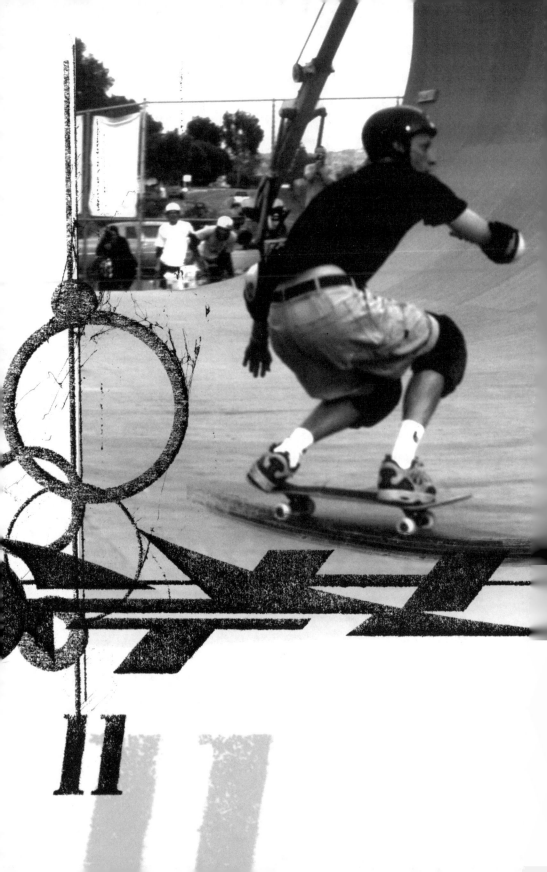

chapter

II

WORLD CHAMPION, BUT WHO CARES?

BY 1991 THE SKATE INDUSTRY was in a panic; they were trying to stick their fingers in the cracks of a crumbling dam. At home Cindy and I tried to budget ourselves, but I was too accustomed to living the good life and buying whatever I wanted without worry.

I have loved Lexuses since the first time I spotted one. So I bought a slightly used LS400 for $30,000, and it was my baby. I had a feeling I'd made a mistake the first time I filled up the tank and saw it cost $30.

I loved purring down the highway in my leather-seated nirvana. I began noticing that people stared at me, a dirty skateboarder who looked like a teenager, and gave me funny looks. I took the looks to mean they thought I either was a spoiled rich kid or was driving my parents' car. The guy we bought the Lexus from wondered if I was a drug dealer, because I paid in cash.

Buying the Lexus was probably the stupidest thing I could have done at the time. I don't regret it, because I loved that car, but I should have been stuffing money in my mattress like a miser.

STALKERS

I skated a contest in Norfolk, Virginia, and the night before I went to the hotel bar with all the skaters. A girl who had been hanging around with them came up to me and asked me to sign something, saying it was in her room. Her room was right next door to mine (which, I later found out, was not a coincidence), so I told her I would sign it on my way to my own room. We went to "our" floor and she invited me into her room. Another girl was on the bed.

"This is my sister, Janice," she said, introducing an attractive woman who appeared to be in her thirties.

"Nice to meet you," I waved at her.

"Hi," she said. "Do you want to watch a porno?"

I just stared at her with a dumb look. I heard the door click shut behind me. What had I just gotten myself into?

"We can get pornos on pay-per-view."

"Didn't you just say you two were sisters?"

"Yeah," she answered as though she didn't understand my implications.

"I just got married last year," I said.

"Well, that's okay—"

Suddenly the door exploded with a boom and an agonizing scream. I jumped and backed away from it. Everybody jumped. What the hell was that at 1:00 A.M.?

"Bllargghh!" the poltergeist screamed. "Blllarrghghg. Baarrg." It took me a few minutes to realize the garbled banshee yell was a

166

HAWK

drunk human. "I know you're in there! You, you, you . . . Hawk, you bastard!"

What the hell? Who was this freak, and what was he trying to break down the door for? "Cooome on, baaaaaaby! It was all a mistake," the voice wailed. I didn't think he was talking to me anymore, and when I looked at the younger sister I could tell she knew this beast. But how did he know I was in the room to begin with?

He started pounding the door like it was a punching bag. Luckily, this was a nice hotel and had strong doors. He punched the door for ten minutes straight, moaning and screaming a garbled commentary. When I figured there was no way he'd be able to break down the door, I took my Game Boy out of my pocket and began playing Tetris. The porno sisters exchanged worried glances; they obviously knew something I didn't. The door abuser screamed at me some more and then screamed at the younger sister for another five minutes before the hallway fell silent. I listened closely at the door for any breathing and got on my knees and peeked underneath, checking for a shadow or a pair of feet.

When I thought the coast was clear, I opened the door quietly and walked to my room. Lance told me the next morning at breakfast that all the skaters were peeking out their doors into the hallway, watching the entire show and laughing the whole time.

After breakfast I went to get my gear from my room. When I stepped into the elevator I saw a huge guy standing there. He had a fresh cast on his right hand. I pushed the button for my floor, and as we waited in the awkward silence that always envelops elevator rides, he cleared his throat.

"Um . . . I'm sorry about last night, dude," he said.

I stared at him. Jesus! This monster of a man was the freak who had tried to snap a solid wood door in half to get to me just eight short hours before. Now he had me trapped in an elevator. I waited for him to start denting my head with his cast, but he seemed embarrassed, almost shy.

"Last night?" I asked, feigning confusion.

"Uhh, I was a little drunk last night, and I heard my ex-girlfriend was going to try and hook up with you," he said.

"Really? Nah, I'm married."

"I was drunk," he repeated, holding up his cast. "I hurt my hand. I just broke up with Aileen, my girlfriend, and I knew she was trying to hook up with you. So I followed her here, and found out where she was staying. She bribed the bell captain into telling her what room you were in so that she could stay next to you."

"That's . . . a really weird story," I said with a shrug.

The elevator chimed, announcing my floor. "Take it easy," I said as I walked out.

I skated the contest and won. A few months later, I skated in a San Jose mini-ramp contest and placed second.

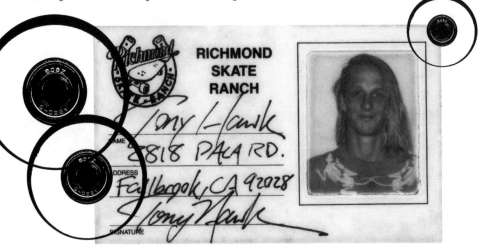

WHERE THERE'S SMOKE . . .

When I die and my life flashes before my eyes, I know one of the most entertaining highlights will be of me and a group of skaters in a hotel room in Santa Barbara in 1991. Powell had built a huge skatepark for its team in their warehouse; they would eventually open it to the public in an attempt to make money.

The skatepark was in Santa Barbara, a four-hour drive from my house, and Powell was holding pro street contests. It rained the entire weekend and Sean, a skater named Charles, Marty (my friend from Oasis days), Lance Conklin (a pro for Powell), and I were

HAWK

bored out of our skulls, because when we weren't skating we were camped out in our hotel room. Charles has the same amazing farting talent my friend Chris had; he was indeed a virtuoso. He entertained us for a few minutes with trumpet solos, machine-gun blasts, and long squeaky wails before we, naturally, went overboard and decided to explore the possibilities of his unique skill.

Lance was the only person in the room who smoked, so we borrowed a cigarette from him. Sean had the video camera and adjusted the lighting, preparing to capture the whole event. Marty was the brave soul who tried to hold the cigarette with shaking hands (from fear or laughter or a combination of both). Charles pulled his pants down a few inches, reclined on the bed, and got in "position." Marty tried to place the cigarette, but he was too shaky and kept dropping it and burning Charles in the worst places. He was yelling in pain as we were laughing. Finally, Charles took control of the situation himself and maneuvered the cigarette; the ember glowed bright red as he took a drag. We waited, breath held in anticipation. "Phweet!" Charles farted and a puff of smoke blew out. For twenty minutes nobody could stop laughing. We were gasping for air, curled up on the ground, clutching our stomachs. We'd calm down for a few seconds until somebody commented on the blast of smoke, Marty's apprehension, or the "phweet" sound, and we'd go off again for another few minutes. Unfortunately, butt smoking wasn't a profession; otherwise I could have borrowed some money from Charles.

I won the Powell contest, but the tiny crowd proved that calling skating a career or a profession was now a stretch. By the middle of the year, Cindy was making more than me as a manicurist. The mortgages on two houses were straining our finances. I had renters in the Carlsbad house, but I still had to pony up $3,000 a month for the mortgage in Fallbrook. I was hardly making that much after taxes. My savings account had a permanent leak.

BIRDHOUSE—A NEW BEGINNING

I won the next two vert contests at Sacramento and Kona, Florida. By then it was obvious that Powell was feeling some serious pain, and I spoke with Stacy about my future. He was frustrated by the direction Powell was headed and hinted he might be leaving the company. Powell tried to fight World Industries on their level. Bad move. World ran aggressive ads that slung mud at people (including me) who represented the older, positive, squeaky-clean image of skating. Powell quickly got its ass kicked—you can't just decide to flip your company's image and expect people to follow. They were eaten alive by World, and I knew it was time for a change. I didn't want to just be a sponsored skater for another company. I wanted to have more control over my future and promote the positive aspects of skating, instead of joining in on the existing companies' pissing contests.

Looking back, I'm stoked skating deep-sixed because it gave me the initiative to start my own company, Birdhouse Projects. I teamed up with another Powell pro, Per Welinder, who had a business degree, and we spent months planning strategies while keeping my plans to leave Powell a secret. I also had to do some financial juggling. I refinanced the Carlsbad house, which gave me a solid $40,000 cash to invest in Birdhouse. We sold the Lexus to Cindy's parents, and I bought a more realistic Honda Civic. If the company didn't succeed, we would have been forced to declare bankruptcy.

I had confidence in our direction and figured I was near the end of my professional career anyway. I planned on dumping my pro model a few months after we started, and devoting my time and energy to running the company with Per. Skaters rarely made it past their mid-twenties as competitive pros; a few like Stevie still ripped, but he was the exception and not the rule. I was going to be twenty-four and thought I had maybe another two years of skating in me. Besides my age, being a vert skater was like being a leper, so even if I was at the top of the game, nobody seemed to care.

We planned to start Birdhouse at the end of '91, and I went to Europe to skate contests in France and Germany. I won both of

them. When I returned, I began talking with riders whom I wanted to get for the Birdhouse team. Jeremy Klein was an insane street skater who skated for World but felt he wasn't getting his due, so he agreed to ride for us. Willy Santos was another amazing street skater who joined the team, and so did Mike Frazier, a Powell vert skater who'd recently had his model discontinued since vert was dead and skaters were only skating street. We picked up Ocean Howell, a former H-Street pro, and Steve Berra, an incredible amateur vert and street skater who rounded out the team.

I won the last vert contest of the year in Houston, Texas, and became the NSA vert champion for the tenth year in a row.

Rumors floated around that I was quitting Powell. Mike Ternasky called me to see if I'd be interested in riding for a new company called Plan B. He had recruited an incredible team, probably the best at that time, and I was honored to have been considered. If I were going to ride for another company, I would have considered Plan B, but I really wanted to have control of my post-skating career. I called George Powell and Stacy to tell them I was out, and they understood. A few weeks later Stacy called and told me he'd just left Powell and was going to work in Hollywood as a director. An era was officially over, and I was nearly broke.

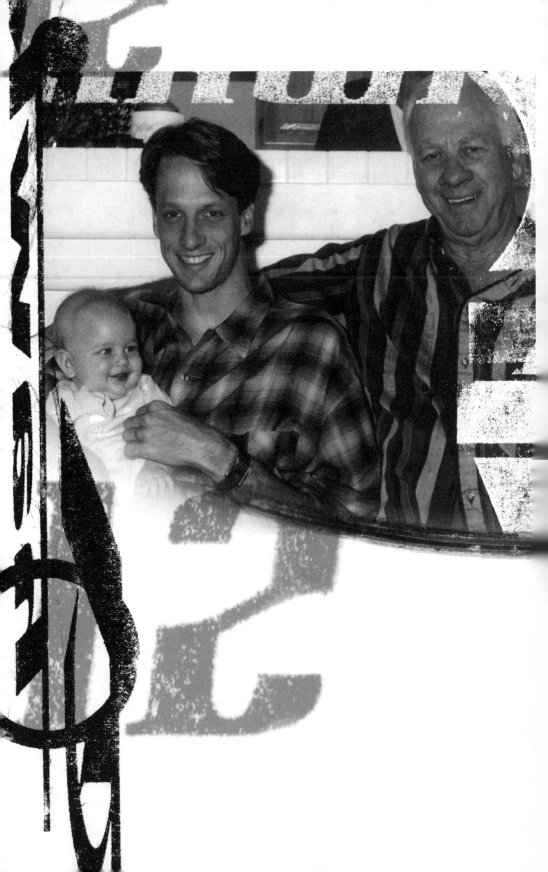

chapter

12

THE LONG WAY HOME

THE FIRST YEAR OF BIRDHOUSE WAS SLOW. Skating had binged for so many years, and now there was nothing left to purge. It's funny to look back on those days. In a way, I loved the dry spell because it stripped skating of all the fringe benefits and left the bare bones. You knew skaters were skating for no reason other than love of the sport.

I had a $30,000 salary from Birdhouse, and most of my other sponsors had either stopped paying me or slashed my salary to a tiny piece of what it had been two years earlier. During skating's heyday,

Airwalk was paying me something like $1,500 a month, but with skating's demise they chopped that amount to a few hundred.

I felt lucky to get clothes from my clothing sponsor, Rusty, and didn't even think about asking for money. I wasn't really bummed about my financial position, because I'd never expected to make any money at all from skateboarding. I never had any textbook plan for my life. I prefer to live day by day and roll with the punches.

Sean had moved back to Vancouver to work as a roofer since he couldn't make a living skating in the States, and Steve Berra moved into our Fallbrook house.

SKATE DAD

By March, Birdhouse was in its third month. I was at a demo in Florida when I received a call from Cindy. We talked every night while I was on the road, but I'd been a lot more anxious lately before each call because Cindy thought she might be pregnant. She called to tell me she'd taken the test and that I was going to be a dad. It was not exactly what you'd call expected, but I was happy just the same. We talked at length and after that phone call, I had a different perspective on life.

It was weird, because hardly any skateboarders had kids and I was only twenty-four. I didn't know how being a father would affect my career. In fact, I didn't know what to expect at all. I was a bit worried about our financial situation, but I was doing everything I could to make ends meet. Obsessing about it wouldn't do anything but give me an ulcer and make things worse. Birdhouse had to work—it was that simple.

Cindy and I cinched our financial belt even tighter. Mortgage and utility bills devoured my salary, and Cindy handled the extra money. By now I wasn't buying anything, and any dream I had of updating my gadget collection had been stomped to death months ago. We worked out another budget. I was restricted to five dollars a day with which to buy food. We dubbed it the "Taco Bell allowance." Between Top Ramen and the occasional drive-thru, my culinary tastes changed drastically.

HAWK

Birdhouse wasn't working as well as Per and I had anticipated. The skate market was close to nonexistent, the industry was flooded with more products than it needed, and we weren't turning any profit. I knew we had one of the best teams in skateboarding and decided a tour would be the best way to show it. That summer, we rented a crappy van for two months and toured most of the Midwest and East Coast.

It was a budget tour, with no trace of the perks we'd received from Powell. Birdhouse didn't have enough money to get everybody his own room, so I'd have to check into the motel and sneak the team in afterwards. We averaged five skaters to a room the entire summer. Every night we'd rock, paper, scissors for the privilege of sharing a bed. The beds were divided into two parts: the box springs and the mattresses. If you got a box spring, you got to sleep solo. Otherwise, you had to share a mattress. Taco Bell was our restaurant of "choice."

Even the best-laid plans go astray, and touring can sometimes be disorganized, but when you put a skater in charge it gets ridiculous. I was in charge of driving, booking hotel rooms, waking everyone up, and getting skate shops to pay us a demo fee—the worst job in skateboarding. The one absolute rule of skateboarding: skaters suck at handling any kind of business. When they've retired they can do all right, but while they're skating, business dealings seem like a voodoo hex. We got burned at almost half the demos we skated. We'd pull up at the agreed-upon time, skate the best we could for the seventy-five kids that showed up, and then get shortchanged by the shop. They never told us they would have a problem paying us until after we'd skated.

Once a shop owner refused to pay us but did offer instead to take us out to eat at a Chinese restaurant his buddy owned. I explained our situation to him.

"We make three hundred dollars a demo and almost all of that goes into the gas tank, motels, and food. If there's anything left over, I divide it up among my riders. Our money literally pays for the expenses to the next demo," I said.

It was either free Chinese food or nothing. We decided to hit the road and get closer to our next destination.

Although the tour was financially tight, and the rock-star vibe had long since faded, it was one of my most memorable tours. The closeness on that team has never been duplicated. Even the darkest, most stressful times were a blast because of our crew and their love for skating. Money and crowds were not huge concerns to us; we just wanted to skate with new people in new places. By the time I drove the van back to Birdhouse's small office, we'd lost $7,000. We knew we'd lose money, but it was our investment in the future—we hoped.

I won a street contest at the YMCA in Encinitas and skated the only vert event of the year, the last NSA contest I'd ever enter, and won. That year the NSA went down the drain, and all my dad had organized was gone.

HUDSON HAWK

Cindy wanted to have a natural childbirth, and by December of 1992 she was ready to pop. When her water broke on the sixth, we hopped into the car and bolted to the hospital. One of the problems with living in the boonies is, well, you live in the boonies. The drive to the hospital was forty-five minutes long, and our son showed his impatience by heading for the birth canal immediately. Cindy had to hold back slightly on the delivery until I could screech through the admitting door and race in to explain the situation. Our son was born twenty minutes after, and I was a skateboarding father.

We named him Hudson Riley Hawk after one of my ancestors, Henry Hudson-Hawk, who discovered the Hudson Bay. This is a great honor, but the movie *Hudson Hawk*, which was released around the same time, was not. We immediately began calling him Riley. If it had been a good movie, maybe we could have stuck with the name.

Riley demanded a change in our lifestyles, and Cindy and I figured out a way to make it all work. Sean and I had kept in touch, and I knew he hated it in Vancouver, so we invited him to live with us rent-free if he helped out with Riley. He came down and became our skateboarding au pair.

HAWK

You might think skaters wouldn't be the best parents, or au pairs, because of our rowdy reputation, but it was the exact opposite. All the skaters I hung around with seemed to take naturally to little kids. Perhaps because we all possess roughly the same mentality. Whatever it was, skaters with scabs all over their body would grab Riley, toss him in the air, and walk around the house making faces and baby noises at him and then laugh at his expressions. It was like discovering a clan of baby-sitters in your backyard. Riley was never upset by the skaters, who spent hours entertaining him.

I began to worry because Birdhouse, and skating in general, continued its downward spiral. If Birdhouse failed, I would have to find another source of income. The sole "occupation" I was interested in besides skateboarding was editing video. I'd hung around with Stacy while he edited the Powell videos and edited some of my own parts. I enjoyed the process and figured the key to my family's financial future lay in attaining some magical video editing equipment. This would be a challenge, since I was digging through the sofa cushions for lost change and my Taco Bell allowance had recently been cut in half.

My parents were never rich. They'd had it pretty rough even before I popped into their lives. I guess it wasn't that tough for them

because they both grew up in Montana, where, according to my dad, the height of elegance was the double-seated outhouse. My dad was not raking in the money and my mom usually worked as a receptionist, so money wasn't exactly abundant. Despite this, they did an amazing job of making ends meet and never letting us know how close they were to the thin red line. I wanted to be able to do the same for my family.

I asked my parents if I could borrow $8,000 to buy editing equipment. They have always had a high level of confidence in their children, so, naturally, they thought nothing of this request. They assured me I'd soon become a Hollywood success. With the money they lent me I was able to buy the essential components needed, which was two three-quarter-inch players, a recorder, and an editing controller. I went to a consignment store in Los Angeles, where an unenthusiastic sales clerk pointed me toward the back room after I told him how much I had to spend. Dust coated the antique machines that cluttered the makeshift shelving unit. I dug around until I pieced together a somewhat complete set.

In my brief editing career, I assembled skate videos for Gullwing Trucks, Foundation Skateboards, Blockhead Skateboards, and NEC Turbo-Grafix. I was also hired to make a series of instructional surfing videos with professional surfer Brad Gerlach. I soon realized the equipment was more trouble than it was worth. I was paid minimally for each job, and barely started to pay my parents back.

Since editing wasn't the pot of gold I'd hoped for and Cindy and I knew we were on a sinking ship, we decided to cut our losses and sell the Fallbrook house and move back to Carlsbad as soon as it was sold.

SPARE SOME CHANGE?

The New Year came and went without any ham rapes. My ramp was falling apart, and I didn't have the money or help to fix it. Holes were worn into the heavily skated sections, and it was so slow that skating on it was like skating against the wind. I thought my career was over. Skating's popularity was lower than I ever thought possible, Birdhouse was losing money, and there were only a handful of vert skaters left. My style of skating was becoming dated, and I was scared of being left in the dust by the new breed. I never practiced any flip tricks on vert because they seemed too modern for my style of skating.

As I was skating my crumbling ramp by myself, I decided to try something new. I started flipping my board as a test. To my surprise, I started catching it with my hand. For an hour straight I dropped in, kicked a heelflip varial lien (you kick the board with your back heel, it flips and turns 180 degrees, and then you catch it and stick it under your feet), tried to catch it and put it under my feet, bailed, and ran back up the ramp. After at least thirty tries I landed one. I was so psyched! I had landed a trick I'd thought I would never be able to do. For the first time in the past year, I felt I could continue to improve my skating. I suddenly felt I was at the top of my game when the game was at the lowest point possible.

Some people had expressed interest in the Fallbrook house. They wanted to test out living there, so we rented it to them. If they liked it, they'd buy the place. Real estate in our area was not booming, so we jumped at the opportunity. I felt like a dog about to be released from the pound. Before we moved, I went on another Birdhouse summer tour.

We couldn't afford to rent a van this time, so we used Cindy's minivan. It was so small we had to tie our luggage to the roof. Once again, we acquainted ourselves with the Taco Bells of the country and slept two to a bed. The crowds were still small and shop owners occasionally shortchanged us, but we still had a blast. By now we were used to having no money, and it was more like a road trip for a bunch of friends than a tour. We lost only $6,000 this time around.

I cut the tour short so I could skate in the Munster, Germany, contests. I won one vert competition and placed second in the other. While in Europe, I skated in a Belgium vert contest and won that too. When I returned home, Cindy and I packed up our Fallbrook house and moved back to the civilization known as Carlsbad.

ALMOST THE END

Per and I anticipated 1994 would be the year when skating picked up. I was still living on my Birdhouse salary and making very little money from demos. I did most demos for free, just to promote Birdhouse. Sometimes I even lost money. One time I traveled to France to skate in a demo for $300. They screwed up the reservation so that my scheduled return flight left before the actual event, and it cost $400 to change the ticket. They refused to pay the difference, citing that most of the crowd had sneaked into the event without paying.

Once we sold the Fallbrook house Cindy and I would be able to exhale a bit because we would have some cash, but the renters didn't seem to be making a move in the buying direction. After a few months they decided not to buy it. We put it back on the market and played the waiting game once again.

Per and I had a meeting a few months into 1994 to discuss throwing in the towel. Birdhouse hadn't made money from the start, and it sucked up a tremendous amount of our energy. I was burnt out from trying to keep up with skating, looking after Riley, and doing various Birdhouse chores, such as designing ads, producing videos, and being team manager. I didn't get to skate very much, which didn't help my outlook. Taco Bell was getting stale, but at least my dad would invite me to lunch occasionally.

Even though I was learning new tricks on vert, no one took notice. Ramp skating was totally dead. I stopped going to contests. The checks for prize money would regularly bounce, and usually only fifteen skaters would show up to the biggest vert contests. I decided to

HAWK

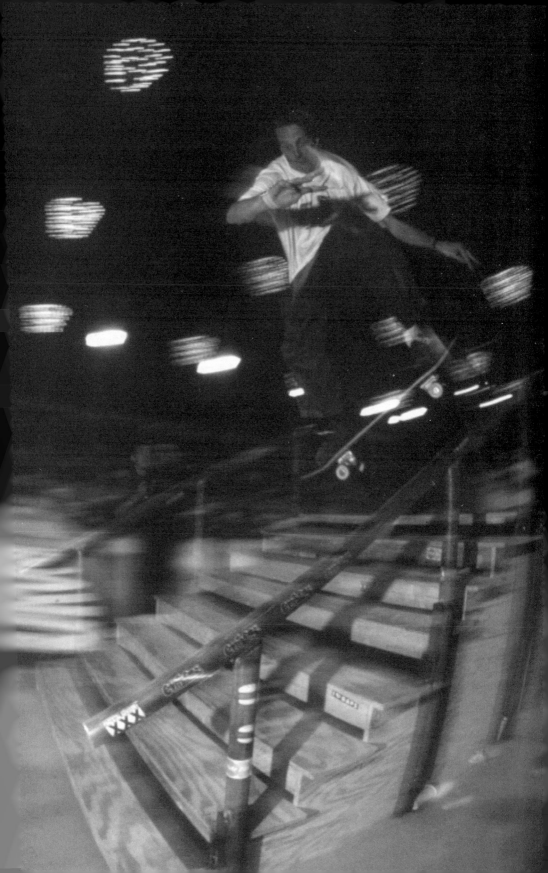

retire and become more involved in the business aspect of Birdhouse, where I thought I would be more valuable. My last board graphic was of an ocean liner sinking, *Titanic*-style.

RETIRED, AGAIN

I continued to skate at the local YMCA ramp, but there were hardly any skaters to skate with anymore. Cindy and I finally sold the Fallbrook place for much less than we'd anticipated. Selling it was a relief, but tearing down all the ramps wasn't something I looked forward to. My dad, Sean, and I spent a few weeks in hundred-degree weather undoing work that was never intended to be undone. My dad had an almost religious attraction to building materials and wanted to save every piece of lumber from the ramp. Sean and I had visions of tearing the support structure out from underneath and watching as it crumbled down the hill in an explosion of splinters and nails. Either that or dousing it in gasoline and roasting marshmallows in the ensuing inferno. We got the first wish.

One thing my dad didn't love was going to get lunch, because it meant he would have to stop working. It was a half-hour round-trip to the deli, which meant the driver didn't have to work for thirty minutes. Sean and I usually fought over who would get lunch, because we are lazy bastards. One morning, however, we decided to send Dad to the deli. While he was gone we planned to carelessly pry the ramp apart (we'd already deconstructed half the ramp by then) and watch as it crashed into an impressive pile. I think my dad knew something was up when we suggested he go to the deli to pick up food. He shrugged, eyed us suspiciously, and drove away. We wasted no time; if he returned while we were in the middle of our job, he'd freak. That meant that we'd have to spend the next week in purgatory pulling nails out of hundreds of two-by-fours.

It took us only ten minutes, because we were so hyper. I'll never forget the ecstasy I felt prying the last strip of two-by-fours apart and running away as the thousands of pounds of wood and nails groaned under its own weight and avalanched in an explosion.

HAWK

Sawdust and splinters filled the air as we screamed in celebration. Twenty minutes later my dad drove up the hill to the ramp, parked his car, and slowly walked over to us as we stood beside the pile of broken ramp grinning like idiots. He shook his head and handed us our sandwiches.

The ramp wasn't the only thing that fell apart in 1994. My marriage was mimicking it. Cindy and I didn't have any knock-down-throw-the-plates type of fights, but we began to realize that we were growing apart. We no longer shared any common interests, except for Riley. Neither one of us made him our priority, nor were we fulfilling our parental duties. We tried to keep it together, but the chasm grew too big. I knew that even though I still loved Cindy, we lived in two separate worlds that were not uniting. In September of 1994 we split up. Unfortunately, it took this event to make us both realize the importance of parenthood.

It was never an ugly separation. We were both dedicated to creating the best possible life for Riley. We agreed on equal custody and trying to make it as easy as possible for him.

SNOOPY, THE MATCHMAKER

My friend Greg Smith, a fellow computer nerd and freestyler whom I'd known for years, moved from Upland, California, down to Carlsbad in 1994. He had moved in platonically with a manicurist who worked with Cindy. After Cindy and I separated, Greg and Cindy played musical houses and he came to live with me. It was weird how clean the separation was, and Cindy and I remained friends. After a few months, we realized we weren't getting back together and started divorce proceedings.

Even though I wasn't competing, nothing regarding my skating had changed. I skated almost all the time at the YMCA ramp and was consistently learning new tricks. I still made very little money, but my cost of living had decreased dramatically. Demo requests were picking up slightly and it appeared there was a renewed interest in skating. I had requests to skate at various Six Flags across the

country, state fairs, and other events. Demo fees hadn't increased since the '80s, but I was just happy to be skating in front of appreciative crowds again.

So there I was in March of 1995 doing demos practically for free when I got a call from Jill Schulz, daughter of Charles M. Schulz, the creator of the Peanuts comic strip. She was organizing a family-type show in Santa Rosa, California, with Rollerblading, BMXing, and skateboarding. She was calling it a truly hideous name, Extreme Wheels Live, and offered to pay $3,000 for a week's worth of demos. That was exactly one and one half mortgage payments.

As I checked in at the airport with various other athletes, one girl caught my attention. Erin was blond, very cute, and very friendly. I assumed she was nice to everyone and didn't really consider me special in her radar. She'd been a competitive ice skater growing up (as had Jill, which is how she fit into this equation). Erin was Rollerblading in these shows in order to pay for her education at the University of San Diego.

Sean, the skating au pair, came for the week of rehearsals and demos to look after Riley. I skated during the shows; hung out with Matt Hoffman, with whom I became good friends; and met Charles Schulz, who was about as unassuming as you can get. And I couldn't get Erin out of my mind. We talked for hours on the phone on a regular basis.

Erin was a natural with Riley. As much as I wanted to find a soul mate, Riley had to be first on the priority list. If a girl wasn't accepting of my son, then there was no point. Riley, fortunately, possessed none of my annoying childhood traits. He was competitive but empathetic. I have always tried to teach him to understand what his actions mean to others, and to treat them the same way he would like to be treated. He has always been a compassionate child, and is accepting of anyone.

Erin and I saw each other often but didn't date for a few months. I had an audition in Los Angeles for a Levi's commercial and then went to visit Jill in Santa Monica. Erin came with me. We talked the whole way up and officially began our relationship. I got the commercial, and she came up and stayed with me during the shoot.

184

HAWK

Cindy and I plowed on with the divorce proceedings. Even though we knew how we wanted to split things up, we had to work with a mediator to make everything legal. She was dating somebody else by the time the divorce was final, and we became better friends than we'd been for a while. I had Riley from Monday to Friday and she looked after him on the weekend. If I had to travel or she had plans, we covered each other. It was never a problem because we lived fairly close to each other.

Birdhouse still wasn't doing as well as we had expected. Since I wasn't the best businessman, Per, Jeremy Klein (one of our riders, who had begun designing graphics for the company), and I decided the best thing for the company would be to resurrect my model and have me start entering some contests again. It wasn't purely a business decision. I had missed the edge of competing over the past year, and even though vert wasn't very popular, being there helped people recognize our brand and our vibe.

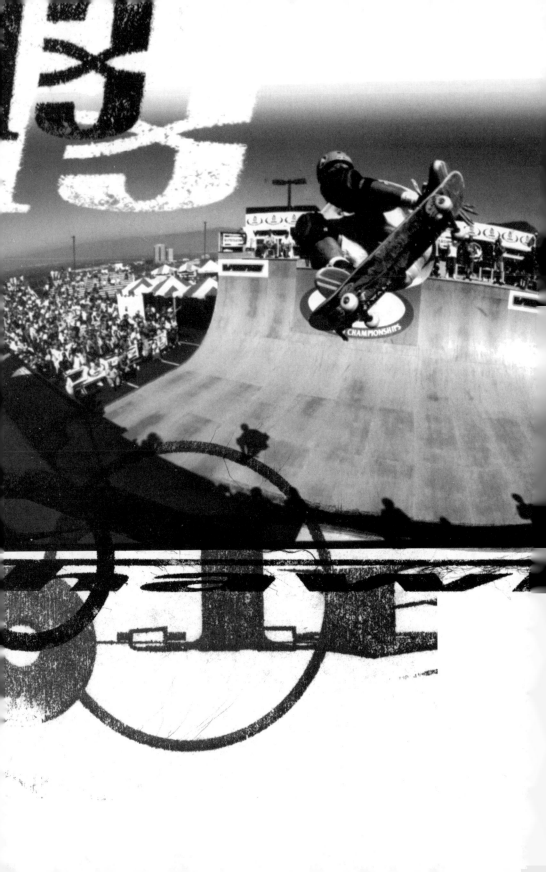

chapter

13

THE EXTREME GAMES

IF I THOUGHT 1994 HAD BEEN UNPREDICTABLE and rocky, the following year was a *Mr. Toad's Wild Ride*. The highs and lows of my life crashed into each other throughout the year. Erin and I were dating. Cindy and I finalized our legal proceedings. Around the same time I'd met Erin, other things had taken a turn for the worse: my dad was diagnosed with terminal cancer. He'd had a chronic cough over the last few months that nobody had taken seriously, but the news dropped like a bomb on the Hawk household. This was my dad, who had lived through two wars, the guy who

could outwork me and wave off two heart attacks like a case of heartburn. He had undergone a triple bypass two years earlier. It seemed impossible for him to die of a terminal illness; our family had always imagined that another heart attack would be the only thing that could stop him from reaching one hundred. The cancer spread quickly. He began to lose weight and immediately underwent chemotherapy. He began popping vitamins by the handful. But as weak as he was, he still found the energy to build mini-tables for his grandkids to play on.

It meant a lot to me, and my entire family, to receive the messages of concern from skateboarders everywhere. As bullheaded and abrasive as my dad could be, it was touching to see that skaters saw past his grumblings and appreciated all that he'd done for the sport. The house was visited daily by two decades worth of skaters. Letters arrived every day from around the world. I'd watch television with my dad and hang out, but he was getting weaker by the day. He'd sit in his reclining chair spitting into a container, because the throat cancer congested him. Erin visited him, Cindy would drop by with food, and Sean took him to Home Depot.

I didn't know what to do. Part of me wanted to halt everything and camp out at his house, but I had Riley and many other responsibilities. My dad solved that problem; he didn't want me sitting around and ordered me to get back to my life.

THE EXTREME GAMES

A few months before summer, rumors of a weird new television event rumbled around the industry. ESPN was supposedly planning an Olympic-style event with all the peripheral "action" sports. Skateboarding, BMX, and Rollerblading were all going to compete on a show called *The Extreme Games* (an awful name that still can't be shaken). This was huge, but you've got to understand that skaters are inherently wary of outside interest in the sport.

Needless to say, skaters and industry people were split as to whether the event was a good thing or bad. Ever since skating started over

188

HAWK

thirty years ago, the mainstream media have consistently misrepresented us. Commercials and movies have presented us as a bunch of rebellious clowns (many still do) and rarely have understood the subculture. So although the skate industry was interested in the X Games (what the Extreme Games were eventually renamed), they were worried about being misrepresented in such a huge forum.

The odd bits of information floating around concerning the Extreme Games were particularly unnerving. ESPN demanded skaters wear contest bibs with the official sponsors of the games plastered all over them. They wanted absolutely no other logos to be visible on our boards or clothing. Every skater freaked. There was no way anyone would skate if we had to wear corporate logos all over our chest and not get to include our own skate sponsors. Since there is no true governing organization in our sport, however, it would be impossible to hold a complete boycott. No matter what, skaters would show up to an event. My curiosity got the best of me

HAWK

and since they were having a vert event (which were few and far between), I decided to go.

The first Extreme Games took place in Rhode Island, in June. By that time the organizers had backed off on their logo demands, but again they showed their ignorance when they thought all the athletes would have no problem rooming together in a big hall. There have been rivalries between skateboarders and in-line skaters ever since Rollerblades were invented. They seem to be the Hatfields and McCoys of the X Games. While no fights broke out in the hall, the air was definitely thick. I stayed in a hotel, so I didn't experience the communal sleeping, but I heard about it on the ramp.

I was excited skating would have such a huge platform. It was on the upswing, and exposure like this was an added boost. During the finals I knew my dad would be watching, so when the camera came in for a close-up I mouthed "Hi, Dad."

I won the vert contest and placed second in street. The contest aired a week later, and the amount of exposure it generated was amazing. People began to recognize me on the street, in the mall, and in video stores. I'd been recognized before, but it had always been by skateboarders; now civilians came up to tell me they'd seen me on television. The Extreme Games had a long way to go before they were respected in the skateboard industry (which they still aren't fully), because they'd include other "sports" like freestyle bungee jumping. You had a guy bungee jumping in a kayak besides skateboarding and BMX. It was insulting and belittled what we had spent years progressing. But the viewers seemed to know what was up, because BMX and skateboarding were the most watched events, supposedly viewed by millions of people worldwide. The event was also where they created the "Michael Jordan of skateboarding" tag.

I enjoyed skating in the contest, but I had a problem with how much attention ESPN focused on me. It was embarrassing how the spotlight seemed glued to me and ignored equally talented skaters. I met with various ESPN people and asked them to spread the exposure to include other skaters. They said there wasn't enough airtime to give every skater his due. They felt that if they highlighted too many people, the viewers would get confused. Because of this, even-

HAWK

tually my name and image became synonymous with the X Games, but besides skating the contest, it had nothing to do with me.

I was happy that my dad was alive to see me skating on television in front of millions. He, more than anybody, appreciated the exposure, and it validated everything that he'd done for the sport. He knew there were problems with the event, but it granted him unimaginable bragging rights. He told people I was going to be more popular than Michael Jordan.

LOSING MY BIGGEST FAN

I hung out with my dad after the Extreme Games for a few weeks before departing on the Birdhouse Tour. I had actually canceled my spot on the tour, but my dad gave me grief and told me he wasn't about to kick it in a month. As weak as he was getting, he still appeared to have a decent amount of energy left. I went on tour never thinking that when I said goodbye to him, it would be the last time I saw my dad alive.

I called him every night. One night I was more depressed than usual when I called my dad. Now, my dad watched more television than anybody I know, and at the time there was a Bud Light commercial in which a son—old enough to drink—and father sit around a cooler with only one beer left. The son spots the sole beer and figures out how he can get it: he'll tell the dad how much he loves him. He thinks his dad will be swayed by this declaration of love and

happily hand over the last beer. The dad, clever guy that he is, cuts his son off saying, "You can't have my Bud Light."

I opened up to my dad. I told him how much I loved him and appreciated everything he'd ever done for me, and how I wouldn't be where I was today if he hadn't been so involved in my life. And he said, dryly, "Thanks, Tony, but you can't have my Bud Light." That was our moment. But I can't think of it without laughing, and that's a perfect way to remember my dad.

I was at Woodward Skatecamp, and I somehow just knew that my dad wouldn't make it through the night. I got a message the next morning that I had an emergency call from home. My cellular phone didn't work there, so I had to use a pay phone. There were campers (skaters) everywhere, hundreds of them, asking for autographs and advice. I had a pack of them around me, peppering me with questions and autograph requests, while my mom told me my dad had died early that morning. I didn't cry or throw my board; everything

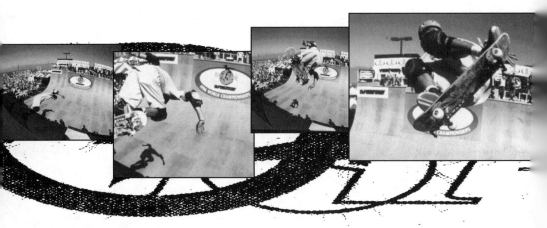

just shut down. I hid in the forest around Woodward for the rest of the morning and had a private grieving.

I went straight to the airport that afternoon. I saw the president of Airwalk there and we exchanged greetings. When I told him the news he upgraded my ticket to first class, and I'll always be grateful for that bit of kindness.

Sean picked me up at the airport and we drove home in silence. I asked him how it happened, and that was it. My dad had been lucid

HAWK

the night before. He was watching a documentary about a battleship from which he'd launched during World War II. He went to sleep and never woke up.

We had a wake at my sister Lenore's house, and the yard was filled with skaters and industry people telling Frank Hawk stories, which were always in abundance.

We spread his ashes in the ocean, but I kept some for later. My brother and I recently sprinkled the rest throughout the Home Depot.

SECOND TIME AROUND

After the Extreme Games, Birdhouse sales shot up, and at the start of the year Airwalk had decided to produce a Tony Hawk signature shoe. At the time there were only Caballero shoes from Vans. Jason Lee, then one of the most popular street skaters, was also getting a shoe from Airwalk.

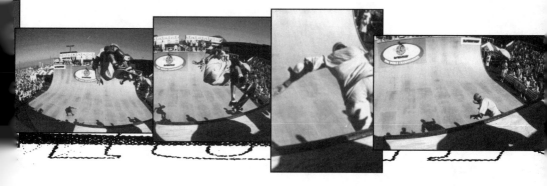

I won another vert contest at the Hard Rock in Huntington Beach, and it seemed that skating was on track again. Toward the end of the year, the Missile Park YMCA held a vert contest and I won all three events: highest air, highest air to fakie, and the vert contest. By the end of the year I'd made $38,000 in royalties from Airwalk. Even though I didn't collect board royalties from Birdhouse, I still received my salary and other income from contest winnings and various other sponsors. I stopped worrying about getting another job and stopped doing demos for free.

HAWK 14

chapter

14

WE DON'T WEAR SPANDEX

NOW THAT SKATING WAS ON A ROLL and Birdhouse's sales exceeded expectations, I decided to spoil myself and build a private ramp. I missed having a ramp I could skate whenever I wanted to. The YMCA was only a ten-minute drive away but it had limited hours of operation, and I couldn't plan my day around a three-hour skating period. I decided to build the ramp in Irvine, since it was a central area for myself and other Birdhouse skaters living in Huntington Beach. We found a decent warehouse with high enough

ceilings, and Tim Payne built the ramp. It was 48 feet wide with 10.5-foot transitions and 1.5 feet of vert. The ceilings were a little low for such a big ramp, but not too limiting. It cost about $15,000 and was eventually dubbed Birdland. It's a tax write-off, one of the benefits of being a professional skateboarder and owning a company.

I had a son and my own ramp; all I needed to complete the family portrait was a wife and a house big enough for us all. Erin and I moved in together at the end of 1995.

My schedule was slowly filling up and I couldn't take Riley with me to every demo, so Erin began watching him while I traveled. She was great with Riley—they'd paint together, put on shows, construct elaborate Lego arrangements, and jump around on the jungle gym at the playground. Rather than considering it a chore, she was actually stoked on looking after him. To me, Erin has always defined compassion; she's naturally giving and wants to help people. When I started traveling, she already had a B.A. in psychology from the University of San Diego and was currently close to completing a master's degree in marriage, family, and child counseling. She decided to stop for a semester. I never asked or hinted that I wanted her to drop school, where she was excelling. She'd evaluated her choices and decided that she'd rather help with Riley.

Because we'd been talking about houses, Erin looked at a few on her own in a new development in Carlsbad. We looked at typical model homes until I got bored. (Home shopping ranks somewhere below taking enemas on my list of favorite things to do.) One house had a great design that included a separate office and Erin seemed smitten with it, but I just shrugged and began planning my surprise.

Big decisions in my life have always come easy and are made without hesitation. It is easier for me to make a life-changing decision than to decide what to get for dessert. I decided then that I wanted to marry Erin and buy her the house that she loved. But, my God, did she make me work for it!

When she asked me if I liked the house, I pretended I didn't care. The next day I lied, telling her I had to go to Los Angeles for a commercial audition and was taking Riley so he and I could hang out together. The next day, I met with the real estate agent in secret and

196

bought the house. I then drove to Newport Beach with Riley. There was a specialty jewelry shop there that Erin had always liked. I couldn't decide among three of the rings, so I asked Riley to pick one. For a four-year-old, Riley had great taste. He had no problem in deciding, so I paid for the ring and rushed back to Erin.

It was getting late, and I still had the second part of my plan to execute. I parked in the garage and threw a flashlight and a jacket for Erin in the trunk of the car. I strolled into the house trying to look relaxed. There was no time to waste, since I had to leave for a contest the next morning.

"Say, Erin, how about looking at those houses again after dinner?"

Now, Erin is usually up for anything, especially if it has to do with model homes, so I assumed she'd be excited.

"I don't know. It's dark. It's late. We won't be able to see anything. Let's go tomorrow."

"Let's go see what they look like at night." I was scrambling for a reason.

"Okaaaaaay, we can go tonight, Tony."

"Yup. Let's go."

It took almost an hour for Erin to say goodbye to her mom, who had come over to visit and knew nothing about my plans. I thought I was going to implode from the anxiety.

We drove to the empty lot and I pulled into the dirt driveway. Miles of empty lots surrounded us. We looked like we'd stumbled onto the *Road Warrior* movie set.

"Let's go check out the lot that you liked," I said, already out of the car and popping open the trunk to get the jackets and flashlight, but Erin's door didn't open.

"Are you going to come out?" I asked.

"No. It's dark. There'll be coyotes or something running around." She still had her seat belt on. I was dying here.

"Come on, they aren't going to bother us. I have a flashlight." I held it as if it were a sword capable of slicing coyotes to bits.

"Let's just go another time."

She must have seen something in my face (most likely panic) at that point and agreed to get out.

We walked around the site and I asked her how she liked it, already knowing her answer.

"Well," I announced, "I just bought it for us."

"Really?" She seemed mildly surprised.

"Yes, but we can only live here if you'll be my wife. Will you marry me?" I pulled out the ring, and the scene was straight out of a Lifetime special.

She had the meltdown, complete with tears and, eventually, the muffled "Yes."

OCCUPATIONAL HAZARDS

In between wedding plans, I skated and prepared myself for the summer of contests and tours. I skated in the Hard Rock vert contest in Las Vegas and won, but I was more excited about meeting Donald Trump. He visited the contest and asked a few people where I was. I couldn't believe he even had a clue who I was, but he walked up and introduced himself. He told me he appreciated what I was doing for the sport and to keep up the good work. I didn't really know what I was doing "for" the sport besides actually skating, but I thanked him and asked if I could borrow a couple million.

I skated two Destination Extremes, a title that, thankfully, ESPN no longer uses for their X Games qualifications. One was in South Padre Island, Texas, where I won vert and placed second in street, and the other was in Seal Beach, California, where I placed fourth, but managed to severely twist my ankle before the vert contest started.

You can twist your ankle in skateboarding, it happens frequently, but then there are times when you *really* twist your ankle. When that happens, you can't walk and should probably head to the doctor. In general, skaters have an aversion to doctors, sometimes to the point of stupidity—myself included. There are stories of skaters who broke their ankles and used duct tape to create a makeshift cast they would use for months. I know a handful of skaters who didn't know they had ever broken a rib until years later, when they were getting something else checked out. Knees . . . oh shit, knees . . . pick a vert

198

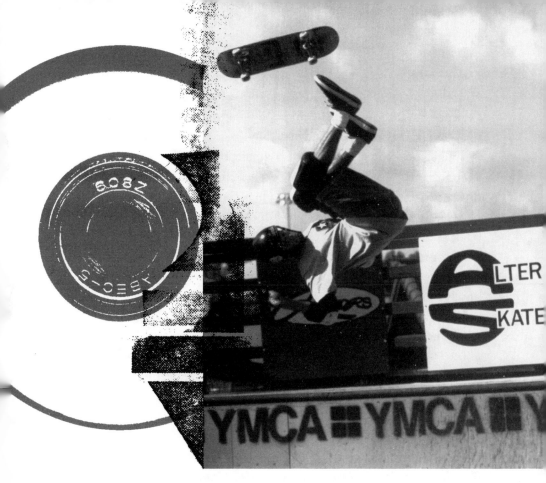

skater, *any* vert skater, and check out his knees—not a pretty sight. Ligaments are usually torn, or at least a few inches longer than nature intended. I know one skater who asked a doctor if his ankle should be able to move around "like this." He then proceeded to bend his ankle to the side, and his ankle bone (that little ball on the side) split in two—his ligament had been torn in half years ago. The doctor started laughing.

But we have a reason for avoiding doctors: they usually tell you to stop skateboarding. I can't tell you the number of times doctors make it sound like you'll never walk again when you get something checked out. They look at skateboarding from their side of the fence, and it's all about preventing injuries. They don't share our perspective, which is that it's fun and worth the pain.

After the event I could barely walk for a week, which was all I had before heading out on the Birdhouse Tour. We'd rented a van that

was supposed to seat nine but in reality seated only six, because if you were in the back row of seats you were in trouble. We dubbed the van the *Titanic*, because after a few minutes in the backseat you felt seasick. People who had never been carsick in their lives were feeling it, and vomit stops were frequent the first few days. If a new skater came on tour, the chance to have an entire row of seats to lie down on was too much to resist. Then came the vomit stop and the backseat would be empty again. I don't know what it was about the back section of that van.

The sprain was a bad one, but I figured it would heal like it always had before. I was already on tour when I realized it wasn't getting any better. I had a robo-ankle brace with metal and springs and doo-dahs in it, and it worked well—until I sprained my other ankle a week into the tour. It was just as bad as the first. I thought I was going to cry. I bought another ankle brace and strapped both my feet up. I couldn't go home, because I was in charge of the tour. Going home would mean missing the rest of the dates and letting skaters down.

Two weeks later, while skating a dilapidated street course, I sprained my first sprained ankle again. I hobbled away from the demo, my ankles shooting pain up my legs, and locked myself in the van. I undid my ankle braces and watched as my resprained ankle swelled up and turned a pretty shade of dark bluish purple.

The responsibilities of the tour and my constant ankle pain started to wear me down. I really started to stress. After one of the demos Paul Zitzer, a Birdhouse skater at the time, asked if I was going to have a breakdown. I couldn't move without pain. Paul, always the joker, suggested I learn to levitate.

I ignored the "broken" rule for demos, which is if a skater is seriously injured, it's better for him to head home than skate crippled. If he does skate, spectators will think he stinks because he isn't skating as well as they've seen him do in magazines and videos—plus skating while broken isn't the best way to recover. I broke the rule and was paying for it. After every demo I'd retreat to the van, take off my ankle braces, and wrap two big bags of ice around them. I had to sign autographs through the driver's seat window.

HAWK

By the end of the tour I was ready to give it all up. I'd spent six weeks with ankle pain. It was so bad it woke me up at night whenever I rolled over. I thought this was my body's way of telling me, "Give it up, old man; you don't bounce like you used to."

I took a month off from skating before the second Extreme Games in Rhode Island. The organizers had listened to the athletes' complaints and didn't room them all together—now they didn't supply rooming at all. Skaters were still wary of the way they presented skateboarding, and I was bummed that they continued to focus so much of the spotlight on me. But they had a new made-for-TV solution to my complaint: they'd manufacture *dramatic* tension during the contest by pitting Andy Macdonald against me. They made it seem as though we'd had some huge rivalry going since grade school and had come to the Extreme Games Thunder Dome to duke it out like gladiators.

Even though skaters compete in contests, they are, for the most part, extremely noncompetitive. Sure, there are a few skaters who have the jock blood running through them, but they're treated like visiting lepers at contests. If you watch the deck of the ramp during a contest you'll see the skaters talking and joking with one another, getting stoked on another skater's good run or crazy trick. What nonskaters don't understand (and I had to explain this for a year after I retired from contests) is that skating is all about what happens when you skate. If you pull a trick during a contest, fine; if it's during a Sunday session at the YMCA, fine—skaters will appreciate it wherever it takes place, and that's the bottom line. Chad Muska, one of the most popular street skaters ever, hasn't entered a contest in years, and it doesn't affect what skaters think of him one bit.

So, if you hear an announcer on television talking about contest runs, what skaters have to do to win, or how they train, remember one thing: it's not a skateboarder talking. It's the announcer trying to figure out how skaters think—and missing it by miles.

This was a huge problem skaters had with the industry during the first few X Games; it was misrepresenting skateboarding on a huge level. It took a few years, but they finally listened to the complaints and hired Chris Miller to help with the commentary. They still do

questionable things; for instance, after I spun the 9, instead of inter-viewing pro skaters that were all around the site, they talked with some guy who hasn't been involved in skateboarding for over a decade and didn't know what he was talking about. But they openly admit they aren't trying to please skateboarders; they're trying to produce an entertaining program that everyone will enjoy, and you can't please all the people all the time.

The street contest took place on the pier, and after my final run, I launched off a ramp, over the guardrail, and into the ocean. ESPN had noticed that the street course offered numerous opportunities for skate diving and warned against it, which made everybody want to do it. A few ESPN people got mad at me, but it didn't stop them from airing my stunt repeatedly. Andy won the vert contest and, according to ESPN, the "rivalry" was full blown now; tensions would be high next year when we did battle. All we needed was a skate Caesar sitting above the ramp giving the thumbs-up or the thumbs-down signal.

NO SPANDEX

Colin McKay, besides being one of the best vert skaters the sport has ever seen, is responsible for saying the immortal line "It's people like you that give skateboarding a bad name" to a costume designer who tried to dress him in weird clothes at a commercial shoot.

You get an impression of how the outside world perceives skate-boarders when you shoot a commercial. Although they try to "dress you up like a skateboarder," they never show up with jeans and a T-shirt. Apparently they shop a surplus store that sells Day-Glo dance costumes and rave outfits. I did a razor blade commercial for Schick, which was bad from the get-go.

Somebody connected with the commercial had seen pictures of me doing the loop (skating all the way around fullpipe), and they wanted me to do it for the commercial. I figured I could land one clean if they built the ramp right, so I agreed. I arrived on the set to a screaming director bawling some guy out. It was your typical Hollywood set

202

with a lot of people standing around smoking cigars. I checked into wardrobe, where a nice lady had me sit down while she got the clothes ready. I could feel my pupils expand as she brought out an armful of clothes. Silver metallic spandex pants were on top. Who the hell wears silver spandex pants? Who the hell wears *spandex*?

"I can't wear those," I blurted, pointing my finger at the pants.

"Oh? Really, they're nice. It will give you a sleek look as you skate."

"I'm not wearing those. I can't." Making two thousand dollars on a shoot wasn't worth a lifetime of humiliation. She pulled out a T-shirt that was bright pink. I was in hell. Fire was lapping around my ass as she showed me how she thought skateboarders dressed. Here's what I think happens: people watch too much television and movies and get their stereotypes from them.

So I vetoed almost the entire wardrobe, except for a black shirt and shorts, and let the wardrobe mistress put silver stripes on my helmet as a way to extend the olive branch.

Here's the second misconception the outside world has about skateboarding: the tricks you might think are the hardest are usually the easiest. It's easy to appreciate a spinning or flipping maneuver. The skater looks like a daredevil. "Oh, he's really going to wreck himself on that trick!" But tricks that look simple, like backside disaster reverts, where you ollie 180 degrees and land on the coping in the middle of your board and "revert," turning your body 180 degrees so that you're going down the ramp backwards, cause uncountable bruised tailbones throughout the skateboard world. On a backside revert you're turning toward your blindside and it's hard to twist your body around completely. If you saw one on television, you'd think it was a simple trick. A 540? Way easier, once you've done a few.

Before we started, an assistant director walked over and gave me a warning. They were balking at my requested $2,000 fee, when they had already agreed to the price weeks before. He said that if I didn't make the loop, I would be "downgraded" to the status of an extra (a standard extra day-rate is less than $200) and receive no residuals. In essence, if I busted my neck during the stunt, they'd

decrease my pay by 90 percent and send me home. They must have been worried their sleazy dealings weren't insulting enough, so they hired a local vert skater and rented a ramp for some other shots. When I asked why they didn't use me for the vert stuff as well, the director responded, "You skate ramps too?" Nope, I'm just the loop guy.

I explained that I'd need to practice the loop with mats a few times first, and then I'd have to keep my rhythm going by doing it immediately afterwards. The director started talking to another person in the middle of our conversation and nodded to me to get out of his way. He was a big-time director, after all. I practiced with the mats five times, and the director kept pushing me to hurry up. I ran up the starting ramp and waited. Ten minutes later, he called action. I looped and slammed. Someone said, "And this guy is supposed to be the best in the world?" They had a laugh over that one.

I tried the loop four more times and made it three-fourths of the way around before the director called cut and moved on to the next shot. I wanted to do a clean loop, but he said I'd wasted enough of their time. Knowing that they would stay true to their promise of "downgrading," I decided to leave. Without my signature on any paperwork, they wouldn't be allowed to use the footage. Although I wouldn't get paid, it was worth burning them and their blatant disrespect for the talent (that's what they call any sort of athlete on shoots) they'd chosen so carefully. As I threw my gear into the trunk of my car, a production assistant ran up. He said they could use the shots they got and were willing to agree to the original terms, plus residuals.

For the next two years, I received a steady income from the commercial, which never seemed to stop airing. Each time I signed a residual check, I would raise my middle finger in dishonor of Schick and my bitter experience.

Erin and I got married on September 28, 1996, in San Diego. It went smoother than my first time around. We honeymooned in Hawaii. It was a good year in all respects; skating was once again on the rise, I had my own ramp, and I was earning a decent living.

HAWK

1997

The next year marked the time when the Extreme Games reared up like a two-headed beast. Skating was growing so quickly it was almost out of control by 1997. The mainstream media jumped in the middle of everything in a feeding frenzy. Companies like Slim Jim and the Marines jumped on the bandwagon, trying to get a piece of the teenage demographic pie. My name and image was right up there, tied to the X Games (they'd decided to change their name that year—smart move). Six months before the contest, I was fielding interview requests for the Games. Birdhouse was selling thousands of decks a month, and I had to turn down demos I wanted to do because I was overbooked.

I couldn't handle the combined responsibilities of skating, running a company, and being a family man. Phone calls, faxes, and e-mails from magazine interviewers, TV show hosts, and newspaper journalists were driving me nuts. I couldn't deal with the pressure. More important, I didn't want to. I don't mind interviews or photo shoots, but arranging schedules just about gave me an aneurysm. My older sister Pat stepped in, and I hired her as my manager.

Pat used to tour as a backup singer with the Righteous Brothers, John Denver, and Michael Bolton. She knew how to organize schedules, and she also knew the value of getting other people to deal with your bullshit. She had a friend in New York, Sarah, who used to work as a publicist for a modeling agency and then split to start her own publicity company. Pat recommended I talk to her, and I dug the idea because it meant I didn't have to say no to interviews I thought were cheesy. You just hire somebody to do it for you—it's the best. But she did a lot more than say no; she set up interviews with magazines I actually liked. In turn, more opportunities began pouring in. I thought hiring Sarah would give me more time to be with the family and skate, but I never realized it would spark so much more interest in my career.

PERFECTION?

By the time the third X Games rolled around in San Diego, the skate industry was having some serious misgivings about the televised event. The past few years they'd been trying to figure out what this TV thing was; now they had a better idea of its impact and it gave everybody mixed feelings.

When the X Games started in 1995, they opened the public's (or at least the couch potato's) eye a tiny bit, but they didn't affect skaters much at the time. But in four short years, everybody involved in skating felt the insane power of television and ESPN marketing.

As skaters, we're used to being dirty little social outcasts because we were always perceived that way. I've been ticketed over a dozen times, chased out of many skate spots by the police and security guards, yelled at by old ladies, hassled by carloads of jocks, and heckled by girls. And if you fall, forget about it; every nonskater around stares or laughs. Skaters are seen as bottom-feeders, but that's part of the fun.

In the beginning, I think a lot of people didn't believe televised skating would last, but by 1997 everybody knew it was here to stay, at least for a few more years. It split the skateboard community down the middle. On one hand it helped introduce skateboarding to the world and helped break the punk/criminal/rebel stigma attached to it, but in doing that the producers substituted their own watered-down version. Nothing pissed off the skaters more than an announcer who acted like he was some skate guru. He'd tell viewers that in order for a skater to win a street contest, he or she would have to do a certain amount of flip tricks. This couldn't be further from the truth, since routines are judged by overall impression. Judges are looking for all types of skating, not simply counting kickflips and giving scores.

It was this year ESPN made their feelings and intentions apparent to the skate industry. When the X Games first started, ESPN had requested input from the skate community, but apparently by the third year of the contest they'd had enough. The world's elite skate photographers, including Grant Brittain, Miki Vuckovich, and Atiba Jefferson, had to wait in a line at the bottom of the ramp with fifty other photographers. They were allowed to go up one at a time, when a photographer on the deck departed. A magazine like *Transworld Skateboarding,* which had begun publishing the magazine when there was no money in skateboarding and was now the most influential skate magazine around, had to wait behind a girl shooting for her school newspaper. And you wonder why they were pissed?

But whatever the industry thought, the contests went on. I had a bit of a fire under my ass caused by getting second the previous year, and this was my hometown, San Diego. My entire family was at the contest.

After my first run, which I was happy with, I kicked back and watched Rune Glifberg kill the ramp. It was one of the best runs I've ever seen. I got amped. Everything came together on my next run, and I made tricks I normally bailed in practice. It was one of the best runs I'd ever had in competition, though not my best run ever. The announcers dubbed it "perfect," which led to a media frenzy. The

whole event was exaggerated, but I was pleased with my performance. Since I had nothing left to lose, I spent my entire third run attempting 900s, but I didn't get close. At that time, they seemed like a pipe dream.

One of the most enjoyable events at the X Games was the doubles event, two skaters skating the ramp at once. My ESPN nemesis (according to them), Andy Macdonald, and I skated together and won. That was a great contest because skaters didn't really care about winning, just about having fun. Skaters rarely do doubles, and while a few teams practiced (Andy and I included), we mostly watched each other and laughed. It was one of the highest-rated events in terms of viewership.

TRAVELING IN STYLE

Birdhouse Projects was now a legitimate company, and we could afford to tour on a decent budget. The five-to-a-hotel-room days were over. We stayed in better hotels, everybody had his own bed, and we made money while skating across the States. We arranged for an RV with a driver, courtesy of Jones Soda. We stuffed it with a PlayStation, a VCR, and a mini-bar. Looking back, the mini-bar may not have been the best idea. Being in charge of tours wasn't a problem this time around, because part of our deal with the driver was that he had to collect the cash from the shops. Collecting was also easier now because people understood the value in having us show up.

We had a blast that summer. We rented a go-cart track and used it until Heath Kirchart, a Birdhouse skater, got us kicked out when he played demolition derby with the team. One thing that sucked was that my ESPN exposure overshadowed the rest of the team. When we hit a town, the newspapers only wanted to talk to me. Hey, I have Willy Santos and Andrew Reynolds in the RV, two of the best street skaters ever; want to talk to them? "Maybe later," they'd say. I would oblige in hopes of drawing bigger crowds to our demos, who would in turn appreciate the talents of all the skaters involved.

HAWK

The response to our tour was tremendous. I'm sure all of the television exposure helped. Regardless of the TV hype, these types of tours are where I feel most comfortable. We can skate with the kids, interact with the skaters, and the skating is always raw and spontaneous.

The Birdhouse team had fun that summer. We covered the country playing video games, watching movies, and listening to music as we were shuttled from demo to demo. Fiona Apple was one of the chosen CDs of the trip, and whenever the song "Shadowboxer" came on, everybody would stop what they were doing and croon along with it. To this day, I can't hear that song without laughing, thinking of eight guys singing along. There were other musical "rules." Madonna's "Immaculate Collection" announced that we were close to our destination. You couldn't play it any other time, or you'd get in serious trouble with the rest of the team. To raise energy levels, Prodigy's "Fat of the Land" CD was blasted before pulling into a demo site. It was one of the most enjoyable tours I've ever been on.

Sometimes we all got a little *too* hyper, and our RV suffered. After six weeks of touring, it had a wide variety of injuries. Bumpers had fallen off from smashing over things, we'd backed into a pole and smashed the exhaust pipe, and the TV had managed to topple over numerous times and finally broke. One night I got a little excited and, with some help from the mini-bar, kicked through the sliding door; it never really worked that well anyway. The RV had little chance of survival.

I managed to maintain some balance. I called home every day and even persuaded Riley and Erin to come on tour for a couple of weeks. The partying slowed down dramatically during that time, but we still had a blast.

The crowds were stoked too, and we skated our hardest every demo.

I flew to London for a vert contest and won. When I returned to the States, I placed second in another Hard Rock contest at Universal Studios. (Bob Burnquist, who'd placed first, had one of the most amazing runs ever witnessed.) I skated doubles with Brian Howard (Andy was not attending) and we won.

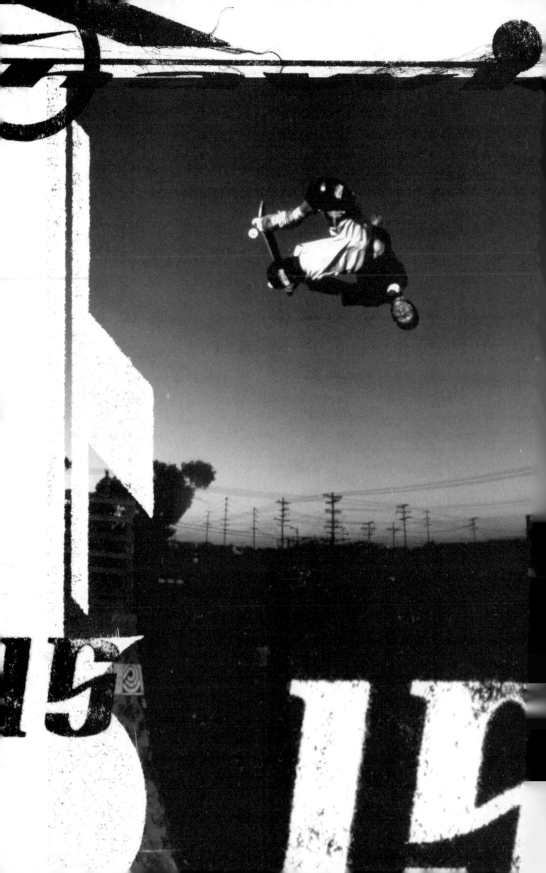

chapter

15

THE END

BIRDHOUSE WAS ONE OF the most popular skate companies in 1998 (it's a fickle market, and a company's success can change monthly). We decided to produce a video that would set us apart from other companies. The raw—and, in many cases, poorly shot—style of videos had been the staple of the skate video market, but I thought it was time to step up and make a video that would have the longevity good Powell videos have had. We wanted to shoot it entirely on film and hire Jamie Moseberg (a.k.a. "Mouse"), an accomplished snowboard video producer and former pro skater, as director.

Birdhouse pro skaters got to work with the director, have creative freedom, and be in charge of directing their own parts. Jeremy Klein and Heath Kirchart decided to film their segments together; Steve Berra, Bucky Lasek, Willy Santos, Andrew Reynolds, and I went solo. The original idea was that each rider would create a segment highlighting his personality and skating. If I said some guys got carried away with the freedom of being in charge of their own segment, it wouldn't be an understatement. Almost immediately our $100,000 budget was spoken for, and each skater had Hollywood ideas of what he wanted to film. By the time we wrapped filming in September we had shot $60,000 over budget, greased palms in Mexico, exploded vehicles, burned down a part of the Birdhouse warehouse, employed porno actresses for nonporno work, and involved professional stuntmen, professional makeup artists, and fire departments. We felt it was a fair representation of skateboarding.

ANARCHY IN THE U.S.A.

Steve Berra filmed his part in Hollywood. He employed a few special effects artists he knew so that when he got decapitated (in the movie, not real life), it would look legit. It looked so legit we got complaints from parents who didn't exactly expect a skater to get his head chopped off in a skate flick.

But it was Jeremy and Heath who got out of control the quickest, and their anarchy only escalated the longer the shoot went on. They purchased $1,500 Armani suits on Rodeo Drive and filmed their entire part skating in them. They'd call Mouse up at 4:00 in the morning, demanding he drive to L.A. to film them skating a gas station or a bus stop. If he complained about their waking him up, they'd torture him with crank calls until he broke down and made the two-hour drive to L.A. from Encinitas. Jeremy and Heath would kamikaze skate spots; it was amazing they never got busted. They'd spend the entire night skating a closed gas station on a busy L.A. street. This wasn't merely Mouse holding a camera and shooting as they skated around the location. There were spotlights illuminating

HAWK

the area, generators running, and at least two cameramen carting around 35-millimeter cameras.

During one particular outing, a few cop cars rolled up across the street. Everyone prepared a story, thinking they were about to get popped for skating on private property, but the cops stayed in their cars and watched the filming. Heath had to push from across the street in order to get enough speed to do a grind on the Blockbuster sign. While he was walking back to his starting point, one of the cops waved him over. He didn't say anything about skating the sign, but he gave Heath a ticket for jaywalking. They then hired Hollywood stuntmen who taught them how to light themselves on fire without getting killed. Naturally, they skated the rest of the video on fire. They smeared fire-retardant gel all over their bodies, sparked themselves up, and skated off the Ocean Beach pier for their finale.

If you've seen the video, you probably know some of the other stunts Jeremy and Heath pulled. Driving down stairs in the middle of the day while the inside of their van was on fire was a favorite of theirs. I can't forget the time they incinerated the wooden shed at the Birdhouse warehouse. Eventually they die, in the movie, when their van explodes and they drift to heaven (in their version, you arrive in heaven driving a Lexus), which is a mansion staffed with porno actress maids and amply supplied with candy and video games in every room.

Filming the video seemed to have permanently altered their brains. The video was over, but their sense of method acting had taken over. A month after *The End* premiered, Jeremy, Heath, Sean, Atiba Jefferson, and I went out for dinner. The four of them came to pick me up at my house in a dented van with one working headlight, a smashed grill, cracked mirrors, and only a driver's and passenger's seat. If you were unlucky enough to be in the back, you ricocheted around like a pinball. Sean had accidentally smashed a bottle in the back and Heath lit a stack of magazines on fire, so when you were flung around (anytime you turned a corner), flaming paper covered you and you would skid on glass.

This wasn't enough excitement for Heath, so he burned a few

sweatshirts. They were a polyester/cotton blend, and if you're ever around flaming polyester—not something I recommend—get away, quick. The stuff is napalm; it melts into a flaming blob that burns continuously. Heath used the flaming sweatshirt as a whip. The van was already filled with ten inches of ash from the burning magazines, and toxic fumes (another by-product of flaming polyester) created a rolling gas chamber. We were choking, our eyes burning. Jeremy, who was driving, was forced to stick his head out the window so he could see and breathe, but we had no windows in the back. We were on the 5 freeway by now, driving eighty miles per hour toward downtown San Diego, swerving across lanes. The smoke was making everybody lightheaded, so Heath decided to open the side door. He struggled with it for almost a minute and almost puked from the smell of the burning sweatshirt fumes before he gave up.

Heath and Sean kicked at the door for a few minutes until it opened. A word of warning, and a bit of elementary physics: when you're traveling in a van at eighty miles per hour air doesn't go out, it creates a vacuum. That means eighty-mile-per-hour wind blowing *in*. It felt like being in the middle of a small explosion. Flaming embers, burning magazine pages, and broken glass blew into hair, eyes, ears—everywhere. We were screaming and laughing, and Heath and Jeremy were having a ball.

By the time we made it to Ruth's Chris Steakhouse in San Diego, we were chalked head-to-toe with soot. Somebody at the restaurant said it smelled like a campfire when we walked in. Heath and Jeremy's plan was to eat, pay the bill, light themselves on fire, and then walk calmly out of this fine eating establishment. Luckily, we persuaded them to skip the lighting-themselves-on-fire detail. During the meal, a few people came up and congratulated me on the X Games. I was afraid that if Heath and Jeremy sparked up, all the people at the restaurant would link them to me.

After a $300 meal we were back on the road. This time Heath lit both Jeremy's sweatshirt and the dashboard on fire. Dashboards are constructed of rubber and plastic, again not the smartest thing to burn in terms of toxic smoke. By then, I just wanted to get home alive.

But Jeremy and Heath wouldn't drive me home, because they

HAWK

wanted to jump Dukes of Hazzard–like from one parking lot to another. I decided to watch rather than participate, so they let me out along with the photographer. The two parking lots are built on a hill. Between them was a ten-foot sloping dirt pile with shrubs and trees. Jeremy and Heath's plan was to gain some speed, bounce over the parking lot curb, plow over the trees and shrubs, and land in the lower lot. They were thirty seconds away from jumping when a police car came screeching in on our right, lights flashing. Then another one came in on our left. Three more drove in on the lower parking lot. A very unhappy-looking cop jumped out and told them to get out of the van slowly.

The head cop made us line up and sit on a curb while he checked to see if we had any warrants on our records.

"We had multiple complaints that a white van was driving recklessly down the highway and the interior was on fire," he said after all our records came back clean.

"Oh, that must have been the flash from our cameras going off. We're shooting pictures for a skateboard magazine," Jeremy answered. While this was going on three cops were inspecting the van, which was still smoking, the dashboard melted and sagging like a strip of taffy while ash carpeted the floor.

Apparently we hadn't done anything illegal, since they didn't catch us in the act, and surprisingly there aren't a lot of laws concerning lighting your vehicle on fire, so they let us go. One of the cops recognized me, and after a few minutes they could tell we were just a bunch of idiots and not dangerous criminals. They were actually cool and agreed to pose for pictures with us. We wanted photos of them busting us and they complied. One cop raised his billyclub above Jeremy's head (joking) and asked, "How about this pose?" They were undoubtedly the coolest cops I've never been busted by.

Luckily we were near my house, and they dropped me off. That was the last time I let Jeremy and Heath drive me anywhere.

THE END

215

BIRD IN A BULLRING

One of the reasons we called the movie *The End* was because I assumed that in my last role, I would get footage of me landing my wish list of tricks. I wanted the video to be a culmination of my video career. I had a decade-old list of tricks etched in the back of my head, and I knew I had to get them on film while I still could. I'd done ollie 540s, kickflip 540s, and stalefish 720s, but the three tricks that had eluded me for years were varial 720s, the 900, and a clean loop. I would do them for this video and finally be able to throw that list away. (It seemed weird that I might *complete* the tricks I'd imagined in my head years ago.)

Because we had a $100,000 budget, all the skaters went crazy with big-budget ideas for their parts—myself included. I didn't want to film at an existing ramp people had seen a million times. I wanted to build a huge custom ramp (in a hidden location), designed with larger transitions so I could go higher than normal, and, I hoped, that would make the 900 and the varial 7 easier. I'd also build a loop at the end of it. At a Birdhouse brainstorming session, our team manager came up with the idea that we could build a ramp that size in a bullring. We all laughed. That would be funny. Weird-looking, too. You know . . . it just might work.

A few weeks later, Mouse hooked us up with a bullring in Tijuana, Mexico. It cost $30,000 to build the ramp and there were all sorts of weird stipulations and hoops we had to jump through to film in the bullring, but Mouse worked out a deal. He'd film a bullfight for our movie, and the board of tourism could have the footage when he was finished. And we'd donate the ramp to their parks and recreation board.

It was surreal seeing the desolate bullring for the first time. It was huge. Seeing a brand-new vert ramp in the middle of the dirt ring with empty stands surrounding it felt like a dream. It was my personal playground. One thing I wasn't hyped on were the monster red ants that crawled all over everything. They were huge! There must have been a radiation leak near the bullring or something. You could see their pincers gyrating as they crawled underneath your feet and all over the ramp.

We rented the ring for eleven days, for a bargain $2,200. Once we handed the money over, a few hundred more was tacked on "for taxes." But we didn't complain; if we were filming in the States we'd be paying at least that much per *day* to rent a location of this magnitude.

Tim Payne flew in from Florida and began building the ramp. By the time he was done, it was forty-eight feet wide with a six-foot channel and a seven-foot-high roll-in. The transitions were a massive twelve feet with two feet of vert, making the ramp fourteen feet high. A loop was attached to the side of the ramp. When I stood on the roll-in, I was over two stories high. But I needed to be in order to take advantage of the big transitions.

I was scared the first time I saw the ramp—the thing was so huge. Once I started skating it didn't get any better, at least not immediately. I had to fight my natural tendencies and, in a way, learn how to skate ramps again.

Everything was different: the way I launched into my airs, the hang time, and how I had to adjust my weight to land. The first day I felt like I was always going to lock up on the coping when I came in on airs, and I almost buckled and slammed into the other side of the ramp when I started rolling in because I'd gather so much speed

I'd miss my pump (when you crouch down to gather more speed as you go up and down the ramp).

After the second day I got used to the ramp. Skating became weird, like being stuck in slow motion. If I normally went six feet high on airs, this ramp would make me go ten. I could do twelve-foot-high 540s and go fourteen feet on Japan airs, one of my favorite airs. To do one you have to do a backside air, but when you grab around your front foot to pull your board back you tweak it. I had some problems at first, because I'd hang in the air so long I wouldn't arc like a normal air; I'd shoot up and feel like I was plummeting straight down. But it was fun. I could get used to the sensation.

We filmed for the next six days, saving the loop and the 900 for the last day, in case I got hurt. I did my first varial 7 on the fourth day, and all that was left was a full loop and the 9. I knew I could do the loop, because a few years earlier Airwalk had hired Tim Payne to build the first fullpipe/loop in Encinitas for an ad. I made it all the way around before I shot out and skipped across the ramp on my ass. In other words, I didn't land it. The ramp had a serious design flaw (my idea, thank you) that made exiting nearly impossible. I redesigned the ramp in Mexico, correcting the mistake.

We borrowed some gymnastic mats from the Encinitas YMCA to use for practice. When I rehearsed the loop, I put as many mats down on the bottom as possible so that when I fell, my head would hit nice soft padding instead of bad hard wood. In order to do a loop I have to get a rhythm going, an unbroken pump, so I can carve the loop in one smooth movement. But I lose that rhythm fast—I'm talking a few minutes. So I told Mouse ahead of time to make sure he had all his cameras ready so that when I felt I had my rhythm, and people ran in to remove the pads, I could go immediately. "Okay, okay, no problem," were his exact words.

I practiced for twenty minutes, got the rhythm, and was ready. "All right, I'm ready," I announced. People ran in and removed the pads, I ran up the starting ramp, and . . . waited. And waited some more. After five minutes, Mouse said he was ready to go. I knew my loop feeling had evaporated, but I thought I'd give it a go. I dropped in, carved halfway around the loop, and at two o'clock fell off the

HAWK

top like a sack of potatoes and slammed to the flatbottom onto my hip. More pads, more practice, and I made it half an hour later (Mouse was much more responsive the second time). I repeated it a few times to make sure we had a clean shot, but forgot that skating the loop is a magnificent way to compress your spine. It's one of the best ways I've ever encountered, pretty close to the 9. If you love back pain, I highly recommend it. I had to stop on the way home from Mexico that night to buy a bottle of extra-strength Advil. I love Advil. I have it strategically placed around my house and in my car so that if my back acts up, I always have some ready. If anybody knows how to get an Advil sponsorship started . . .

The 900 did not work out, and I felt like a loser after failing to land.

By the time we'd finished the entire shoot, Mouse had shot 14,000 feet of film with three 16-millimeter and four 35-millimeter cameras. The collective cost of permits, greased palms, and the ramp came to $40,000. Mouse, Jeremy, and Heath went back to Mexico and filmed the bullfight a few months later, but watching a bull get stabbed repeatedly isn't exactly my idea of a good time, so I declined.

ANARCHY IN THE THEATER

We premiered *The End* at the Galaxy in Santa Ana, California, on October 8, 1998. I rented a stretch limo and bought an Armani suit for the occasion. Sean, Greg, Matt and Cathy, Kevin Staab, Chris and Jennifer Miller, and Erin and I all piled in for the hourlong drive. I expected a decent crowd, but the parking lot was packed and skaters swarmed everywhere. If you've never been to a skate video premiere, let me clue you into one absolute: it always ends with the police coming. Skaters always show up en masse to premieres hoping to get in if they don't have a ticket, and the theater was already maxed out before we arrived.

To make everything go smoother, Mouse, who'd had months to edit the video but decided to leave much of it to the last minute, arrived two hours late with the only print we had (a common occur-

rence at skate premieres). Drunk skaters waiting two hours for a video isn't that pretty, but they knew where to draw the line. If they were too rowdy, the place would get shut down and nobody would see the video. We'd hired Crackhead Bob from *The Howard Stern Show* to introduce the video, and he managed to calm the crowd down and assure them the video was on the way.

The End premiered, skating strewn with obscene orangutans, exploding vans, porno actresses, food fights, and lots of fire. Everybody loved it. I was incredibly happy. Because the skaters were unnaturally well behaved, the bouncers took it into their hands to get the party going.

Birdhouse had rented the Galaxy until 1:00 A.M. and it wasn't even midnight yet, but the moment the movie ended bouncers flooded the theater and began yelling at skaters to leave. Not asking, but yelling, like we were bratty children being sent to our rooms.

One stubby bouncer took his unprovoked rage out on the skaters. I was on the balcony when he came running up, yelling at skaters, "Get the fuck out!" He grabbed a skater that was walking down the stairs by the back of his shirt and threw him down. He tried to grab another skater, who knocked his hand away and said, "Chill out, hillbilly." The stubby bouncer freaked! I almost thought he was faking it, because he resembled a bad-acting pro wrestler on TV. His face flushed red and his eyes bugged out, and other bouncers had to hold him back.

The cops showed up and tried to break up the crowd, which filled the parking lot and was getting moblike due to the bouncer abuse. Skaters were trying to get back in past the bouncers at the door to fight Stubby Bouncer; cops were trying to get everybody to leave and soon began arresting people. I made sure Crackhead Bob had a ride to the hotel, then jumped in the limo with Erin and the rest of the gang and headed home.

Red and blue flashing lights filled the parking lot as we drove through packs of skaters and police handcuffing people, but I knew Birdhouse had completed what we'd set out to do with *The End*, which was to make a movie that raised skate video standards.

HAWK

16

chapter

16

1998

IN MARCH OF 1998, I had to attend an ESPN Athlete Advisory meeting. This offered a chance to speak to ESPN on behalf of the skaters and voice our concerns. I felt it was important, since I'd been chosen by the skaters to represent all of the competitors. I had issues to bring up. The conference took place the day before the annual Tampa contest, which I wanted to skate.

The Tampa contest is regarded as one of the most legit contests in skateboarding. It takes place at the Skatepark of Tampa in Florida, which used to be located in one of the less desirable parts of the city but has since relocated to a different section. The park has an old, outdated vert ramp that's small by today's standards, but still fun. You might win $1,000, compared to the $10,000 you could pull in at the X Games, but the contest involves raw skateboarding by

skaters and for skaters. Nobody cares what the prize money is or what the ramp is like; the contest carries the most credibility in the skate world. It's the polar opposite of the X Games; all the flash and glitter is exchanged for a dank and slightly grubby place—in other words, a real skatepark.

I caught a red-eye flight after the conference and arrived the morning of the contest. The schedule allowed me four hours of sleep on the plane. You don't sleep too well, though, when you're six-foot-three and squished into an airplane seat looking like you're holding a yoga position. But I was psyched to be at the event, and managed to place first in the vert contest. Andrew Reynolds won the street event, so it was a Birdhouse sweep.

In the summer I placed third in the X Games, which surprised me because I thought I had landed in second. It also seemed to surprise the crowd, because when the results were announced and they got to my name the crowd flipped off the cameras. They began yelling obscenities at the judges. Needless to say, you didn't see that on television. The only announcement I heard was that Andy had won; I didn't even realize I'd placed third until the trophy ceremony. I partnered with Andy Macdonald and won vert doubles the next day.

I won every other contest I entered that year. I was proud of that accomplishment, because I'd turned thirty years old in May and to some people in this sport that is considered ancient. But I didn't feel my age, and I wanted to prove to myself that I could still hold my own on a ramp. I didn't bounce back from slamming the way I used to, so I cut down on street skating (not contest street skating but actual street skating, which is a lot different), because that's where the majority of my injuries occurred.

In Germany, at the end of the summer, I pulled what I think of as the best contest run of my life. I did everything I could do and sort of surprised myself. I did tricks I'm not usually consistent with, such as frontside cabs and ollie 540s, and managed to stay on my board. For my last run at the Germany event, I did a retro run as a joke: all my tricks were pre-1990, and the crowd seemed to appreciate it.

After the contest, I met Erin and Riley in Italy to meet with Diesel Clothing and talk about a potential sponsorship. It wasn't the

HAWK

romantic Italian trip that you read about. Riley had a fever and Erin had morning sickness. But I was happy to finally be with the family while traveling.

SELLING OUT?

By the end of 1998, I was getting some weird offers for endorsement deals. The money was ridiculous compared to what I was used to. Some of the offers themselves were just plain ridiculous, regardless of the monetary potential. It became overwhelming. Pat suggested I hook up with an agent, and Sarah, my publicist, knew a few agents because her husband works with some. I met with some people and hemmed and hawed, because I was scared of being misunderstood and treated like a football player, or an ice skater, or any other type of mainstream athlete. It was unheard of for a skateboarder to have an agent for anything besides television commercials. But I also realized I was heading into uncharted territory with all the mainstream interest, so I decided to test the waters.

I signed with the William Morris Agency and Peter Hess became my endorsement agent, and at first it was bit rocky. He didn't know the skate world or what I wanted to do with my career. I have to admit I wasn't the most articulate guy on the planet when it came down to explaining my direction. He'd set up a deal with a flaky company and I'd shoot it down, and he couldn't understand why. I think I frustrated him a great deal in the beginning, but after a few months we got comfortable and it was smooth sailing. I was constantly amazed at the deals he negotiated; he got me ten times what I thought would be a decent offer.

Since I started working with Peter, a few other skaters have hired agents. I think that in the future, more and more skaters will need them to get a fair shake in the endorsement world. Skaters can't deal with a huge company and expect to get a good deal—it's two different worlds and we're out of our league. Skaters don't know their worth outside of the skateboard world and, at least right now, we need people on our side to tell us what that worth is.

1998

225

chapter

tony hawk

birdhouse

17

1999, THE YEAR OF THE '9

I KNEW FROM THE START of 1999 that it would be my last year of competition. Unlike the other times I temporarily stopped entering contests, I wasn't bummed about any particular thing; I was just burned out after more than twenty years of competition. I didn't have the same drive to skate in them, and I found myself going through the motions in May during the first contest of the year in Richmond, Virginia.

A journalist for *The New Yorker* tagged along at the contest in Virginia to write a story on skateboarding and me. He was a nice enough guy, a poetry teacher on the side. He could probably relate

to skating better than most writers, because poetry seems a bit on the subculture side of things, although you don't see "No Poetry" signs everywhere you go. You know skating has become popular again when a stuffy magazine like *The New Yorker* (I always picture long-nosed aristocrats reading it in their spats) does an article on skating.

A yin-and-yang deal was beginning to happen: almost all the mainstream media worked with me when doing features on skating. I became the unofficial ambassador. I had one foot in the skate world and the other in the civilian world. It was beginning to seem as though I had been chosen by the media to represent skateboarding on many different levels, and I was happy to accept the role.

I didn't tell anyone how I felt about contests. I was still trying to figure out for myself what I wanted to do with my life. Was this just a lull? Was I over contests totally? I didn't know, but I knew even when I won that I wasn't as excited about them as I used to be. I knew if I retired from competition what the ramifications of my decision would be. I'd hit a crossroads. I was the most recognizable skater in history, and a lot of it had to do with my contest record—at least as far as my popularity outside of skateboarding went. I had no doubt that skating would get more popular in the next few years, so popular in fact that I don't think it will die again. If I'd wanted to, I could have ridden out another ten years placing in the top ten at contests. I wouldn't have been at the top of my game, but I'd still be in the spotlight and making money. Would I continue to be courted by sponsors and endorsement deals if I weren't running around on TV with a trophy? I wasn't that concerned. Sure, it was a blast to hang out with my friends at contests, but competitive-style skating was turning into a job. I might as well have been digging a ditch. In my mind, I decided I would stop competing after the last contest of the year.

Shortly after I had made this decision, my second son, Spencer, was born on March 28. He was one of the skinniest babies I've ever seen, but also one of the happiest. He was nothing like I was, no inconsolable temper tantrums. I must have some serious karma stored up, because both my sons have been extremely happy babies.

228

HAWK

ME TARZAN

The Disney movie *Tarzan* came out in the spring. Since I'm also a dad, I already had the ability to recite *The Lion King, Robin Hood*, and *Toy Story* verbatim. Naturally, Riley wanted to see *Tarzan*.

One of the main *Tarzan* animators had a son who skated, and he watched *The End* as much as Riley watched *The Lion King*. He was trying to figure out how to animate Tarzan's movements through the jungle. While he was brainstorming he caught my skating, because his son was watching our movie. He animated some of my skating and the loop, and then he used them for the part in the movie when Tarzan whips through the trees in the jungle. Disney contacted me and interviewed me for a documentary on the movie, and invited me to the premiere. Now skating, and inventing tricks, and winning contests is great—but I scored some serious bonus points with Riley for being involved in a Disney movie.

Minnie Driver, the voice of Jane, and the other *Tarzan* stars were hanging out at the premiere. I asked if I could have my picture taken with her and she was kind of snotty. She acted as though it were a great inconvenience to stand in one place (where she was already standing) and look toward a camera. It was disappointing to learn that many of these Hollywood actors are not willing to exert a little effort for their fans.

After the movie, I was walking around eating food when I happened to see none other than Josh Brolin, son of James Brolin, but more importantly the star of *Thrashin', A Love Story*. (He's since had a very successful career on Broadway.) I remembered him as Corey, his character's name in the movie. I talked to him for a while—it took a few minutes for him to realize we'd worked on the movie together—and who should come up but his girlfriend, Minnie Driver. She had no idea it was me she'd snubbed earlier, and was nicer to me this time around.

X-CITEMENT

I was not very excited going into the 1999 X Games. After a year of contests I wasn't exactly enthused about, my feelings avalanched onto me. Skating a contest run felt like trying to get out of bed when you're still tired. But I got to stay in the W hotel in San Francisco, and I love that hotel. My publicist and agent came from New York to watch, and Erin and Spencer were there too.

In skateboarding, people are almost uniformly indifferent about their accomplishments and contest records, or at least act like it. For instance, a skater could win $18,000 by winning a contest. But somebody like Colin McKay, who could easily walk away with the winner's trophy (and has many times), doesn't care too much if he doesn't even make the cut into the finals. Contests are not a measuring tool for a skater's abilities. No skater thinks Colin is a crappy skater; every skater still has magazines and videos with Colin destroying everything he skates, and knows that he's one of the best the sport has ever seen. His sponsors don't care about his contest placings (they're happy if he does well, but if he doesn't, you won't ever see them bawling him out), because skaters respect the guy.

This is how skateboard sponsors think, but nonendemic companies can get fruity pretty damn quick. There was one company in particular that wanted to sponsor me simply to get the word out that they sponsored me. Nothing wrong with that; it's the whole point of sponsorship. It is a company that I believe in, so I have no problem promoting it—to an extent. We agreed I would wear their sticker on my board and helmet whenever competing. Let's reiterate: I wear the sticker; my job is done. Or so I thought.

At the X Games, a woman came up to me with the sponsor's company sticker, which was so big it would have covered my bed. I don't know why she didn't just bring me a cape with their logo on it to wear. For the entire X Games it was a constant battle of where to put the stickers—now they were saying they had to be strategically placed on my helmet. It was as though I were selling real estate or something. After a few days I told Peter that if it went on like this, the company could take its sponsorship back. I didn't care. It was a

230

case of skateboarding clashing with the corporate world head on. We've worked things out since then.

I skated into third, and I can't complain about the contest. Bucky won the vert event, and I wouldn't have traded that for any victory. Hell, who knows, maybe if I hadn't got third (I wasn't exactly clicking my heels over that) I wouldn't have pulled the 9. It gave me the incentive to go for broke in the Best Trick Event.

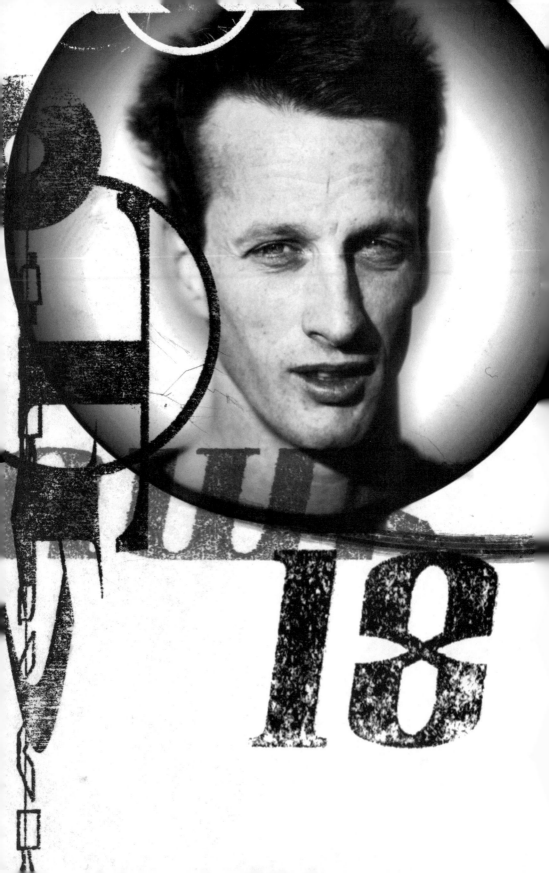

chapter

18

ONE 900 HISTORY

TO GET A PROPER PERSPECTIVE on what the 9 means to me we'll have to backtrack to 1986 to the town of Bourges, France, where I was teaching a skate camp for three weeks. Because it was in France, my days were divided into four parts: skating, searching for toilet paper (they use bidets there), eating hard bread, and attempting to pick up girls. My odds of any female interest were drastically reduced by the fact that there were mostly males at the camp, and you don't find yourself eating too much bread when it makes your gums bleed. But at least I could skate.

I had 540s pretty dialed by then, and one day on the ramp I tried spinning them sooner, before the peak of my air. I figured that if I could go high enough, and spin fast enough, I could whip off another 360-degree rotation. I goofed around and couldn't come close. I always wimped out on the second rotation and ended up bailing seven-foot-high 540s. I never really "tried" the 9 in the land of bidets, but the seed was planted there. I couldn't see myself ever pulling the trick and didn't even try for another decade. That's how unfeasible I thought it was at the time.

In February 1996, I was at the Action Sports Retail Show (ASR), a trade show where skateboard companies show off the next season's line of products, and they had set up a halfpipe in the middle of the convention center for demos. At the time, vert skating was still considered a novelty and vert ramps were scarce, so most surviving vert skaters showed up for the demo. ASR, in a sense, was a class reunion.

We had a good skate session going, and someone in the crowd yelled at me to try a 9. Now, when I say I didn't attempt it for a decade, I mean it. But for some reason I thought this was a fine suggestion. I was hyped from the crowd and the chance to skate again with my friends. I practiced a few high airs, a few 540s, and then prepared myself mentally. I thought about how hard I'd have to pull off the side of the vert ramp so I wouldn't hang up on the deck, and how hard I'd have to wind up to spin a tight 540, and then wind myself up again to crank another 360 immediately after. But I felt good, like I was finally ready to commit to the extra spin. I practiced a few more 540s.

I did three setup airs to get my speed going. After the third air I went as high as I could and started spinning, and spinning, and spinning, until I didn't know where the hell I was. I now have an enormous amount of empathy for gymnasts and their ability to land gracefully. You don't panic in moments like that, because you're too busy trying to figure out which way is up. A huge part of skating is falling, and you get used to it quickly. So it's a matter of finding the best way to slam, i.e., the one that causes the least amount of pain, which you improvise when you're starting your descent.

HAWK

Skaters are amazingly creative when it comes to getting out of awkward slams. I once saw Sluggo (his real name is Rob Boyce, but his nickname is Sluggo since he sort of looks like the character in the Nancy comic strip) miss a pump on a backside air. He shot into the air, feet first, ten feet above the ramp. He knew he had to turn his body around to avoid landing on his head, so he did a midair somersault and turned his body to face the ramp as he fell. This was impressive, because he had less than a second to react to the situation. In all fairness, Sluggo used to be a gymnast.

It hurts when you fall. Your elbows swell, your knees ache, and your spine crushes into chalk dust from constantly falling ten feet onto your knees—but remember, skating is fun. When I got lost in the 9, I wasn't worried about being hurt. I was worried about falling the right way, and I was having some difficulty doing that. I was up, then I was down. My board flew off into the crowd and nearly impaled a spectator, and while I was in the air I couldn't see the ramp to tell where I was going to hit. I had to keep spinning the full 900-degree rotation because stopping anywhere before makes it more dangerous, sending you to the flatbottom of the ramp on your back. Not being able to find the ramp wasn't a problem for long, because I dive-bombed into it soon enough. My shins hit the hardest part of it, the steel coping on the top, and I bounced, back first, onto the flatbottom of the ramp. As I lay there, I realized a little too late that I should have pulled off the wall more. With my shins bleeding and swelling, I tried to pinpoint the evil bastard who suggested the stupid trick to me.

PIPE DREAMS

Since the early '90s most skaters figured that nobody would land a 900 anytime soon, but every vert skater knew it was a trick to shoot for. A few other guys, including Danny Way, Sluggo, Giorgio Zattoni, and Tas Pappas, four of the best vert skaters in the world, began trying it too, but we all resembled aerobics instructors being shot out a cannon. We'd spin and twirl through the air, our skate-

boards flying and our bodies slamming on the flatbottom, straight onto our knees. We were more like performance artists than skateboarders. We had learned 540s and then 720s, but the extra 180 degrees needed for the 9 was a nightmare. I felt I couldn't wind myself up that much and still maintain control. It wasn't a progression from the 720, but an entirely new trick. I needed to figure out a way of spinning that would keep my body in line with the wall of the ramp so I could land on the ramp properly balanced.

Eventually, we all got a little bit of the spinning technique down and ceased flailing as often. But this created another problem: we couldn't stop spinning. It was like trying to jump out of a washer locked on the spin cycle. We'd land on the ramp and our bodies would continue spinning until we hit something or whipped off our boards and hit the ramp violently enough to stop. Chiropractors loved us. Our spinal columns evolved from a line of straight vertebrae to a corkscrew design in a few short months.

But after constant slamming, Danny, Sluggo, and I began thinking the 9 was finally within our grasp. The biggest problem was that it wasn't a trick you could practice for a week, because it killed you. After ten or so attempts, you felt as if you'd just walked away from a car crash. No trick comes close to scaring me like the 9. Maybe once a month I'd give it a shot to see what would happen, but it always ended with my slamming on the deck or spinning across the flatbottom. I knew I was getting closer. It didn't seem impossible anymore, but finding a decent place to skate did.

In 1996 a decent vert ramp was like an oasis in the desert. Danny and Colin McKay skated for Plan B, a skate company, and at the time the team had built the best vert ramp in San Diego County. The Encinitas YMCA had a ramp, but it was falling apart and kinked all over. It was too hard to get enough speed on it to pull a 9. On the other hand, Plan B's ramp was located indoors in the back of their warehouse, so the masonite never got wet and slow. It wasn't open to the public, and generally only Danny or Colin and a few Plan B employees skated it. I had to call each time to see if it was all right if I came by. I was excited that they let me skate on it; after all, it was their ramp and they'd paid for it. It meant a lot to me.

236

Amazingly, Human Skateboards also built an indoor ramp in downtown San Diego. Andy Macdonald skated for them at the time and let me skate there. The ramp was too small for 9s. Its curve (transition radius) was smaller than Plan B's, and I thought I needed larger transitions in order to go higher and have more speed and more time to spin. By then I had turned into a fanatical 9 scholar. I dissected every aspect of the trick and experimented. If I sped up the first 540 rotation and spun the last 360 slower, would that stop me from whipping out when I landed? If I spun it all at once, would that make me whip out more or give me more time to straighten out and land? What would happen if I went higher or lower, or if I went slower or faster? What if I had a regular bowel movement that morning? How would that affect it? I couldn't solve the problem. I'd get close in one aspect, but even a small adjustment would throw other variables off. I felt like a preschooler trying to solve a physics problem.

RAMP VS. RIB

By the end of 1996 I had started getting really serious about doing the 900. I usually tried at least one whenever I skated vert. Finally, one day at Plan B it started coming together. Sean was filming me as I skated. Sometimes it's hard to psyche yourself up if you're skating alone, but I was ready to go. I tried a few 9s and was getting closer and closer. After each attempt, I'd check it out on the video camera and make some adjustments. My biggest problem was that I was being a wimp. I just had to land or slam. When you spin a 9, no matter how good you get at it, you're always going to be blind to the ramp. You don't know where to land, and you have to try landing based on feeling rather than "spotting" a landing. As Danny says, "You've just got to stomp it."

I had it that day. I knew I could do it if I committed myself to trying. So I did. I spun, landed, and couldn't believe it. I was still on my board! However, I was leaning too far forward, tipped over, and slammed into the flatbottom. It felt as if I had just skated into a wall

while turning around. I lay on the ramp for a few minutes, my shoulder throbbing in pain. I knew I was done for the day and besides, I had to pick up my son Riley from preschool.

That night I couldn't sleep. I was furious that I hadn't landed the stupid trick, and my shoulder and chest killed with each breath. The next day I felt worse, so I went to the doctor. He took some X rays and told me that I'd fractured a rib.

I didn't attempt the 9 often after that. I had to be *really* determined to start trying it and I had to have skating a ramp that was perfect— a combination that doesn't occur too often.

At the 1997 X Games in San Diego, I had what I considered a good run and attempted a 9 during my last run. I wasn't close to landing one; I was still monkeying around with the spin. I never again got as close as I did at Plan B. I ended up trying a few at every skate contest to see if the trick would click on one of the ramps. Nothing worked until an enlightening session at the same Plan B ramp. I finally figured out the spin. After the first rotation, I would shift my body weight from my front leg to the back, preventing another top-heavy collision into the flatbottom. Carving (starting the spin at an angle so that you don't go straight up and down) the spin also helped the process. Solving the spin problem amped me up again. It was perfect timing for my video project, *The End.*

In Mexico the cameras were ready, the light was perfect, and everyone was watching as I rolled in and flipped a big 540 to warm up. But after that I got super nervous. The last time I'd really tried to stick one was at Plan B when I broke my rib, and I couldn't stop thinking about how much it had hurt. If I did eat it, the odds of finding decent medical help in Mexico were not high. I had to block the flashing doubt out of my mind and amp myself up. I rolled in and tried to spin a 9. I rolled in again and pussed out again, and again, and again, and again.

The day in Mexico wasn't my day, and I didn't try to make it my day. That's what killed me. I didn't try hard enough, and I let myself down. I ended up spinning a few full rotations, but I never tried to stomp it. If I'd slammed or knocked myself out, I'd at least have been satisfied knowing I'd given it my all. I sat in the corner of the

bullring in the blazing sun with my head in my hands. I didn't want anybody around me. I could have eaten a bucket of Prozac after the day of half-assed attempts and still have been depressed. It was the worst feeling I'd had in years.

Afterward, I thought I'd never be able to do the 9. After all, the unspoken reason for building that ramp had been to land the trick, and I had failed.

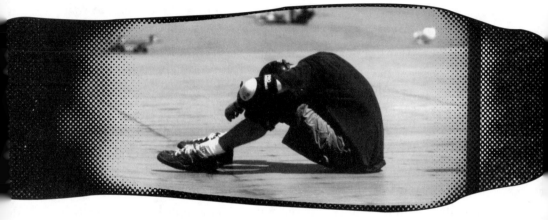

SPINAL ABUSE

A few weeks after *The End* wrapped, Sluggo called a few of the major skate photographers and announced he was going to land the 9 at the Encinitas YMCA. It was a ballsy move, but he was close. I think he wanted to put the extra pressure on himself so he would be forced to land it, since as a skater, you never want to let the photographers down. At that point I was so wrecked and bummed I would have been happy just to see anybody land it—conquer the beast. I heard Sluggo got super close with every attempt, but he ended up wrecking himself. He slashed his shins open and fell on his head. The 9 continued to keep us at bay.

My Mexico depression soon turned into anger. I was infuriated at myself for wimping out, so I set about to do the 9 at the Encinitas YMCA, the only local ramp at the time. I didn't care anymore about transitions and speed and all the stupid little variables I thought I

needed. I spun a few and stomped them down and slammed over and over. After awhile it felt like somebody had stomped on me. I once attempted the trick for half an hour straight before my back seized up. I walked off the ramp stooped over like an old man.

But I was still pissed. I visited my chiropractor every day and he adjusted me. After a week I was ready to spin again. My next 9 session lasted fifteen minutes before I walked off the ramp hunched over. It was back to the chiropractor. Two weeks later, I participated in another 9 session. This time I lasted five minutes and had to visit the chiropractor twice that day. That retired me for a while.

I gave up on the 9 for a few months, until I skated a contest in New Jersey. I had a few decent runs and tried the 9 in my last run. Good thing, because I piled into the ramp like a sack of potatoes being thrown out a window. I managed to get up, but I could barely walk. My back locked and I could have used a walker.

The best part was yet to come. I was scheduled to do a promo for a new Kellogg's cereal two days later in New York. I hadn't skated much, but my back got tighter and tighter as the day progressed. Finally I managed a pathetic ten-minute demo that I barely finished. I should have rented a wheelchair and rolled around on the ramp with it instead of my skateboard. I probably would have looked better. You wouldn't believe how enjoyable the seven-hour plane ride back to San Diego was that night. Airplane seats in coach are not designed for grown humans.

I like my spine. I like how it goes up my back and houses my nerves and lets my feet move and allows me to do nifty things like getting dressed; that's why I wasn't that eager to administer a beatdown on it again. I hadn't admitted defeat; I was just waiting for the right time to come back. I had no idea when that would be, but I wasn't about to rush it. To tell the truth, I stopped thinking about the 9 for some time after that.

The next time I gave it any thought was at the '99 X Games, and I'm glad I did, because now the ordeal is over.

HAWK

CLOSURE

After I landed the 900 at the X Games, newspaper after newspaper wrote articles about me. Sports programs showed the 9 on their highlight reels. Surreal. My schedule filled up with interviews, and television shows filmed segments about me. Old ladies, jocks, waiters and waitresses, policemen, security guards, and entire families congratulated me on landing the 900. What the . . . ? How did some basketball fan even know what a 9 is? Or why did he care? I was awestruck. ESPN had to assign a security guard to escort me around for the rest of the Games. Fans mobbed my family and me. It's ironic to think that a few years earlier skateboarding had been as passé as you could get, and now there were rent-a-cops fighting with teenagers to get a skater's autograph.

A week later ESPN televised the best trick contest, in its entirety, on television, and then things got really strange. Most of my life had been in a skateboard bubble, and now the bubble included a ton of people who watched television. I got an e-mail from a basketball coach who said he was going to use the 900 clip as a motivational tool for his players. He didn't skate, and none of his players did either. It was an honor, but definitely surreal.

The congratulations that meant the most to me were from other skaters. A lot of them called. Danny Way's meant a lot to me, because he was one skater whom I'd been trying the trick with for all those years. My childhood idol, Eddie Elguera, e-mailed a congratulatory note, and I finally had a sense of closure.

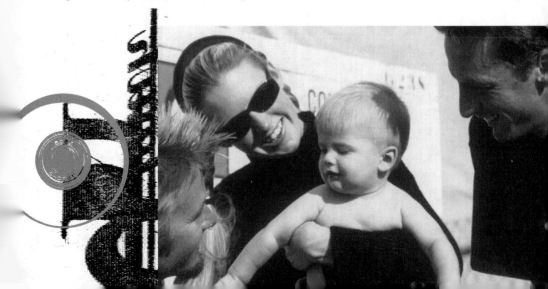

chapter

19

AFTER 9

I DID THINK ABOUT RETIRING after the 9, but I wanted to finish the year and skate well enough to satisfy myself in a contest. Even if I hadn't won the last contest at the Hard Rock in Huntington Beach, as long as I had skated up to my personal standards, I still would have stopped competing.

Lots of people thought I should have retired after the 9. "What are you going to do for an encore?" they asked. I had no intentions of topping it. Some told me, "End your contest career like Jordan and his last shot that won the game—that's his last image in pro basketball." But I still wanted to finish out the year.

THE END, FOR REAL

I won the Vans Triple Crown finals and that was it. After my second run, I walked on the deck and stood next to Grant Brittain, the old manager of Del Mar and now the most famous skateboard photographer in the world.

"How's it going, Tony?" he asked as we watched Bob Burnquist tear the ramp apart.

"All right. You know, I think this might be it, Grant. I'm done."

I'd had a run I was happy with, and even if Bob or Colin won I still would have been happy. All he said was, "Really?" He had expected it.

In an interview at the Hard Rock I told a small, local newspaper about my decision. I didn't want to make a big deal out of it, and I liked the fact I was doing it at a smaller venue where it was mostly just skaters. I don't know why, but I never told anybody this was my last contest. Erin found out because somebody who'd read my interview asked if I was serious about retiring. She didn't know what the person was talking about. Most of my friends and family weren't at the contest and chided me afterwards. But I was happy. It was done. After hundreds of contests and well over half my life spent competing, I was done.

YOU CAN'T ALWAYS GET WHAT YOU WANT

I was halfway home when I remembered I'd made a previous commitment to an MTV Best Trick and Highest Air event in Las Vegas. It had completely slipped my mind. Shit. When MTV heard about my retirement, they called to make sure I'd be at their event. I said I would, but since they knew this would definitely be my last contest they hyped the crap out of it. Not what I wanted.

By the time I arrived in Vegas, MTV was hyping up my situation. I asked them to tone it down, but they didn't do too much about it. Again, the problem with dealing with nonendemic companies is that

244

HAWK

you and they don't share the same goals. MTV wanted to produce a program that would get high ratings; I wanted to end my competitive career without a parade on TV. I didn't get what I wanted. By the time I was there and skating, it was too late. I felt I would make a bigger deal out of it if I pulled out of the contest. The drawback is that some people think I planned to go out on national (international?) television. Regardless, after I placed third in Highest Air and won the Best Trick with another 9, I was done.

NO REST FOR THE WICKED

Guess what? After I stopped skating contests, nothing changed. When I say nothing, I mean nothing in the skate world—it didn't make any difference to people on my side of the fence. Outside of skating people freaked, which emphatically proved a point to me about the mainstream media. *They don't get it.* Still, after all the years skaters spent trying to explain what we do and why we do it to nonskaters, it all fell on deaf ears. They treated me as though I were a football or basketball player when I said I'd stop competing; they made it mean I wouldn't skate anymore. I must have explained it over a hundred times in the month following the MTV event that I'd only retired from competing, not from skating. I explained numerous times that competition isn't the only aspect of skating. I told them that Jamie Thomas, who is currently one of the most popular street skaters, hasn't entered a contest in years, and it makes no difference in his ability to skate or his popularity. No matter how big skating gets, no matter how many people around the world get it zapped into their living rooms or see it in movies, they won't understand skating until they go and do it.

LOOK MA, I'M A VIDEO GAME

I've always liked video games. I bought a computer in the 1980s simply so I could play Marble Madness, and when Game Boy came

out I spent more time on tour playing Tetris than skating. But that was just the beginning; soon PlayStation, Nintendo 64, and Dreamcast popped up, and I bought all the systems.

Over the past year, as skating grew in popularity, a few companies approached me because they wanted to make a game and slap my name on the title. But even though they were major names, they were wishy-washy and dragged their feet, which was weird considering *they* had approached *me*. But three's the lucky charm, because Activision came to me in September of 1998 with a solid offer to produce Tony Hawk's Pro Skater. They already had an engine for the game, and surprisingly, the engine was good. Better than good: it was by far, and I mean *far*, the best skate game I've ever played.

I had loved the video game 720, and spent droves of quarters playing it. But this game was different, because the image it created actually looked like a real skater doing real tricks. They had captured the motions of skating perfectly, some so perfectly that you could tell who the animated skater was. Wonder why that stalefish looks so tweaked and sick? Think of Rune Glifberg, who owns that trick. The best thing about the game was how easy it was the first time you played, but it took a lot of practice to get the combinations of tricks down. There's nothing I hate more than games you can't play because you have to know two thousand sequences right off the bat.

I went to Activision's headquarters in Santa Monica, and we got to work fine-tuning the game. I started working closely with Neversoft, the development team chosen by Activision to be in charge of the project.

One of the first steps was to engage in a motion-capture session. They dressed me up in the worst outfit ever. It actually resembled a costume that a wardrobe designer on a commercial shoot would try to get me into: black spandex jumpsuit with white Ping-Pong balls velcroed to my hips, elbows, hands, helmet, feet, and skateboard. Skating with that uniform was a new and refreshing experience. I skated, did a few tricks, and fell a few times. Every time I fell I crushed the Ping-Pong balls on my legs, butt, and elbows. Well, I thought they were Ping-Pong balls, but they were obviously something else, because I noticed people flinching every time I picked a

246

HAWK

crushed one off my body and stuck another one on. Finally, one of the producers came over and explained the balls cost $90 apiece, and I'd wrecked at least a dozen of them already. I also hit one of the nineteen cameras, which took two hours to reposition, since the cameras have to be in *exactly* the same spot every single time for motion capture to work.

Every few weeks, an updated version of the game would arrive at my house. I'd play it incessantly and tell the Neversoft team what we should change or add. The best part of the deal was getting to sit in front of the TV playing video games, and I was *working*. Working damn hard, if I do say so myself. That meant when Erin asked me to take the garbage out or clean up my office (always a mess), I could tell her I couldn't because I was working. Unfortunately, after ten months the game was complete, and then my excuse well ran dry.

I thought I'd make a little bit of money off the game, but mostly I was amped to help create a good skating game. There was no way I thought it would take off beyond the skate world, but almost immediately it sold out in all the toy stores. In Las Vegas, during the MTV contest, Andy Macdonald, Greg, Sean, and I visited FAO Schwarz and filmed a segment of us playing the game against kids in the store for ESPN (though the store was sold out of the game and it was on backorder). Video game magazines put me on their covers, and I can't remember anything but stellar reviews (this has more to do with the game designers than with me, though). In a matter of months, Neversoft's projections were being lapped. Pro Skater was the bestselling PlayStation game of the 1999 Christmas season.

The thing that I love about the game is that it's the perfect marriage between the mainstream and the skating scene. Skaters love the game, and people who would never go near a board rave about it. It bridged a gap between hard-core skaters and mainstream viewers. For the first time I can think of, the two worlds worked together and nobody felt burned.

LOOP GONE BAD

Disney, the media conglomerate, owns ABC and ESPN. ABC did a little making-of documentary on *Tarzan* and interviewed me for the part I played in helping give movement to Tarzan "skating" through the jungle. At the end of '99 the *Tarzan* VHS and DVD release was gearing up, and they shot a commercial featuring me. In the spot I would rent *Tarzan*, skate home through an industrial part of town where I'd spin a 900 on a loading dock ramp (that happens to be shaped like a perfect halfpipe), do a loop that was disguised as coils of steel and wire, ollie the fence to my home, drop in the back-yard pool, and do a flip out of it. My son, who was played by Riley (one of my stipulations), is waiting there for my return. I hand him the video and he says, "That was cool, Dad, but can you do it in a loincloth like Tarzan?"

HAWK

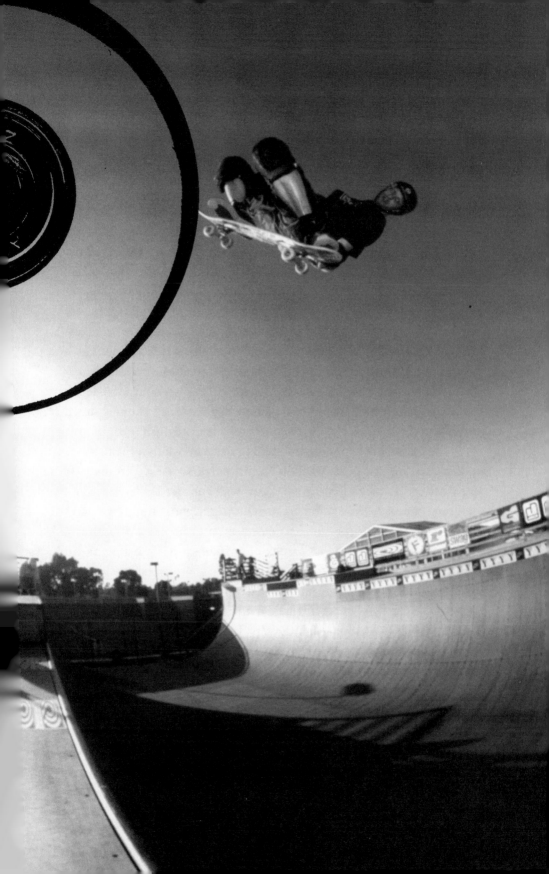

The razor blade/loop commercial was one of the worst experiences of my life, and while the other commercials I've shot have been all right, they've never been anything to jump around about. This was different; it was a great experience on all levels. What made it different was that the company actually listened to my wishes. They hired Sean as a technical advisor (because I was away during most of the preliminary work) and hired Tim Payne to build the ramps. In other words, they actually wanted real skating and respected what I said.

Stumpy, who had shot me a decade earlier for a Swatch promo video, was the director. He was a crazy skier (they call themselves extreme skiers now, but Stumpy did the sport years before it collected an official name) who'd blown his back out, had made a few ski movies that got him noticed, and now was directing a commercial for Disney to be aired during the Super Bowl. Since he was a skier and a professional athlete, he understood that he couldn't just snap his fingers and have me perform my little skateboard dance for the cameras. He told me ahead of time that he'd give me as much time as he could and let me tell him when I was ready. A dream shoot.

As a joke, the crew planned on telling me they wanted me to skate in a loincloth. Now, this wouldn't really surprise me, given my past experiences (I once dressed up as a well-endowed skateboarding grandma for an AT&T commercial). But in the end, Stumpy couldn't go through with it. The ramp was perfect, and I spun a 900 after a few tries—albeit with a sketchy landing—and then it was on to the loop.

I would do the same routine I'd performed for *The End*. I'd practice a few times with the gymnastic mats and when I got my rhythm, I would pull it without them. Except I didn't pull it. I was on the loop, positioned at about 11:00 with 12:00 being completely upside down, when I screwed up my pump and fell straight onto my head. I missed the stunt mats. I had just taken on TSG as a helmet sponsor, and I can only attribute not getting knocked out again to their product. I've been KO'd enough times to know this could have meant another trip to the hospital and a case of slight amnesia. My helmet took a beating and my ears rang, but I could tell my neck was

HAWK

okay. I got up and walked it off, tried the trick with mats a few more times, and then pulled three for the cameras.

I didn't even have time to go home the night the commercial ended, because I was flying out of Los Angeles to go to Australia for an Adio Tour. Kris Markovich, Jeremy Wray, my friend Greg, Jonas Wray, Ed Selego, audio team manager Jeff Taylor, and Dimitry Elyaskevich from *Big Brother* magazine rounded out the group.

It was a fun tour, the highlight being Dimitry's digital recording of himself on the toilet after a rough visit to Mexico. Blowout. Whenever he'd play it, everyone would laugh for at least ten minutes straight. People were crying. We'd play it everywhere we went. We hooked it up to the car stereo and played it full blast, and then watched as the surrounding people recoiled with disgusted looks on their faces—you couldn't mistake the sound. I'm laughing right now, thinking about its profound effect on innocent bystanders.

chapter

20

STILL GOING

THE YEAR 2000 is going great so far. I've got more demos lined up than ever before, and for some odd reason in the months since my "retirement" I've been in demand more than when I skated around in every televised contest. I regularly receive lists of names for autograph requests from various members of my family. Last year this averaged ten names a week, but now it's up to at least fifty a week. That's just through people we know.

Life is good. We moved into a new, larger house on a lagoon, close to the beach and, more importantly, with a gate. Some kids had found out where I lived, and my family was soon answering the door at least five times a day and fielding requests for autographs

while the skater's parents waited in their car. I have no problem signing autographs, but it freaks me out when people I don't know come to our house out of sheer curiosity (I also have too many toys that I wouldn't want to go missing).

I want a place where my family can be a family without constant interruptions. If you see me walking down the street or at a demo and want an autograph, come on over and I'll be more than pleased to oblige. I appreciate fans and realize the lifestyle I enjoy wouldn't be possible without their support, but when I'm at home I'm just your regular husband and father who has a problem keeping the house clean and usually forgets to take the trash out or empty the litter box. And that's the way my family likes it.

LIFE WITHOUT COMPETITION

I thought I'd have a problem when I removed the competition from my life. Ever since I was twelve years old I'd been preparing for contests. This had become second nature, and I thrived on it. It wasn't the reason I skated, but it supplied an edge to my motivation. Since retiring, I haven't had that problem. I'm more relaxed now. Stacy saw me in February and commented on how calm I was. He said he could tell this before he'd even talked to me. Personally, I don't notice any difference, but I'm sure there is one. Stacy has always been one of the most observant people I've known.

I don't think skating will die again. At least it won't take a crushing blow like it did during the early '90s. The foundation is too solid, too vast. It may dip down, but I doubt it will dry up. There is also a new generation of female skaters, which is a good sign in terms of diversity.

One thing I think skaters need now more than ever is a group or union of some sort. You may think it's great to win $10,000 at a contest and you're right, but only one skater bags that, and a lot of the time the television networks are raking in millions of dollars. They don't create skating programs as some altruistic gesture

HAWK

toward skateboarding. Most of the televised contests have entry forms that include a clause in which the skater signs away his rights to be paid anything other than the contest winnings. I was checking Amazon.com the other day and saw a new skateboard video for sale: *The Gravity Games* contest, starring Bob Burnquist, who had won the vert event. He'll probably never see a dime from that video. Yet skaters will buy that video because of Bob, because he's one of the best vert skaters to ever step on a board.

If an NBA video is released, the company producing it has to pay the league for licensing. Skating has no such agreement right now, and it's nobody's fault but our own. Yes, I know they help pump up skating and create a platform that reaches millions around the world, but the efforts need to be reciprocal.

Although skaters have many similarities in attitudes and beliefs, there is a serious lack of unity in the industry. We need an organization that can look out for the skaters' best interests and have the power to negotiate. All you'd need is for the top five draws in an event (say Bucky, Bob, Andy, Colin, and Danny in a vert competition) to boycott a contest or two for the powers that be to understand their value. I have to credit my agents for creating the financial situation I enjoy right now. There were numerous times I received substantial money for something I would have previously done for free or for a minimal charge. If an event or promotion is skate-based (for a shop or skatepark), then I'm not concerned with big money. I enjoy anything by skaters and for skaters. But if some company that has jumped on the bandwagon (but one that I believe in) wants to use my name to sell something, they need to talk to my agent. When I have other, more qualified people dealing with the business side of things, I have more time for what's important. In other words, I get to spend more time with my family, and it gives me more time to skate.

Skating made me who I am. I spent the better part of my summers and a majority of my weekends on the road from the age of fourteen and I credit that for forming my personality. I was thrust into so many different situations that I learned how to deal with almost all of them. I was there. It was reality. I had to learn how to relate. I've

gone from first-class suites to five-in-a-room at budget hotels and then back to the suites.

I now want to spend more time with my family and am working on a way to balance that with my demos and other obligations. I have more important reasons to stay home these days.

I still skate just as much, and I usually end up going to many of the contests to watch and hang out with my friends. I recently went to the Skatepark of Tampa contest, and Brian Schaffer, the owner, awarded me a "Just For Showing Up" trophy. Those words were actually engraved on the trophy.

I signed a three-year contract to commentate skate contests on ESPN. If you thought you'd seen the last of my mug on television, you're wrong, because I'll still be there on some level. My performances might be worse, because now I have to rely on my interview skills instead of my skating.

There are a variety of different projects I'm working on. I have two video games. We are considering another Birdhouse video. We have created Hawk Shoes with Adio, and Quiksilver recently bought Hawk Clothing, which will drastically widen its distribution. I recently started 900 Films with my friends Morgan, an accomplished video director, and Matt, a 16-millimeter expert. Erin and I are considering having another child (Erin may be considering it more than me). It's a lot to think about, but I've grown used to it.

I can't complain. I started out skating as a dirty, ratty little kid, and now I'm thirty-two years old and still rolling around. I never expected to make a career out of it, but here I am, with a beautiful family and more opportunities than I ever dreamed possible, more surprised than anybody about my situation in life. And you know what? I can still walk out my front door, skate to the local school or the curb at the grocery store, and see NO SKATEBOARDING signs almost everywhere I look. Skateboarding is not a crime—it's my career.

HAWK

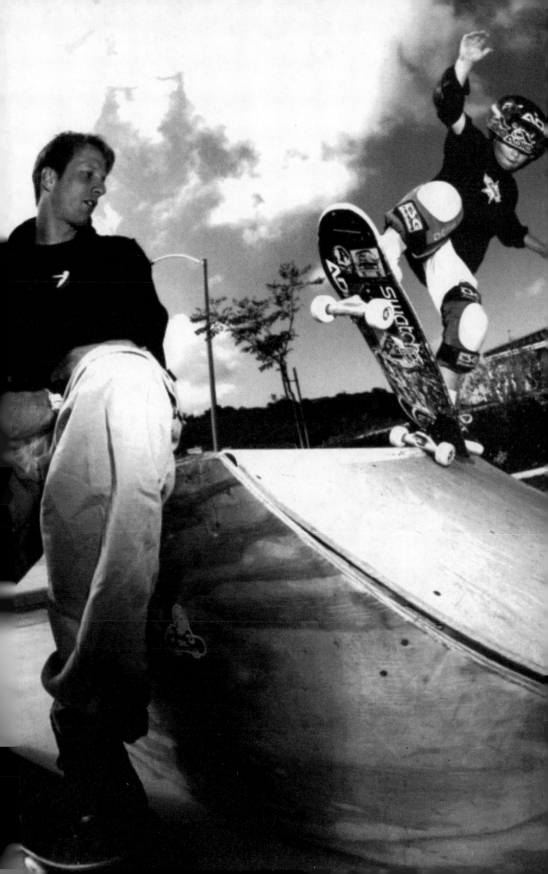

APPENDIX A

PROFESSIONAL SKATEBOARDING AT A GLANCE

Things not to do if you're a pro skater:

1. Spend your entire royalty check at The Sharper Image.
2. Wear Spandex.
3. Buy a house while you're still in high school.
4. Buy a Lexus when you're going broke.
5. Tell customs agents that you skateboard for a living.

How you know you're a skateboarder:

1. Police give you tickets on a regular basis and know you by your first name.
2. You always have a scab somewhere on your body.
3. Your ankles hurt.
4. Your hips hurt.
5. You wake up in an ambulance with your front teeth missing.

How you know you're not a skateboarder:

1. You've never broken any bones and you have no visible scars.
2. You think backside is another word for ass.
3. You feel safe around policemen.
4. You've never heard of the Muska.
5. You think the McTwist is a McDonald's dessert.

How you know you weren't a pro skater in the mid-1990s:

1. You never slept in a hotel room with five other skaters.
2. Taco Bell never seemed expensive.
3. You've never looked behind car seats and between sofa cushions for change.
4. Policemen have never felt sorry for you and continued giving you tickets.
5. You've never won a pro contest where the prize money checks bounced.

How you know you're Tony Hawk:

1. People ask you to do a 900 when you're walking into a coffee shop.
2. You're asked if anybody ever calls you Bony Cock.
3. You love gadgets and new technology.
4. Your ankles sound like a tin drumroll while walking up a flight of stairs.
5. You go to a demo when you're ill and the crowd of thousands chants "son of a bitch" at you when they learn you're too sick to skate.

HAWK

APPENDIX B
TRICKS ARE FOR KIDS

Tricks are strange . . . I'm extremely proud of some of the ones I've invented and some of them are hilarious to look back on and wonder what I was thinking at the time. But I have a soft spot for some of the ones nobody ever does anymore (the airwalk, for example). It's almost like carbon-dating skating. You can see an evolution of skating over the past twenty years with this list. Back in the '80s for the fingerflip air you had to use your hand to flip. Now skaters kickflip with their feet without the use of any hands.

I come up with the ideas for tricks when I'm doing anything from driving to falling on a basic maneuver. Once you learn a new trick in skateboarding, I think it's only natural to try variations of it. When you think that way, the possibilities are almost endless.

If you don't skate or know the lingo, this list may seem like it's written in Swahili.

1980
BACKSIDE VARIAL
I saw a sequence of Eric Grisham in *Skateboarder* magazine performing the original varial, done frontside. It was named after his sponsor—Variflex. I couldn't do frontside airs at the time, so I figured out a way of doing them backside using my other hand to spin the board. I would grab it through my legs in a stinkbug position while riding up the wall and turn the board once I jumped. I now do it around the leg and with less preparation. This is now considered an easy vert trick.

1981
SHOVE-IT ROCK 'N' ROLL
Shove-its were a big freestyle trick, so this was the only way I could figure out how to take it to vert. Landing in a rock 'n' roll actually gave me a pause to get my feet straight before coming back in.

FAKIE TO FRONTSIDE ROCK
I could do frontside rocks easily at the time, and I had just learned 360 rock 'n' rolls. I combined the two to make a back-and-forth motion. I remember doing it at a Gold Cup contest as an amateur and later seeing Eddie Elguera trying to learn it in a smaller bowl the same day. That was a huge honor.

261

OLLIE TO INDY

I had been experimenting with doing ollies into airs, but I couldn't figure out the most efficient grab. While I learned it in the main pool at Oasis, Steve Rocco and Rodney Mullen watched and commented on how much higher I was able to go.

1982

FINGERFLIP BACKSIDE AIR

This started out as a joke, imitating a freestyle trick while in the air. As I flipped the board, I realized that there was still time to catch it and get my feet on before landing. Since I grabbed the nose, my hand stayed in one place while the board spun on an axis in my palm. Even after I made it, it was still considered a joke.

VARIAL GAY TWIST

Kevin Staab and I came up with the idea to combine a varial with a gay twist, so we learned it together.

GYMNAST PLANT

Some people were doing one-footed Inverts at the time, so I tried to take both feet off. The best way to make it work was to extend both legs upward and together, so it looked like a gymnast's handstand. Maybe it wasn't as precise, but it worked.

1983

FRONTSIDE 540/RODEO FLIP

Billy Ruff had invented the unit, which is a frontside Invert 540. Basically, I tried to learn the same trick without putting my hand down. I had to pull off the wall more than a unit, since using your hand allows you to push off the wall and makes getting around easier. After doing it a few times the first day, I could make it a few feet out and stand up every time. I haven't done them as consistently since that day.

LIPSLIDE REVERT

Whenever I did lipslides, I tended to turn my body too far and had to adjust it back to come in straight. I decided to go with the motion and turn 180 on the way in. The first few slid halfway down the wall sideways before coming in fakie.

AIRWALK

Micke Alba was doing one-footed airs at the time (judo airs), so I tried the same thing while kicking my back foot in the opposite direction. I didn't have a name for it until *Thrasher* printed a sequence of it shortly after, and the caption labeled it an airwalk. The shoe company was spawned about a year later.

1984

AIRWALK TO FAKIE

Anything done regular during this time would eventually be attempted to fakie, so this was one of those cases. The first time I did it, Sin (Airwalk designer) shot a sequence and it became my first Airwalk ad.

262

HAWK

MADONNA

I combined a one-footed lien air with a lien-to-tail, but I didn't think much of it at the time. I had a conversation with Lester Kasai at the time and I asked him why nobody ever bothered with the tricks that I had invented. Most new tricks at the time were adopted and performed by other pros, but not the ones that I had come up with. He told me that I had to name my tricks something trendy, so we chose Madonna for the last thing I learned. I don't know if it was just the name, but it seemed to work.

SWITCHEROO TO FAKIE

Neil Blender had invented the switcheroo—an Invert where you grab the board on the outside rail (Andrecht style), stall on your other hand, let go of the board and grab it on the inside rail, then come back in. I learned it to fakie, which was harder than I expected. Stalling an Invert to fakie is way harder than stalling a regular Invert.

SARAN WRAP

Another freestyle trick that started out as a joke. I wanted to do an air where I would take my front foot off, wrap it around the board, and put it back on. The hardest part was switching hands in order to get them out of the way of my foot's path. My mom was a leftovers addict, so Saran Wrap was always a big part of our life.

1985

STALEFISH

At the time almost every grab was done and defined. The only way that hadn't been explored was to grab with your back hand around your back leg and between your heels. It takes more effort to reach back there, so spinning moves are a little harder. I first did it at a summer camp in Stockholm. One day another camper was reading my daily journal, which was a cryptic description of each day's events, tricks done, and meal explanations. He asked what a stalefish was and if it was that weird grab that I had been doing. It didn't have a name at the time, so I said yes. It was really my brief description of what we had for dinner, which was literally a whole cooked fish in a tin. By the time the meals arrived at the camp, they were all stale. Nobody ate it—not even the Swedes.

INVERT TO LAYBACK AIR

This is also known as an accident, which is exactly what it was in its inception. I stalled an Invert too long, began to fall backward, and just held on. It tends to bend my wrist a little too much, and I can rarely do it on purpose.

720

Also a product of the Swedish summer camp. The ramp in Stockholm was much bigger than the standard ramps in those days, which enabled us to go higher than usual. On a particularly high gay twist, I almost overturned and realized that there might be time to spin another 360. An hour later the 720 was realized.

1986

BACKSIDE OLLIE TO TAIL

While shooting *Animal Chin,* I started trying this on the *Chin* ramp while Stacy was filming. I did it in a few tries, but I didn't really expect it to be in the video. I was surprised that people noticed it.

INDY 540

Up to this point, the only backside 540 was a McTwist, where you grab mute. To do an Indy 540, you need to ollie into it and grab the board while already in the spin. I tested it a few times over the course of the year and finally committed to it as the sun was going down on a solo session on a backyard ramp in Ramona, California.

1987

FRONTSIDE GAY TWIST

I started trying tricks in different directions and decided to try gay twists the other way. It was difficult to not see the ramp during the spin, but I finally figured out how to anticipate a landing instead of spotting it.

NOSEGRIND

I could do a nose pivot (not grinding) on vert, stall, and grab the board for the reentry. I realized that grinding made coming back in easier, and that grabbing was no longer necessary.

BACKSIDE POP-SHOVE-IT

This was basically an attempt at doing a shove-it on vert, but I had to take a different approach when doing it above the coping. Instead of pushing off the nose (like a freestyle shove-it), I launched off the back wheels as I took off. This kept the board near my feet instead of on the deck. These still take a number of tries to land.

360 FRONTSIDE ROCK 'N' ROLL

Another case of "try it the other direction."

1988

FRONTSIDE CAB

Same, but much harder to make. I was coming very close to these while practicing one day when Kevin showed up. I pretended that I could already do them and told him to watch. I made it and he freaked. He thought I had it wired.

STALEFISH 540

I was coming close to these, but could never commit to the landing. I was overdue for an Airwalk ad, and Sin wanted to shoot one before I left for our summer tour. I posed a few of them for still shots, but never made it that day. This was the only time I ever posed a trick for the sake of a picture and I felt horrible about it. During

264

HAWK

that tour I set out to actually learn it, which I did during a demo in Amsterdam. I made it before the ad was ever published, so I didn't feel too guilty.

EGGPLANT TO FAKIE
If it can be done, try it to fakie. This is hard because your body is shifted forward during an eggplant, and you actually have to reverse momentum just as you would coming in forward.

HALF-ELGUERIAL
The idea was spawned by considering switch frontside Inverts. My Elguerials were always pretty sloppy since I could barely hold myself up on one arm, so this was especially hard to muscle in. Also known as a Giddy Goon from the video game Dragon's Lair.

FRONTSIDE HURRICANE
Backside hurricanes had been around awhile, but I always wanted to try them frontside. I first learned it on my mini ramp without sliding and eventually realized that it is easier on vert.

CAB SHOVE-IT
There were certain tricks that I wanted to learn without grabbing, so this was actually an ollie version of a varial gay twist.

360 VARIAL TO FAKIE
This has become one of my standard tricks, and I have actually found it to be more consistent than backside 360 varials because you can see the board the entire time.

1989

FRONTSIDE LES TWIST TO TAIL
It started off as a joke while Stacy was filming a video at my house. I tested it just to see how ridiculous it looked, and it seemed to work. The hardest part is making sure my tail comes down in the right spot; I can't see it until it's already on the coping.

FAKIE-TO-FAKIE FRONTSIDE 540
I had been working on these for nearly a year and finally pulled one for the video *Ban This*. It took me a long time to get the courage up for it again since it's a sure way to get whiplash if not executed properly.

FRONTSIDE HURRICANE TO FAKIE
A small variation and way easier than frontside hurricanes because you don't have to turn a full 180 out of it.

FINGERFLIP AIR TO FAKIE
I probably could have done this a few years earlier, but I never thought about it. I did it for a Powell video, but forgot about it shortly thereafter. By this time, finger-flips were considered passé among the kickflip generation.

BACKSIDE REWIND GRIND
I pictured a backside pivot in the reverse direction, as if you were watching a video rewind.

OLLIE 540
I would try these sporadically through the years, but as a complete joke. The board would always float away from my feet after getting halfway around. I realized that if I tried it lower, I could stomp my back foot on the wall when the board was starting to float away and pivot the rest of the way around. The first ones I did were a struggle to get around and I always ended up sitting on my board through the flatbottom. I eventually learned how to get more lift in the takeoff, which let me extend my legs and stand up.

1990
FRONTSIDE BODY VARIAL REVERT
Body varials had basically come and gone by this time but I wanted to keep the fire alive.

BACKSIDE VARIAL REVERT
This landing is very blind, so I had to be confident with backside reverts in order to make it work. This trick still scares me on the landing, even though it is less of a spin than a varial 540.

FRONTSIDE CAB TAILGRAB
This should have come before a frontside Cab but I think it is harder. In order to grab the tail I need to have more lift from the wall. I also need to bend my knees more than usual in order to reach the tail with my hand.

FRONTSIDE BLUNT
Taken from the mini-ramp, I committed to learning it on vert. I have to hang my front toes off the board, since the reentry always shuffles my front foot toward the heel. If I don't compensate for this, I slam on my hip.

BACKSIDE OLLIE ONE-FOOT
Inspired by Matt Hensley's one-footed ollies on street, I tried to make it work on a ramp. Instead of sliding my front foot all the way up the nose (as done on street), I learned to be more subtle and to kick the foot outward instead of over the nose.

VARIAL 540
I had just learned how to spin 540s much more easily and faster, so I figured I could turn the board at the same time. I figured out that actually kicking the board into

266

a spin works better than trying to muscle it around with my arm. Sending the board into the right motion with my feet allows my hand to simply guide it back.

1991

CAB TO TAIL

I had been doing les twist body jars for a while, so I wanted to do it without grabbing. It takes a lot of pop on the takeoff, and usually ends up in a disaster—which is dangerous when you're expecting to land on the tail. It never really felt like it was worth all the effort.

TAILGRAB ONE-FOOTED 540

I did one for a Powell video, and then took numerous slams to my hip trying it again. After the video came out, I would always get requests for it during demos. I finally quit trying it when my hip ballooned out to scary proportions.

360 VARIAL DISASTER

A good way to break a board. I could never do these without pausing on the coping, which is considered a half-assed disaster, so I stopped doing them.

CAB REVERT

I learned this by doing it very low on the wall and sliding all the way around. Eventually I learned to pop off the coping in order to do it in the air. If I go too far above the coping, my feet come off. I've succumbed to the fact that I will only ever do it at coping level.

CAB BODY VARIAL

Very much the same process as a Cab revert, and only done at coping height. I have to compensate for my board turning too much by spinning it the opposite direction when I take off.

1992

FRONTSIDE CAB DISASTER

The disaster makes this a scary trick because I can't see where I am until my board touches down. If I'm too far over the deck, I end up diving headfirst into the flat.

FRONTSIDE CAB DISASTER REVERT

Sometimes this trick comes easier than the last because I don't have to stop spinning. The revert can get sketchy depending on how slippery the ramp is.

ALLEY-OOP BACKSIDE BLUNT-SLIDE

This is hard to pull consistently because I can only slide on the tail. If the back of my truck hits the coping, the slide stops abruptly.

HEELFLIP VARIAL LIEN

I was just testing different types of flips and how to grab them when this trick came together. I learned it alone on one of the last days of having my own ramp. Learning this gave me a renewed confidence in my skating, which I was worried about at the time.

360 FLIP MUTE TO FAKIE

I had this in mind since learning 360 flip mutes (invented by Colin McKay), and finally did it for a Birdhouse video. It is much harder to make the board flip than with a regular version. I have to hang most of my foot off the board in order to get my front toes in the right place for the flip.

FRONTSIDE NOSESLIDE

The ramp in Encinitas had a hip, which made it easier to get into noseslides on vert. People can now do this on flat walls, but I never figured out how.

BLUNT-SLIDE TO FAKIE

This trick works as long as the coping and the deck are slick. Otherwise, it stops without warning and sends me into the wall on my back.

1993

GAY TWIST HEELFLIP BODY VARIAL

The hardest part about learning this was trying to do it with the small wheels we used to ride. I couldn't get the speed to go high enough to make it all work. It was a struggle to make, but they are much easier now that I ride bigger wheels.

HALF-CAB TO BLUNT-SLIDE

Basically a Caballerial with a blunt-slide thrown in the middle. The deck must be slippery to make it consistently.

SWITCH INDY AIR

I wanted to do one for our Birdhouse video, but it was sketchy. I'm stoked to have done it, but mine look awful. Bob has mastered it.

DOUBLE KICKFLIP VARIAL INDY

Learned in the days of double flips, I tried this every day during a two-week tour in Europe. Finally made one in Hamburg, Germany, and haven't done it since. It's the first trick in our last low-budget Birdhouse video—*Untitled*. You can't tell that it's a double flip in the video, which is so disappointing.

BACKSIDE HEELFLIP BODY VARIAL

The same principle as heelflip varial liens, but as you turn backside the board remains on the same axis as it flips and the body turns. I always feel like I'm going to hang up on the coping on this one. Doing it for *The End*—over the channel— was one of the most frustrating days of shooting.

HAWK

SWITCH BACKSIDE OLLIE

I never really did these properly. I kind of slide partway down the wall instead of completely turning like a proper backside ollie.

HALF-CAB FRONTSIDE BLUNT REVERT

Only done on mini-ramps . . . too scary on vert. Serious whiplash potential.

1994

540 BOARD VARIAL

As I spin the board around the first 360, I use my hand to guide it around the next 180. The spin is done completely with the feet at takeoff, and the board tends to flip too often. I get many requests for it since it is in Tony Hawk's Pro Skater, but it takes more effort than it appears to.

KICKFLIP MCTWIST

I tried this every day for four weeks straight before finally landing it at the Skatepark of Tampa. Sean shot it for a potential Birdhouse video, but some other guy was shooting video and gave it to 411. *Transworld* called and asked to shoot it for a cover, which led to an entire day of wasting film and finally making it after the sun had set. They had run out of photos by then, but they got a video shot of it. I haven't made it since.

SWITCH NOLLIE HEELFLIP INDY

More like a half-frontside gay twist heelflip. I would like to do it all the way around, but I haven't been able to catch it properly. It's difficult to see the board and spot the landing at the same time, but Bucky seems to have mastered it.

1995

CAB LIPSLIDE

A Cab disaster while sliding along the deck. I used to do it regularly, but I had a few serious slams, getting tangled up and falling backward to the flat. It doesn't come as naturally anymore.

HALF-CAB BODY VARIAL HEELFLIP LIEN

Another version of heelflip varial lien, but coming up backward and landing backward.

GAY TWIST VARIAL DISASTER REVERT

I did this once for a Birdhouse ad but didn't enjoy it very much. I haven't done it since—I think I got stitches in my shin trying to learn it.

HEELFLIP VARIAL LIEN REVERT

Another one-hit wonder, done for an ad but only captured on video. The revert can be deadly on this one, because I barely get my feet on the board before setting it back on the wall. I would like to shoot this on film, but it will take a lot of preparation to get motivated again.

APPENDIX B: TRICKS ARE FOR KIDS

FRONTSIDE 270 OLLIE TO SWITCH CROOKS

I always had this in mind after seeing people do overturn grinds. It's hard to aim for the truck on the coping so that I actually do a crooked grind and don't slide in.

CAB TO BACKSIDE SMITH

Much less painful than Cab to lipslide, but much more room for error. The aim for a Smith grind has to be precise.

SWITCH 540

I saw Colin try this in a Plan B video, and I always thought it would be possible. I tried it for a few weeks straight before finally making one without squatting through the flat. I made a squatty one at the 1996 X Games during the preliminary runs, which was a surprise.

1997

FAKIE HEELFLIP VARIAL LIEN

The final chapter for the heelflip varial lien. This was much harder than I had anticipated—the timing for the flip has to be perfect.

FRONTSIDE CAB REVERT

Shot for a Birdhouse ad, this was a trick I wasn't sure I could do. The last 180 was completely slid around, and I haven't been able to do it since.

1998

HEELFLIP SLOB AIR

I wanted to do heelflip tailgrabs, but I could never get my feet back on correctly. This was the next best thing.

STALEFISH 720

Inspired once again by Colin—I saw him do a tailgrab 720, which I consider harder. It gave me incentive to try a different grab. Danny Way had already done Indy, so I chose stalefish.

FRONTSIDE GAY TWIST VARIAL

Something I wanted to do since I learned frontside gay twists. It's another varial that is done mostly with the feet. I learned it exclusively for *The End*.

FRONTSIDE KICKFLIP BODY VARIAL

This came while trying to learn frontside kickflips on vert. I rarely could get the board to flip, but it all came together once I added a body varial.

VARIAL 720

I've wanted to do this since learning 7s, but I could never get enough height (or balls). The bullring ramp served as the perfect setting for finally committing to it.

HAWK

1999

BACKSIDE SHOVE-IT FRONTSIDE NOSEGRIND
This was way too much effort for such a minor trick. I thought it would be something to learn on a whim and forget about. It took a few days and a lot of frustration just to make a sketchy one.

GAY TWIST 360 VARIAL
Another trick conceived long ago, but never seen through to completion until I could get the necessary speed. I finally landed it in Germany during an Adio tour.

SLOB GAY TWIST ONE-FOOT
In Prague, Pete Thompson (photographer) wanted to shoot a sequence during practice for a competition. I thought of it on the spot and we shot it.

FRONTSIDE GAY TWIST MADONNA
I wanted to do this since learning frontside les twist to tail, but I was always too scared. I finally committed to it during a best-trick event in Biarritz, France. Nobody really noticed (including the judges), but I was stoked to have finally done it.

SACKTAP
I attempted these almost fifteen years ago as a joke, but decided to make one for a sequence and to include in Tony Hawk Pro Skater 2. I still consider it a joke, but it is hard to make.

900
First tried in 1986 in France, I never committed to a spin until 1997. I tried to land several, ending in one cracked rib and a crooked spinal cord. I finally made it during the best-trick event at the X Games. I still have to work for each one, but they are less difficult knowing that I have made one.

2000

STALEFISH FRONTSIDE 540
I tried this throughout the filming for *The End* (post-bullring), but always came up short in the spin or off balance in the landing. I finally realized that I needed a bigger ramp. I made it at Mission Valley for a Birdhouse ad after falling on my ass in the flat a few times.

THE CONTESTS

1980 (AMATEUR)
ASPO Series (sponsored 12 and
 under)—2nd overall
Del Mar State Finals (boys 11–13)—5th
Gold Cup Series:
 Oasis—22nd
 Colton Ranch—10th
 Marina—7th
 Upland Finals—9th

1981 (AMATEUR)
Potato Bowl—4th
Skate City Pro Am—4th
Variflex Easter Classic—3rd
Tracker Pro Am—3rd
Lakewood Pro Am—4th
ASPO Boys 13–14:
 Colton—2nd
 Del Mar—1st

1982 (AMATEUR)
Rusty Harris Pro Am, Upland—2nd
Rusty Harris Pro Am, Whittier—3rd
Rusty Harris Pro Am, Del Mar—1st
CASL Series Boys 14–17:
 Del Mar—1st
 Del Mar—3rd
 Del Mar—1st
 Del Mar—1st
 Del Mar—3rd
 Del Mar—7th
Kona Summer Nationals—10th
Skate City Christmas Classic,
 Whittier—6th
World Challenge (Pro)—3rd

1983 (PRO)
Great Dessert Ramp Battle—4th
Spring Nationals Pro Am—1st
Oceanside Freestyle—15th
Kona Summer Nationals—6th
St. Pete Pro Am—1st
Summer World Series—1st
Turkey Shoot—4th

1984
Tahoe Massacre—3rd
Booney Ramp Bang—1st
Summer Series #1—2nd
Sundeck Eastern Pro Am—1st
Pipeline Summer Series—2nd
Summer Series Pool Finals—1st
Summer Series Halfpipe—1st

1985
Del Mar Spring Pro Am—1st
Rage at the Badlands—1st
King of the Mount—1st
Terror at Tahoe—2nd
Showdown at the Ranch—2nd
Arkansas Ramp Jam—1st
Shut Up and Skate Jam—1st

1986
Southern Shred—1st
Houston Southest—2nd
Down South at Del Mar—1st
Eastern Assault—2nd
Transworld Skateboard
 Championships—1st
Chicago Blowout—1st
Festival of Sports—1st
Holiday Havoc—1st

1987
Southeast—1st
Skate Wave—1st
V.P. Fair Pro Championship—1st
Duel in the Desert—2nd
Skate Escape—2nd

1988
Skate Fest—1st
Savannah Slamma Street—4th
Bluegrass Aggression Session—3rd
Capital Burnout—1st
Gotcha Grind—1st
Ramp Riot—1st
Heartland Invasion—1st

1989
Pacific Mini-Ramp Challenge—5th
Vans—2nd
Scandinavian Open—1st
Scandinavian Open Street—1st
Titus Cup—1st
Titus Cup Street—2nd
Savannah Slamma Street—2nd
Chicago Shootout Street—3rd
St. Pete Showdown—1st
St. Pete Showdown Street—1st

1990
Del Mar Fair—1st
San Francisco Street—1st

1991
Norfolk—1st
San Jose Mini Ramp—2nd
Vision—3rd
Powell Street—1st
Kona Skatepark—1st
Capital Burnout—1st
France—1st
Münster Ramp Jam—1st
Shut Up and Skate—1st

1992
NSA Spring Fling Street—1st
NSA Finals—1st
PSA Street—2nd

1993
Münster Ramp Jam Vert—1st
Münster Ramp Jam Street—2nd
Belgium—1st

1995
Tampa SPOT, Tampa, FL—3rd vert
Extreme Games, Newport, RI—1st
vert, 2nd street
Hard Rock World Championships,
Huntington Beach, CA—1st vert
Missile Park Monster Mash, San
Diego, CA—1st vert, 1st high air,
1st high air to fakie

1996
Hard Rock Triple Crown, Las Vegas,
NV—1st vert

Destination Extreme, South Padre
Island, TX—1st vert, 2nd street
X Games, Newport, RI—2nd vert
Hard Rock World Championships,
Hollywood, CA—2nd vert

1997
Hard Rock World Championships, Las
Vegas, NV—1st vert
London—1st vert
X Games, San Diego, CA—1st vert, 1st
vert doubles with Andy Macdonald
Hard Rock World Championships,
Hollywood, CA—2nd vert, 1st vert
doubles with Brian Howard

1998
SPOT, Tampa, FL—1st vert
X Trials, Virginia Beach, VA—1st vert
X Games, San Diego, CA—3rd vert, 1st
vert doubles with Andy Macdonald
B3, Woodward, PA—1st vert, 1st street
Triple Crown, Asbury Park, NJ—1st
vert
Goodwill Games, New York, NY—1st
vert, 1st street doubles with Anthony
Furlong
Münster Mastership, Münster, Germany
—1st vert
Hard Rock World Championships,
Huntington Beach, CA—1st best
trick (varial 720)

1999
X Trials, Richmond, VA—1st vert
X Games, San Francisco, CA—3rd vert,
1st best trick (900), 1st doubles with
Andy Macdonald
Mystic Cup, Prague, Czech Republic—
3rd vert
Triple Crown Finals, Huntington Beach,
CA—1st vert
MTV Sports and Music Festival, Las
Vegas, NV—3rd high air, 1st best
trick (900)

APPENDIX D

A TOUR IN THE LIFE

NOVEMBER 27, 1999
MIDDLETOWN/PROVIDENCE, RI

WE ALL ARRIVED LAST NIGHT from California to start the Birdhouse and Hoffman Bikes "Whoop-ass" tour. The crew consists of skateboarders Willy Santos, Brian Sumner, Jeff Lenoce, Steven Hennings, and bikers Matt Hoffman, Rick Thorne, Rooftop, Sweet Pussy Frank (who got his name from wimping out while snowboarding), and me. We're touring in a massive RV supplied by Jones Soda. Luckily none of the skaters have to drive and Frank is the captain of the ship. Frank and I woke up early to gather our tour necessities: a digital camera and a PlayStation—the two most important objects for anybody who tours.

Our first stop was Skater Island in Middletown, which is one of the best-designed skateparks I've ever seen. The place was already packed when Frank steered the RV into the parking lot. We exited the van and stretched our muscles on the street course. People were already calling me out on 900s as we skated the street course. Here's the deal with doing 900s: there has to be a halfpipe (which there was), it has to be big (which it wasn't), I have to be seriously psyched to make one (which I definitely wasn't, this being our first stop), and the stars must align (which they probably hadn't). But don't get too annoyed with me—I'm practicing flatground 900s as we speak. Brian and Jeff killed the street course for thirty minutes straight. Willy strolled in a little later, did some big stunts, got the crowd all frothed up and then chilled. I skated vert with the bikers when the street guys burned out. I did a 720 and a kid asked me what it was— I told him it was a 9 and it seemed to suffice. I only sign autographs after I skate, because once I start to autograph stuff (anything from boobs to beer cans), it can get seriously out of control and it's lame to just cut people off. I also lose my skating time, so I apologize to

the many people who I told "I'll do it after I skate." Don't hate me because I like to skate.

We left Skater Island and headed to Impact in Providence, Rhode Island. It's Kevin Robinson's park and it's mainly for bikes, so the Birdhouse crew sat it out. I tried to skate, but I couldn't get motivated on all of the huge quarterpipes with rough plywood surfaces. I was worked from the last demo anyway. Willy shot me doing a rodeo flip off the launch box so we could get at least one thing from that stop. The video clips are all on the B-house site. We got back in the RV and Frank powered a five-hour drive to New Jersey. Matt and I have technology wars during the trip. His new video camera is all right, but I think my Firewire to Go takes the competition since I can pull video clips on my PowerBook (no PCs allowed). *Reservoir Dogs* blasts from the VCR as we drive onto some random highway, which means swearing and shooting are the temporary tour soundtrack. The RV is packed with bikes, skateboards, everybody's clothes, beer, videos, video games, and Top Ramen from gas stations, which isn't really too bad.

NOVEMBER 28, 1999
NEWARK/TOMS RIVER, NJ

WE ENDED UP IN NEWARK at 2:30 A.M. because Frank got sick of driving. He's a driver—how does he get sick of driving? (Just kidding, Frank.) Woke up the crew at 11:30 A.M. (early for them) and grabbed a quick brunch and headed to Tom's River for our next stop. As we pulled in, there were huge crowds of people blocking the entrance into the park. The manager sneaked us in through the side and things got a little crazy as we tried to skate. Kids were running through the street course trying to get near us, like a real-life version of Frogger. How could we skate? Do we treat the kids as movable street obstacles? We'd barely start pushing before some kid would sprint across the course. Do they even want to see us skate? Sometimes I wonder. We managed to clear out an area on the street course (but not all of it) and skate for a while. Willy, Brian, and Jeff performed an encyclopedia of tricks on the sketchy ledges and handrails. The vert ramp was puny—barely a vert ramp. I tried to skate it for a while. Each time I dropped in, a chorus of "Do a 900!"

roared from the crowd. That ramp was too small for a 720. Too bad because then I could have done one of those and told them it was a 9. After not doing the 9, I went near the RV where the rest of the team was throwing stuff from the top into a frenzied crowd below. A police car was parked next to the RV—this is where tours can go really bad really quick. I had no doubt that this was about to be one of those situations because kids were climbing all over it, standing on top trying to get closer to the RV and free products (stickers/shirts/CDs/sodas) being pitched out. The cop strolled around on the other side and was either uncaring or oblivious to the anthill of skaters covering his car. Willy threw a board into the center of the mayhem and there was a group beatdown that wrestled most of the crowd onto a dogpile. The cop charged from the other side, shoved his way through the crowd, broke up the squabble, and grabbed the board in a matter of seconds. He gave it to the guy who had the best grip on it, and never said anything to us about causing a rumble or his car being used as scaffolding. Later on he even thanked us for coming. I expected Rod Serling to walk out from behind the RV. Since when did the police support these types of activities? Thanks, TRPD!

We ended up at a hotel on a freezing New Jersey beach. I could never live in this weather. Today was more draining than most, for some reason. Tomorrow Frank drives to Pennsylvania, but I can't remember where. My modem is dying and I have no idea how to fix it while in transit. It feels like we've been on tour for two weeks already . . .

NOVEMBER 29, 1999
TOMS RIVER/NEW YORK CITY

LAST NIGHT FRANK HAD A WILD HAIR (and a few beers) and exclaimed that "we should drive to Manhattan in the morning, real early like, and get on *The Howard Stern Show*! Then we can drive to Pennsylvania." Yeah! That's right, get our priorities in order! What are we on this tour for anyway? I loved this because I listen to Howard almost every day in California. Frank and I convinced everyone else that this would be a good idea. "Who cares if we get on? We'll be in New York! It'll be an adventure!" As we

HAWK

yelled about it in the hotel bar, the manager claimed to know someone who knows Bababooie. He instructed us to page his friend in the morning and we'd have a way in.

Frank and I were committed and awake at the crack of dawn, but try getting ten skaters and bikers up and running by 6:00 A.M. That's when they all normally go to bed (remember, I have two sons). We finally dragged their dogged asses out of the hotel and Frank was steering us onto the freeway by 7:30 A.M. Howard's show was almost halfway over. I paged the guy, but he never called. Rick started calling the station directly claiming he was me. "We're passing through town, come on, we want to give Howard a board!" After a few calls, Rick finally got through to Stuttering John, who told us that we could have been on the show if we'd called a few days in advance. By then we had the purple beast parked outside their studio. He said that he'd meet us outside the studio anyway to say hi. We waited outside for half an hour and saw Chuck Zito and some girl that wanted to be in *Playboy* exiting from the building. (They were just on the show. We had been listening the whole way in.) It was too cold to wait any longer for John, so we split. It wasn't a successful outing. We spent the rest of the morning in Manhattan, doing our own things. I had lunch with my agent, who I annoy a great deal. My publicist Sarah joined us and I think I may also annoy her, but she doesn't let on as Peter does. The tourmates all met back up at the RV later. Everyone passed out on the way to Pennsylvania. It would have been sweet to be on *Howard,* but I'd be a bit scared to go on that show to tell the truth.

We drove straight from Manhattan to our Pennsylvania stop. I never caught the name of the city. A massive crowd that outsized the park awaited us. There wasn't much to skate in terms of street, but being the professional that I am, I managed to twist my ankle on a elementary 360 flip anyway. Who wants my autograph? After icing it for half an hour, the bikers and I did a quick demo on the short vert ramp.

After another manic autograph session, I made the following observations:

1. If you'd like to get something signed, it's best to hold it in the direction you would like it to read.

2. No, our hands don't get tired and we don't get writer's cramp.

3. Without fail, one of these scenarios will pan out when somebody asks to take a picture:

 A. The person will not have a camera.

 B. The camera is off.

 C. There is no film in the camera.

 D. The photographer's finger is covering the lens.

 E. The disposable camera is not wound or the flash is not on.

 F. Each person in a group photo will want the photographer to take one with his or her own camera.

 G. If there is an anti-red-eye function, the photographer will think the initial flash is the shutter and aim it away by the time the actual shot is taken.

 H. And just so you know, most babies do not like to be held by strangers for photos.

4. Ballpoint pens do not work well on decks, helmets, or stickers.

5. People (mostly mothers) hold us responsible for their stuff getting stolen during demos.

6. When I'm surrounded, it's difficult for me to go find Willy/Matt/Rick/Mike so that they can sign it, too.

7. Signing hands or arms is a waste of time, since there is no sense of permanence or souvenir factor in doing so.

8. I am stoked to be doing this, but I do appreciate thank-yous. As I type this, we are pulling into Villanova to find a hotel.

NOVEMBER 30, 1999
PENNSYLVANIA/OCEAN CITY, MARYLAND

WE WOKE UP IN AN UNKNOWN TOWN in Pennsylvania, got in the RV, and drove straight to Maryland. I felt good because we'd left in plenty of time. We made only one stop at Dunkin' Donuts—our nutritious meal of the day. There was Los Angeles–style traffic during the first part of the trip, detours in the second, and for a finish the road into Ocean City had stoplights every three hundred feet. Needless to say we were late, arriving at 5:00 P.M. instead of 4:00. Unfortunately it was already dark and this was an outdoor park that didn't have lights. People were already

278

HAWK

vibing us as we pulled up. One happy spectator climbed the fence and flipped us off. Another satisfied skater yelled, "Hey, Tony, what happened to four o'clock—bitch!" Such a warm welcome in a freezing place.

We tried to skate, but it was about thirty-five degrees and the wind was in full effect, making one wall on the vert ramp unskatable. You'd roll up one side, do a trick, and when you hit the other side you felt like you'd skated into a wind tunnel. I could have worn a 3X-large T-shirt and done some para-skating. Luckily the mayor was there and he pulled some strings and called in a fire truck to come and illuminate the ramp with floodlights. He also presented me with a key to the city. Let's review: skaters calling me a bitch and the mayor giving me the key to the city—what's wrong with this picture?

As cold as it was I didn't want anybody to go home bummed, so Matt and I tried to ride the vert ramp, but the freeze and the wind got the best of us. Then we had the shortest autograph session of the trip, because nobody wanted to hang in the weather any longer than they had to (including us). We went and had a decent meal and discussed how my key to the city didn't seem to bring any special privileges. We all concluded that today was not one of the more enjoyable stops (but I do think Ocean City has the coolest mayor in the country). We checked into our hotel and noticed that the neighboring bar was having "'80's night"—we're there! We busted out some serious break dancing (I was a break-dancing fool during the '80s) and wormed the last ten dismal hours out of our system. I lost my cell phone somewhere in the festivities.

DECEMBER 1, 1999
OCEAN CITY/LEESBURG, VIRGINIA

WOKE UP AT 9:00 A.M. and returned to the club in a haze searching for my phone. The club manager had found it the night before. Upon entering, flashbacks of last night's activities came back to me. My favorite was Rooftop and me singing "Don't You Forget About Me" and "Whip It" with the live band. We just jumped onstage and grabbed a microphone during their set and they let us run with it.

We drove straight to Leesburg, where we realized the awful truth:

APPENDIX D: A TOUR IN THE LIFE

279

another outdoor park. I began to feel that we were on the Arctic Tour instead of Whoop-ass. We donned clothes more suitable for snowboarding (including gloves) and skated. The park is actually very good; more street-oriented and no vert ramp (which was a relief in the brutal weather). Willy nailed every modern handrail trick within our hour of skating, while Brian and Jeff worked the pyramid and ledges. The bike guys used the park in ways probably never imagined, stalling on fences left and right. Everyone was having fun, even in the cold weather. The vibe from the crowd was positive until the manager came running over to us like there was a fire and pleaded with us to grab our promo boxes because they were getting looted. We get stuff sent to each demo to give away, and it is the staff's responsibility to give it to us when we finish riding. This guy just left them outside his office and was surprised that they were opened and pillaged by such a huge crowd. No wonder everyone was in such a good mood. Matt had some videos sent from his office so that we'd have more to watch than *Mallrats* and *Reservoir Dogs* in the RV. These were taken in the looting. Gee, thanks! The loss of movies really hurt. Afterwards we drove as far toward Raleigh as Frank could before falling asleep and hitting the horn with his head. We ended up in some Holiday Inn in some state. I was asleep before we got there, so I have no idea where it was. When you live on tour, you tend to forget minor details such as the city or state you're in, the day of the week, the month, and sometimes what happened the night before (if you're lucky).

DECEMBER 1, 1999
RALEIGH, NORTH CAROLINA

TODAY WAS OUR FIRST DAY OFF and we had a crew change in Raleigh. Willy bailed on us for a contest in Germany (by request of Vans), and Steve had to get back to school. Erin, Riley, and Spencer flew in to spend a few days in the Jones Joyride, and Lance Dalgart came in to cover the tour for skateboarding.com (and to shoot stuff for *Transworld*). Most of the day was spent driving back and forth from the hotel to the airport, as everyone had different flights and most arrivals were delayed. Riley asked me when

280

HAWK

we get to skate as soon as he walked off the plane, and every half hour he repeated the question.

DECEMBER 2, 1999
RALEIGH

WE WOKE UP AND GOT BAGELS in a nearby shopping center and headed for Chapel Hill to get CDs and warmer clothes. The RV garners some incredulous looks from people on the street, especially when ten scruffy-looking guys come strolling out with a family right behind them. Frank, an old driving pro (he has a flame-painted limo at home), knows all the tricks and usually parks in loading zones and slaps the flashers on. We haven't been hassled yet. I guess they assume that we're dropping off soda or starting some sort of RV fight club and they're too intimidated to ask us to move.

We left Chapel Hill and headed for the demo, which was supposed to be thirty minutes away. Frank called the contact guy when we neared Raleigh to have him guide us in. We drove for nearly a half hour, Frank telling the guy various landmarks that we passed, and the guy continued with his directions. Suddenly we were in the boonies with no exits in sight. The guy handed the phone to a girl and she determined that we were about forty minutes past the park. We turned around at the next exit (another ten minutes) and finally got on the right track. Once again we were an hour late through no fault of our own. At least it wasn't outdoors . . . or freezing . . . and no skaters called me names. Utopia is the biggest park we've visited and had the crowd to match. I'm now counting the number of times I hear "900!" screamed at each demo. I heard four yesterday and there was no vert ramp in sight. Today I heard at least ten over blaring music and I'm sure there were more drowned out by the noise. I tried one just to please the masses, but the ramp was too small to pursue it. Riley skated in the demo as well, jumping hips and pulling a kickflip on the pyramid. Brian sprained his ankle on a backside lipslide and decided that he should go home early because it wouldn't heal before the tour ends. So now, as well as hearing "Where's Bucky?" and "Where's Andrew?" or most recently "Where's Willy?" we'll also get to hear "Where's Brian?" By the time we fin-

ished signing stuff, throwing product out, eating, and driving back to the hotel, it was midnight. Erin, Riley, Spencer, and I were supposed to drive to Wilmington to visit our long-lost friends the Underhills, but we had to wait until morning. I don't think that they would have appreciated us showing up at 2:00 A.M. for a visit.

DECEMBER 4, 1999
RALEIGH/WILMINGTON, NORTH CAROLINA

WOKE UP AND DROVE A RENTAL CAR to Wilmington so that we could hook up with the Underhill clan before our 2:00 P.M. demo. There was no sense in getting everyone else up just so we could have a family-to-family visit. I forgot how boring it is to drive in a normal car with limited entertainment, as our two-and-a-half-hour drive dragged on. Tour with Birdhouse and Hoffman and you develop attention deficit disorder. I hung out with Ray, Kerry, and Keaton at their house. Ray and I had serious Macintosh-computer-nerd discussions. Ray maintains my personal site and b-house.com. We showed up on time for the demo just as the Purple Predator was pulling in behind us. There were an estimated two thousand people waiting and the 900 requests were countless. I warmed up and did a 540. As I walked back up the ramp one kid pleaded at me, "At least do 540!" Do people even realize what exactly they're requesting? Do they just know a few trick names that they've heard on TV and are compelled to sporadically blurt out? Is there a new form of Tourette's syndrome? Either way, I made another attempt to nip the Call Of The 9 in the bud. Jeff provided the true street skills that are required when showing up at a skatepark and being watched by a scrutinizing new-school crowd. Riley was once again ripping the street course, making a noseslide on a ledge and slamming end-over-end numerous times.

After the demo we made Ray buy us dinner and drove off into the great two-laned unknown. At one point Frank pulled into South of the Border, where fireworks stores flourished. Neon signs screamed at us and we bought armfuls of explosives to be set off somewhere down the road. We made an explosive stop at a deserted frontage

HAWK

road and lit fuses. I think Rooftop went overboard with his purchases—two of his shot seventy-five feet into the sky and exploded like a Disneyland parade. It was only a matter of time before the police zeroed in on our location—anyone within a few miles would have seen the explosions. We cut our display short and drove away, stopping at another Holiday Inn in another town at 1:30 A.M. This schedule is brutal for family life, but the Hawks have adapted well.

DECEMBER 5, 1999
GREENVILLE, SOUTH CAROLINA

WOKE UP AND DROVE STRAIGHT TO Greenville, stopping once at McDonald's. We received more bad directions and three hours later we pulled up to the skatepark. It was our smallest crowd by far (maybe three hundred people). This was a good thing because the park couldn't handle much more. It was small, with low ceilings, but we made do. Ironically, ESPN showed up to cover the tour for *X Today*. They missed the huge events, but at least they are going to the next few stops, which will probably be bigger. This, however, was my last day on this tour. Tomorrow is Riley's birthday, and we promised to be home for it. I also have to do a Disney commercial on Wednesday and Thursday and then I leave for an Adio tour in Australia on Thursday night. The kids were stoked on the demo, but there were some seriously tiring requests made from the crowd. First, a photographer asked to take a picture of me giving my board (the one I ride) to a kid who was sick. I don't want to be lame, but it's my only board. If the guy had called ahead and asked me about it, I could have arranged it. It put me in an awkward position. Then a father brought his kid, who was in tears, up to me and asked for a board because his was stolen. Are we responsible for this? Does our tour have the mystical power of turning law-abiding citizens into unruly thieves? I don't understand why we're blamed for kids unable to keep an eye on their own stuff. I barely have enough product to last the trip, never mind the fact that my boards are a custom shape and not mass-produced. The third request to set me off was a guy insisting that I meet his girlfriend, who sat waiting in his car.

APPENDIX D: A TOUR IN THE LIFE

283

This guy tailed me around the park while I signed autographs, pleading for me to come to the parking lot to see this girl (who, he informed me, has played the video game Tony Hawk's Pro Skater). When I finally got burned out on the guy I walked outside with him to his car, which was parked very close to the RV (and very close to the park). His girlfriend was lounging in the driver's seat. For the amount of time he pursued me, he could have had his girlfriend actually GET OUT OF THE CAR and come meet me five times over. She was not disabled.

Brian was injured so (un)luckily he had extra decks to fill the first two requests. It seemed like they were mildly appreciated, but more expected than anything. We left, ate, and drove three hours to Atlanta. Bucky, Andrew, and Ali had just arrived to start touring. Erin, Riley, Spencer, Brian, and I fly out in the morning.

HAWK

PHOTOGRAPH CAPTIONS AND CREDITS

TEXT

All photographs are courtesy of Tony Hawk unless otherwise credited.

2–5 The 900. © *Grant Brittain*

6 I needed to have every single Frisbee—even the ones my brother and his friends were playing with.

9 Mom and me.

12 In fourth grade.

14 In first grade.

15 In second grade.

16 In sixth grade.

20 In fifth grade.

22 In seventh grade.

25 *(top)* Posing an air in my driveway on the first ramp my dad built. © *Lenore Dale*

 (bottom) The little guy at Oasis, the first skatepark I ever went to. The pads were useless.

27 Frontside disaster at Oasis. I don't know how I ever maneuvered that giant board.

28 Fakie ollie at Oasis. My first aerial in a pool—below the coping. © *Steve Hawk*

29 Fronstside grind at Oasis. This was the first time I ever hit the top of a pool.

32 Zorro, the attack cat. He could sleep wherever he wanted.

33 Frontside air in the Oasis halfpipe on the Dogtown board that Denise gave me.

39 My first winnings: Whittier Skate City ASPO contest. © *Frank Hawk*

42 *(left)* Padded to the hilt, complete with gardening gloves. Layback air at Oasis.

(*right*) So-called rivals: Christian Hosoi and I used to hang out together. © *Grant Brittain*

45 (*top*) "Pipe pasting" used to be a special event in which you place a sticker as high as you can in a full pipe. My best attempt at Whittier. © *Frank Hawk*

(*bottom*) Fakie foot plant during the Gold Cup Series at Marina Del Rey Skatepark. This was the first day I met Stacy.

46 Grabbing the nose on a backside air like my hero Eddie Elguera at the Del Mar Skate Ranch, my home away from home.

52 Frontside ollie nosegrab (later known as a lein air) during a pro-am event at Pomona Pipe and Pool. © *Frank Hawk*

58 Skating the ditch that started at my school, San Dieguito, and ended practically at my front door. Did I mention it was a sanitation ditch? It was hard to skate while carrying a stack of books. © *Grant Brittain*

62 Graduation shot of the McSqueeb hairdo in its infancy. © *Dick and Lenore Dale*

64 Since my dad was running the contests, I felt obligated to be a judge for the events I wasn't in.

65 This was the first backyard ramp event—in Palmdale, California. I thought it would look cool to make eye contact with the camera. It didn't.

71 Another attempt at eye contact over the hip at the Del Mar halfpipe, another dorky facial. © *Steve Hawk*

72 The man they called Frank—my dad—about to yell at someone to get off the ramp. © *Grant Brittain*

77 The lucrative monthly salary of a pro skater in 1983.

80 I finally figured out how to get fakie ollies above the lip. Del Mar.

93 The McSqueeb in full effect.

95 A proud member of the Bones Brigade. Bones and I had matching fingers. © *Grant Brittain*

96 One of my first demos. This seemed like a huge crowd at the time.

111 Lance and I practicing karate-style doubles. © *Bouroqui*

112 A typical night at my house.

115 I call this a Holmes air. Christian Hosoi did it best . . . his nickname was Holmes. © *Grant Brittain*

122 Cutting-edge technology back in the '80s: a boy and his Watchman in Japan. I found out later that the symbol on my shirt means "guts."

125 McTwist at Expo '86 in Vancouver, Canada. I skated the contest between Pomona in 1982. I placed third.

126 The "Hollywood" premiere. © *Grant Brittain*

128 Models, Inc.: Lance, Cab, and me in St. Louis convincing ourselves that we look cool.

129 Cindy and I caught in an embarrassingly '80s moment.

132 Stacy and me at my first wedding.

139 (*top*) My favorite time while building our ramp—lunch. My dad tells me what needs to be done as soon as I finish that bite.

(*bottom*) My own ramp thanks to my dad, a couple of helpers, a few thousand nails, and hundreds of sheets of plywood and Masonite. © *Frank Hawk*

148 Street skating? Nice, France.

158 Skating the mini-ramp a few feet from my backdoor in Fallbrook. © *Miki Vulkovich*

168 My membership card for a Canadian skatepark. The McSqueeb has taken a turn for the worse.

172 Three generations of Hawks: grandson, son, and father.

177 Riley and his young father.

178 A family moment during a skate event, 1993. © *Grant Brittain*

181 Lipslide during the 1993 Münster World Championships street event. © *Grant Brittain*

184 During my days as a single father: Riley and me at Disneyland.

186 Hard Rock World Championships, Hollywood.

189 Fatigue in the finals—1995 Hard Rock World Championships, Huntington Beach. The head-to-head format takes its toll. © *Grant Brittain*

191 The exhaustion pays off. Riley shares in the victory. © *Grant Brittain*

192–93 Ollie 540 over the channel, 1996 Hard Rock World Championships, Hollywood. © *Grant Brittain*

194 Erin, Riley, and me in Italy, 1998. © *WOWE*

199 One of my many failed attempts at a switch 540. Encinitas, California, 1996. © *Grant Brittain*

205 To promote the 1998 X Games, ESPN sent Andy MacDonald and me up in F-18s, courtesy of the Marines. The training was harsh, but we didn't puke in the air.

HAWK

206 The winner's podium with Riley. 1997 X Games, San Diego. © *Grant Brittain*

216 A ramp in a bullring built exclusively for *The End* and torn down within a week. Tijuana, Mexico, 1998. © *Mouse*

221 Doubles practice with Andy MacDonald. Backside ollie over a nollie heelflip Indy to fakie. Mission Valley, California, 1997. © *Grant Brittain*

222 Annie Leibowitz checking my mustache placement and consistency for the Got Milk? ad.

226 The best things in life: Riley holding Spencer.

231 Backside ollie, Encinitas YMCA, 1998.

232 McSqueeb, R.I.P., 1997.

239 Another day at work, another failed 900. Encinitas YMCA, 1998. © *Grant Brittain*

241 Kevin Staab, Erin, Spencer, and me. Spencer can't decide whether to be amused or terrified of Kevin's hair. © *Grant Brittain*

242 Indy-oop over the channel at Birdland, my second private ramp. The ceiling was too low, so we finally shut it down. © *Grant Brittain*

252 The Hawk family, March 2000—shot by Jennifer Miller (wife of Chris Miller, fellow pro during the '80s).

257 Watching Riley learn to skate at six years old—an age that I wouldn't have considered skating an option. © *Grant Brittain*

284–85 Overturned Smith grind (a.k.a. Sugarcane) on the bridge of death at Encinitas YMCA, 1998. There is little room for error on this trick—inches, literally.

INSERT

5 © *Bouroqui*

6 © *Grant Brittain*

8 *(bottom)* © *Grant Brittain*

10 *(top)* © *Atiba Jefferson*
 (bottom) © *Grant Brittain*

12–13 © *Grant Brittain*

15 © *Mouse*

16 © *Grant Brittain*

ACKNOWLEDGMENTS/ THANK-YOUS/SHOUT-OUTS/ PROPS/ASS KISSES

To Erin for her endless support, inspiration, and understanding. Riley and Spencer for their boundless energy and for showing me the true meaning of responsibility. My dad for his undying devotion to his family. My mom for her positive outlook on everything. Pat for her organizational skills and her ability to balance business tasks and family time—sometimes more than me. My brother, Steve, for introducing me to skateboarding and for bestowing on me his perverse sense of humor (the standard Hawk trait). My sister, Lenore, for setting the standards in parenting. Mort for living this book while trying to launch a website and plan a wedding and for the daily calls regarding the most minute details. Renée Iwaszkiewicz for her editing wizardry and her ability to mediate last-minute changes. Per and everyone at Blitz; Birdhouse team riders; the Ridge; Hawk Clothing staff; Sarah Hall and the entire staff at SHP; Brian, Raoul, Eric, and everyone at William Morris Agency; Peter Hess; Jared; PGA Greg; Matty, Cathy, and Miles; Alan Deremo; Pamm Higgins; Dick, Greg, and John Dale; Hagen and Emily; Will and Cameron; Morgan; Shon; Sweet Daddy Rob; Sweet Pussy Frank; Chez la pez; Ron Semaio, Jack Weinert, Chris Steipock, Ian, Esther, Douglas, and Boomer at ESPN; Dave Stohl, Will Kassoy, RZA, Serene, and Nicole at Activision; Joel, Scott, and all the geniuses at Neversoft; Stacy Peralta; Lance, Steve, Mike, and Tommy—the O.G. Brigade; Chris Miller and Jeff Taylor; Danny Kwock, Bob McNight, and Mark Oblow at Quiksilver; Andy Mac; Tom Green; Grant, Dave, and Atiba at TWS; Matt Hoffman; Tom Lochtefeld; Nancy Lee; Jill Schulz; Bob Burnquist; United 1K desk; GPS technologies; MP3s; Firewire; Apple Computers.